D1482890

YOU NEXT

NEXT

REFLECTIONS IN BLACK BARBER SHOPS

ANTONIO M. JOHNSON

Lawrence Hill Books Chicago

Copyright © 2020 by Antonio M. Johnson

All rights reserved

First edition

Published by Lawrence Hill Books

An imprint of Chicago Review Press Incorporated

814 North Franklin Street

Chicago, Illinois 60610

ISBN 978-1-64160-285-3

Library of Congress Control Number: 2020939599

Cover and interior design: Jonathan Hahn

All photos copyright © by Antonio Johnson

Printed in the United States of America

5 4 3 2 1

CONTENTS

YOU NEXT

ANTONIO M. JOHNSON

Some time ago, I trekked from my home in Brooklyn to the famed Apollo Theater in Harlem to watch the comedian Hannibal Buress perform. In the middle of his act, and out of nowhere, Buress asked the crowd, "You ever think you were depressed but really you just needed a haircut?" The joke elicited mostly chuckles from the largely white audience, but the Black men in the room erupted in laughter.

As Buress's joke and the response it received suggest, there's something about a fresh haircut that can change a Black man's outlook on the world, change his outlook on himself. And if getting a haircut is an external experience that can have a profound internal impact on a Black man, that experience extends beyond just the cut to the environment of the barber shop itself.

This is something I've always felt. Growing up, getting my hair cut was a weekly event I looked forward to more than anything. My uncle Jason—my mother's youngest brother—was a barber and always embodied everything cool, stylish, and "fly."

Between semesters at college, he worked in a barber shop on Market Street. I can still picture it—the old wood paneling, the receptionist in her pink shirt with gold doorknocker earrings and long nails.

When it was my turn, my uncle would sit me in his chair, turn me toward the mirror, and say jokingly, "Man, your hair is peasy! Let me hook you up."

There in that tilted chair, under the hand of my uncle, surrounded by members of my community and totems of our shared experience, I felt safe. I felt like anything was possible. Those feelings of confidence and power only grew as I saw myself transformed from "peasy-headed" to crisp and new, ready to take on the world.

Then there was my dad's barber, Mr. Leon in Southwest Philly, just around the corner from my dad's childhood home. Despite his wet and silky Jheri curl, Mr. Leon was in high demand. On the drive to Mr. Leon's shop, my dad would remind me that this man had cut his hair for every major moment in his life—graduations, first dates, his wedding.

While my dad was getting his usual cut, I'd study the style guides taped to the walls in the small shop and flip through every issue of *Jet* magazine I could get my hands on to see the "Beauty of the Week." And of course, I'd listen to all the back and forth in the room. It was at Mr. Leon's, for instance, that I learned my dad was a basketball legend in our community. "Your dad was better than Magic," a customer might say before another chimed in to describe my dad's jump shot or an incredible play he once made.

From experiences like that, I came to understand barber shops as are more than places simply to get a shape-up, shave, or trim. They are where Black men can speak freely and receive feedback about who we are, who we want to be, and what we believe to be true about the world around us.

That is, of course, not to say that barber shops are perfect. Indeed, they can be as flawed as the communities that maintain them. But at their best, barber shops are sites for the cultivation of Black male identity and wellness—the only such spaces in American life.

In June 2018, I set out on a trip across the United States to visit Black barber shops and photograph the communities that exist within them. I gathered images and stories in Gary, Indiana; Washington, DC; New York City; Oakland; Atlanta; Los Angeles; Detroit; New Orleans; Montgomery; and my hometown of Philadelphia.

I met a toddler in DC on the occasion of his first haircut and a New Orleans barber who's been in the business for more than half a century. I've talked to fathers, sons, husbands, and brothers about what it means to be Black men in America and what the barber shop means to them.

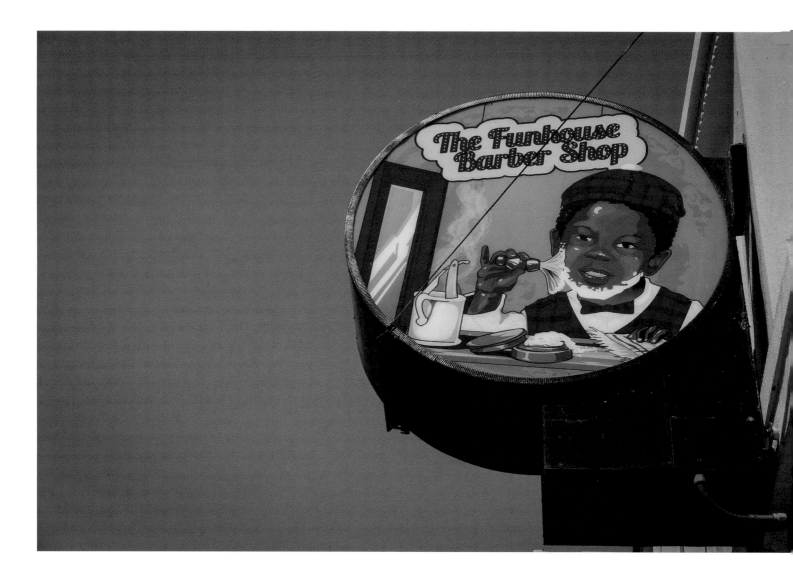

The result of that reporting is the book you hold in your hands. It is my humble attempt at capturing the magic of the Black barber shop, my way of saying thank you to the space for all it has given me.

As for the title? Well, in Black barber shops, "you next" is what a barber says to customers to communicate that they're on deck for a haircut. It's also used as a question between customers to determine where they are in line. Thus, it is an invitation, an invocation, an affirmation. Because after waiting your turn in a barber shop—sharing, laughing, debating—those magic words signify you are about to be transformed.

Shop sign for The Funhouse Barber Shop owned by Michael Elton Casey on Wilshire Avenue. The Funhouse Barber Shop in Los Angeles, CA. September 2018

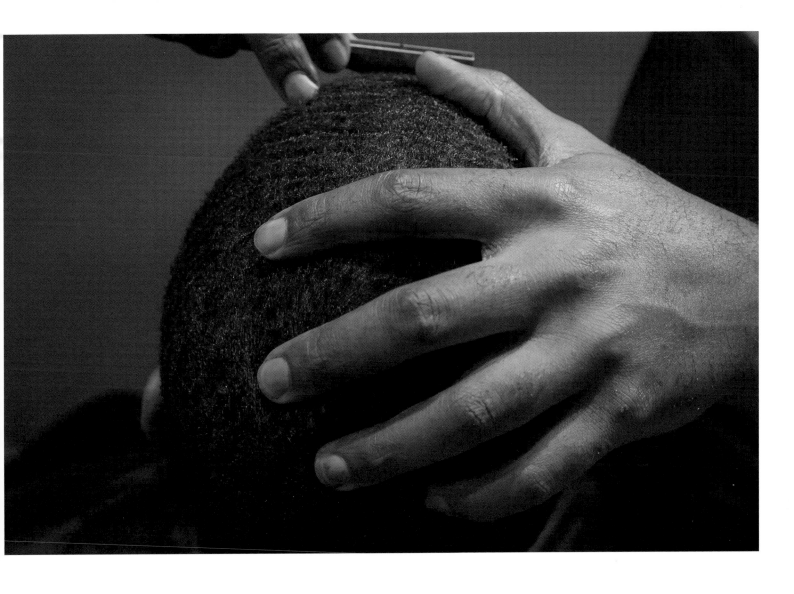

Donald Perry holds a client's head still while giving him a lineup.
The Grain Grooming Studio in Atlanta, GA. August 2018

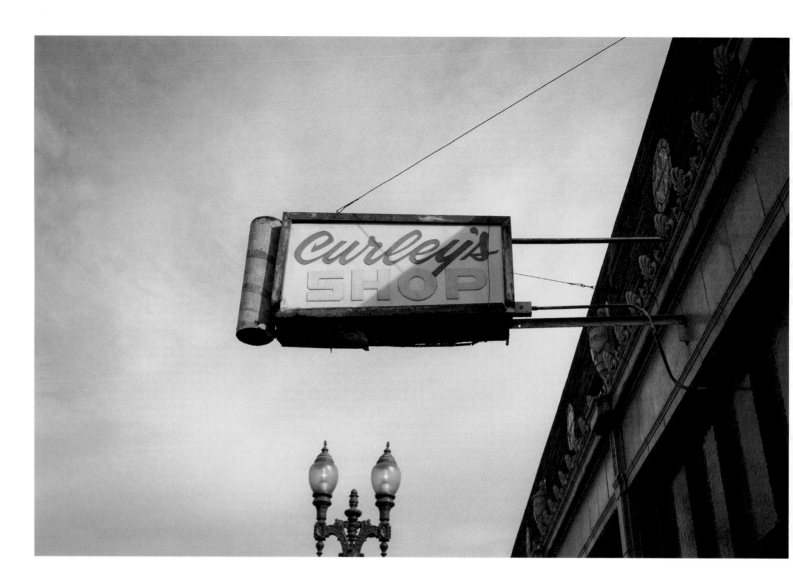

Vintage shop sign.
Curley's Barber Shop in
Oakland, CA. October 2018

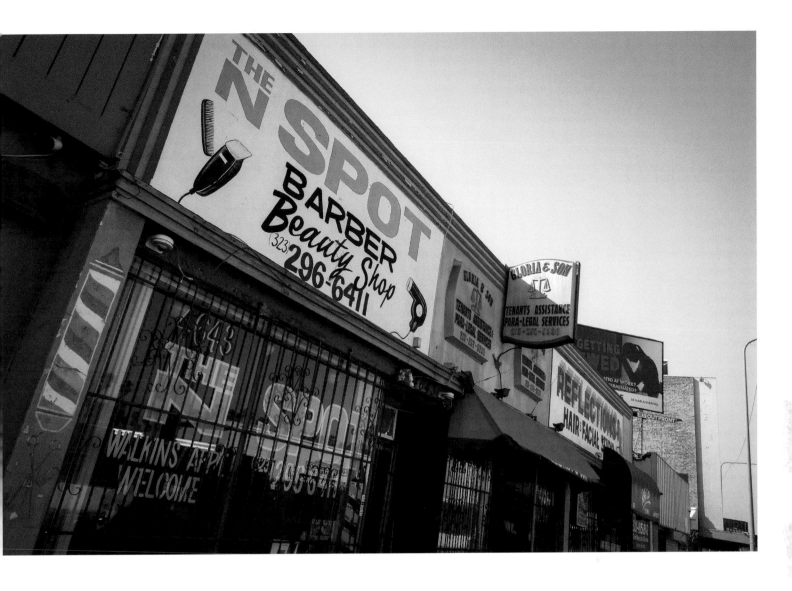

Exterior signage.
The N Spot Barber Beauty Shop in
Los Angeles, CA. September 2018

THERE'S SOMETHING ABOUT A FRESH HAIRCUT THAT CAN CHANGE A BLACK MAN'S OUTLOOK ON THE WORLD.

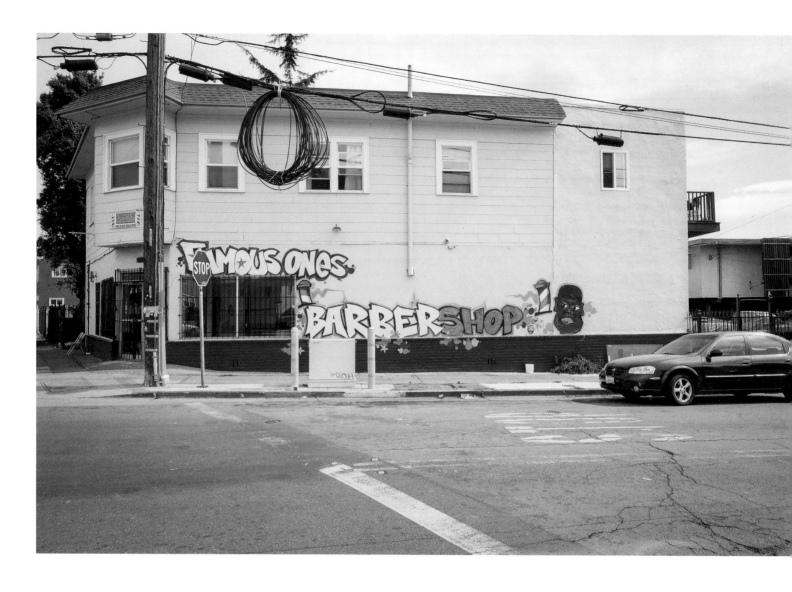

THEY ARE WHERE BLACK MEN CAN SPEAK FREELY
AND RECEIVE FEEDBACK ABOUT WHO WE ARE,
WHO WE WANT TO BE, AND WHAT WE BELIEVE TO
BE TRUE ABOUT THE WORLD AROUND US.

Spray painted sign.
*Famous One's Barbershop in
Oakland, CA. October 2018*

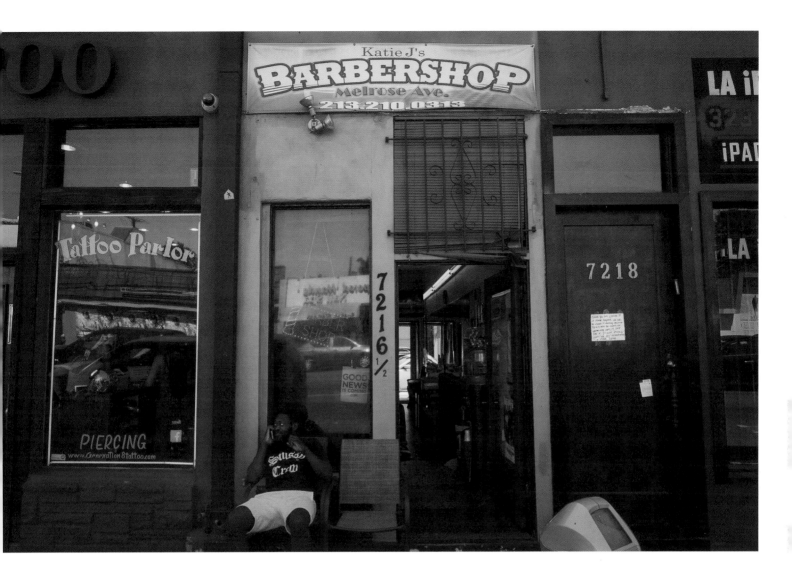

A man waits outside Katie J's Barbershop on Melrose Avenue in the Melrose section of Los Angeles.

Katie J's Barbershop in Los Angeles, CA. September 2018

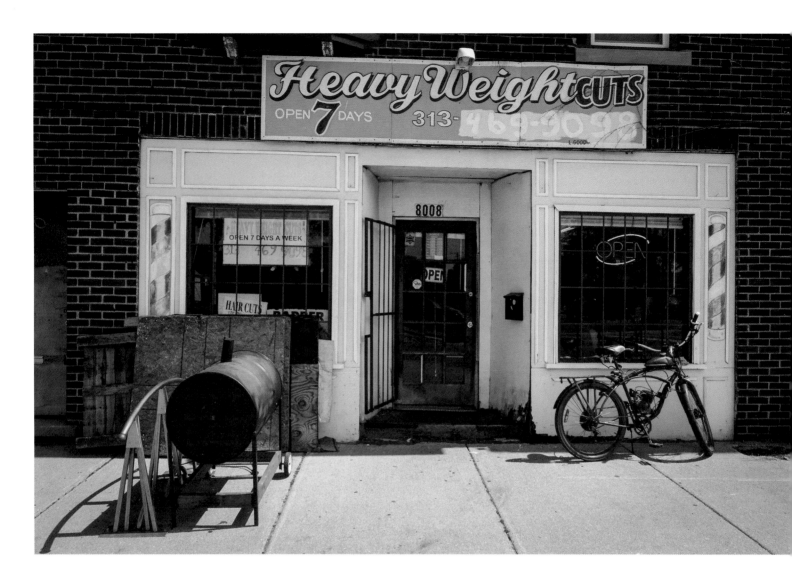

Barber shop in the Indian Village section of Detroit.

Heavy Weight Cuts in Detroit, MI. July 2018

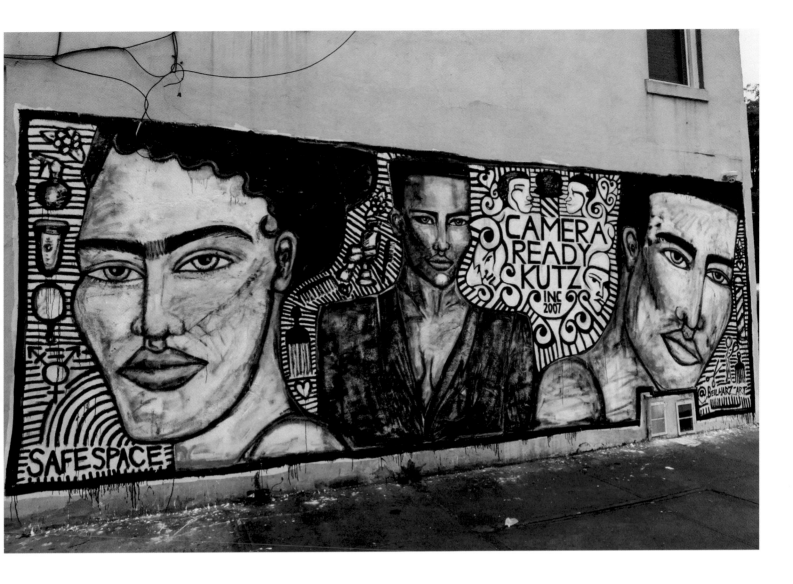

Exterior photo of Kane Kutzwell's barber shop in Crown Heights, Brooklyn. The shop caters to members of the Black lesbian, gay, bisexual, and trans community who oftentimes are ostricized in heteronormative barber shops.

Camera Ready Kutz in Brooklyn, NY. May 2019

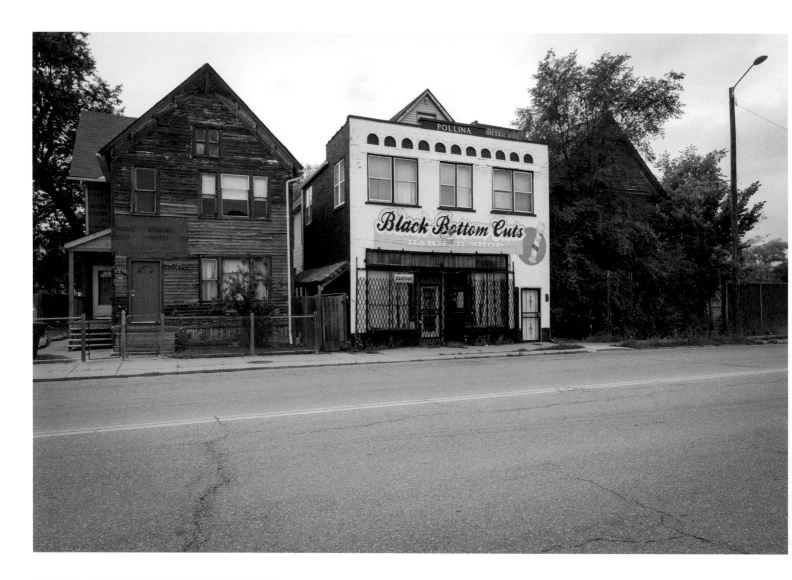

AN INVITATION,
AN INVOCATION,
AN AFFIRMATION

Detroit barber shop.
Black Bottom Cuts in Detroit, MI. July 2018

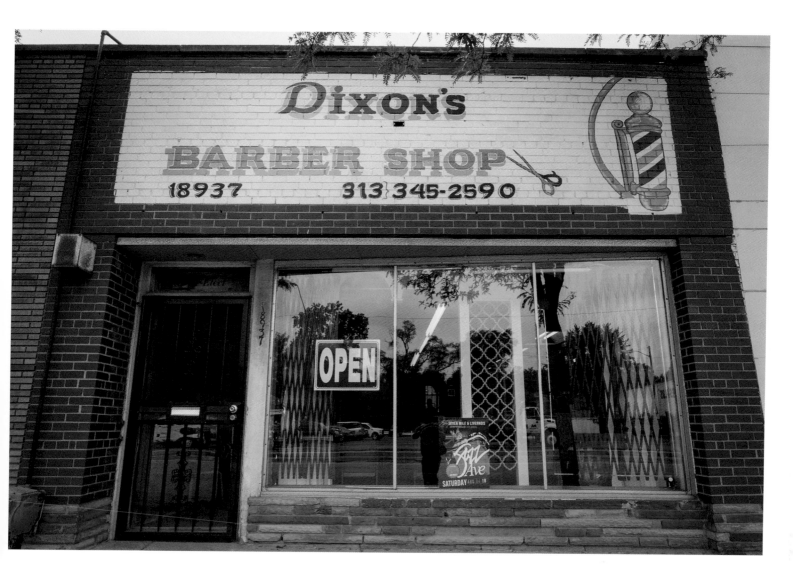

Family-owned Dixon's Barber Shop has been a community shop for more than four decades.
Dixon's Barber Shop in Detroit, MI. July 2018

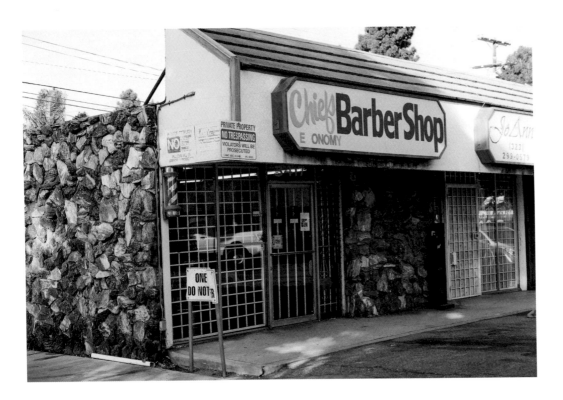

Established in 1945, Chief's Economy Barber Shop is located at 3417 West 43rd Street in Leiment Park.

Chief's Economy Barber Shop in Los Angeles, CA. September 2018

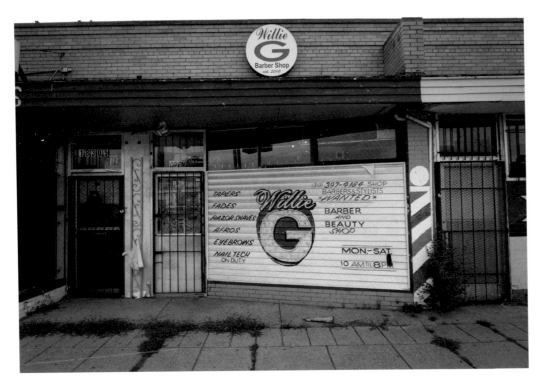

Detroit shop.

Willie G Barber Shop in Detroit, MI. July 2018

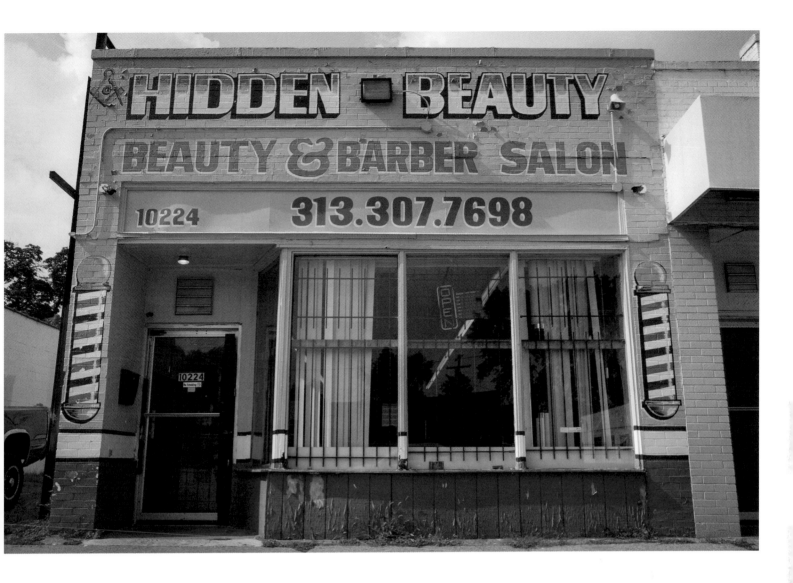

Hidden Beauty Beauty & Barber Salon in Detroit, MI. July 2018

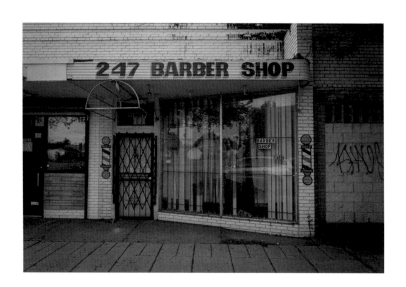

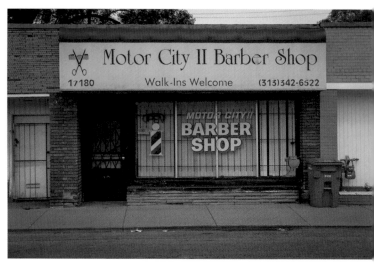

Detroit barber shops.
247 Barber Shop in Detroit, MI. July 2018
Motor City II Barber Shop in Detroit, MI. July 2018

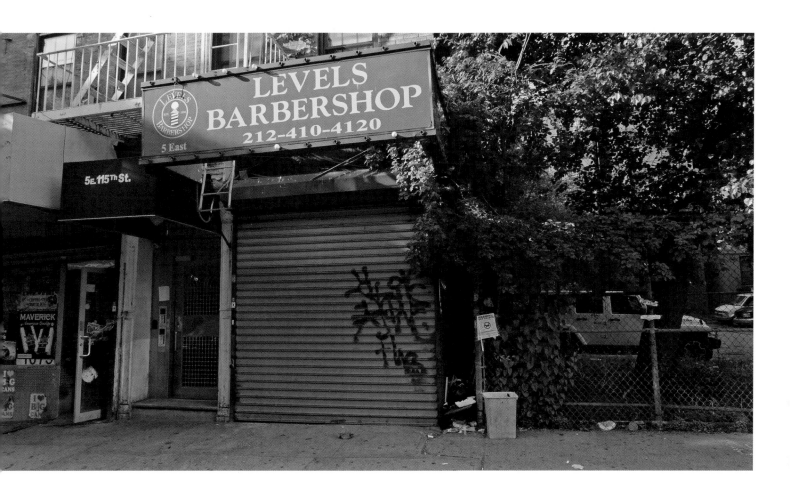

One of many Levels barber shops owned by Kamal Nuru.
Level's Barbershop in Harlem, NY. May 2019

Vintage the Barber Shop is tucked inside the historic
Healy Building in downtown Atlanta. The Healy building
was built in 1913 and was the first skyscraper erected in
Georgia after the Civil War. The current owner of Vintage,
Herbert Williams, purchased the barber shop in 2004.
When Mr. Williams opened Vintage he was committed to
preserving the history of the barber shop by maintaining
the original decor and accents.
Vintage the Barber Shop in Atlanta, GA. March 2019

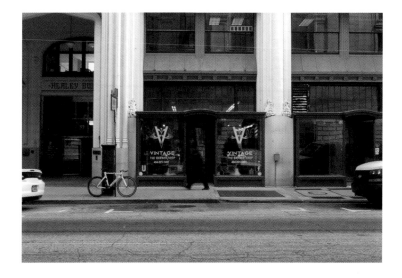

THE UNDEFEATED BUSINESS OF THE BLACK BARBER SHOP

AARON ROSS COLEMAN

Try as the American economy might, for all of its ingenuity, scale, and technology, it has not yet figured out how to mass-produce the perfect temp fade. Corporate executives cannot outsource a hairline. Tech bros have not figured out how to automate a high-top. Until they do, the role of master barber and the business of the barber shop will persist as an exceptionally accessible path to entrepreneurship for everyday Black folks.

Unlike many other sectors, the barriers to barbering remain scalable. You buy a pair of cheap clippers or, in many cases, are given a pair by a family member. You recruit friends to let you turn their fros into frohawks. You scrounge up money for cosmetology school. You're on the way to being your own boss one day. But this relative accessibility of the shop cuts a sharp contrast with the requirements of mainstream entrepreneurship.

In business schools and venture capital firms across the country, the phrase "friends and family round" floats around a lot. It describes the traditional part of the business life cycle when an entrepreneur has a good idea, and they call their rich uncle or one of their mom's coworkers to borrow $10,000 for their locally sourced, artisan-crafted salad shop, or pet cafe, or cupcakery, or whatever.

Entrepreneur magazine describes this as "one of the most common" forms of funding. But in many Black communities, access to capital is not common. The median Black income is only $40,258. The median Black household's wealth is only $17,600. This means the amount that Black people have to seed business ideas of friends and family is often zero.

Access to capital is only the first hurdle Black businesses face. Those that manage to get investment too often fall prey to larger firms that steal their business model and use their scale to replace it. If you don't believe me ask the Black woman who owns Prince's Hot Chicken about how KFC ripped her off like a tag on a new shirt. But yet, while corporate looters steal and sell everything from hip-hop to hoop earrings, the barber shop's business remains unlooted.

From Quincy T. Mills's *Cutting Along the Color Line* to Melissa Harris-Perry's *Barbershops, Bibles, and BET*, academics have marveled at the ingenuity and durability of the Black-owned barber shop. These scholars document what laymen can see—that in the face of recessions, globalization, automation, and discrimination, the barber shop chugs on, an engine for Black community and commerce undefeated.

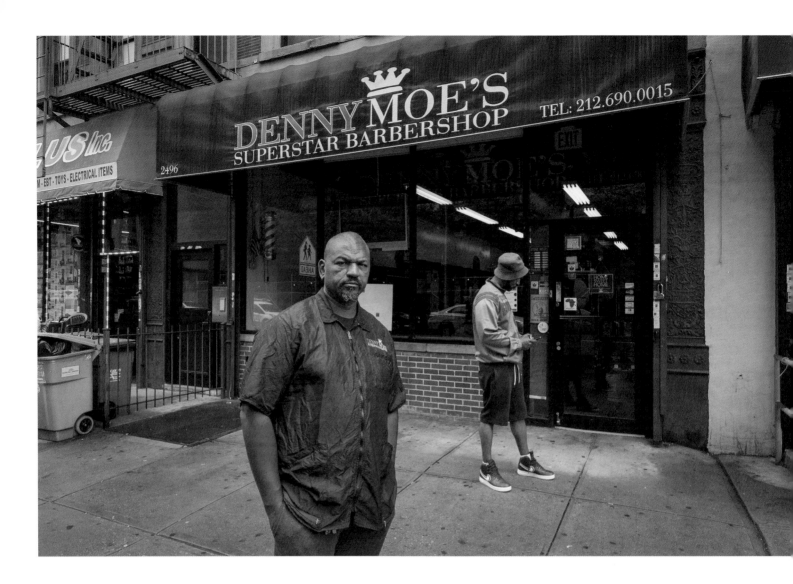

The legend, a pillar of the community: Denny Moe of
Harlem's Denny Moe's Superstar Barbershop
Denny Moe's Superstar Barbershop in Harlem, NY. May 2019

THE ROLE OF MASTER BARBER AND THE BUSINESS OF THE BARBER SHOP WILL PERSIST

A Denny Moe's customer poses after his cut.
Denny Moe's Superstar Barbershop in Harlem, NY. May 2019

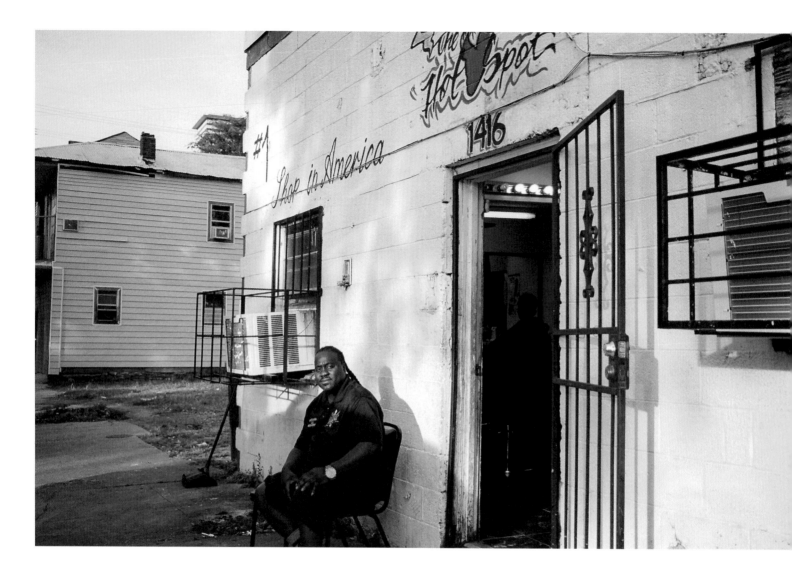

Larry Francois Jr., also known as Mr. Hot Spot.
The Hot Spot in New Orleans, LA. 2017

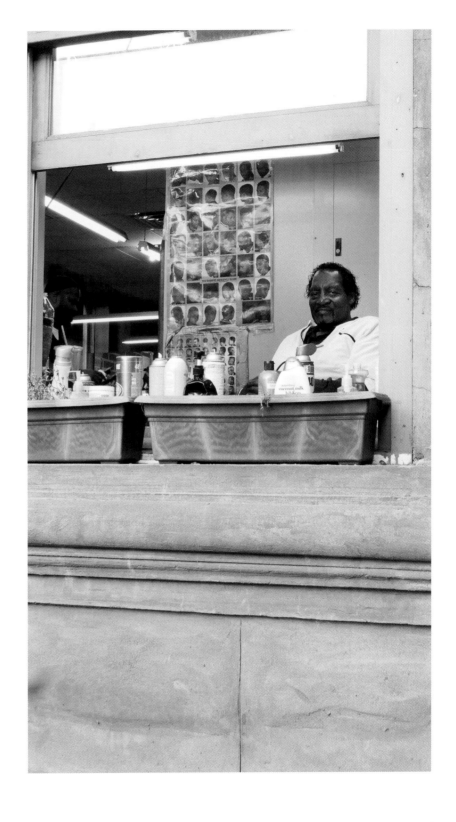

Holsey McKissic sits for a photo through the
window of his Harlem shop.
HKS Harlem's Finest Hair Salon in Harlem, NY. May 2019

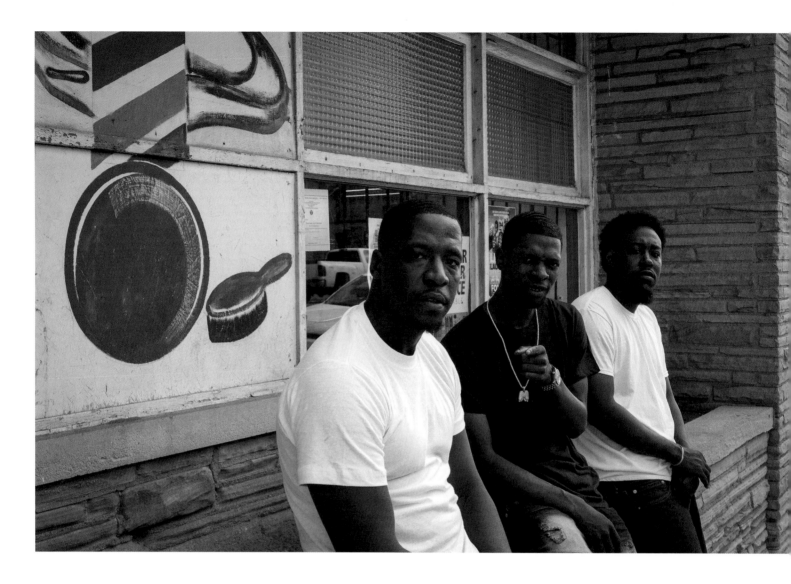

The barbers of McMan and Son Barber Shop take
some time to talk and pose outside of the shop.
McMan and Son Barber Shop in Detroit, MI. July 2018

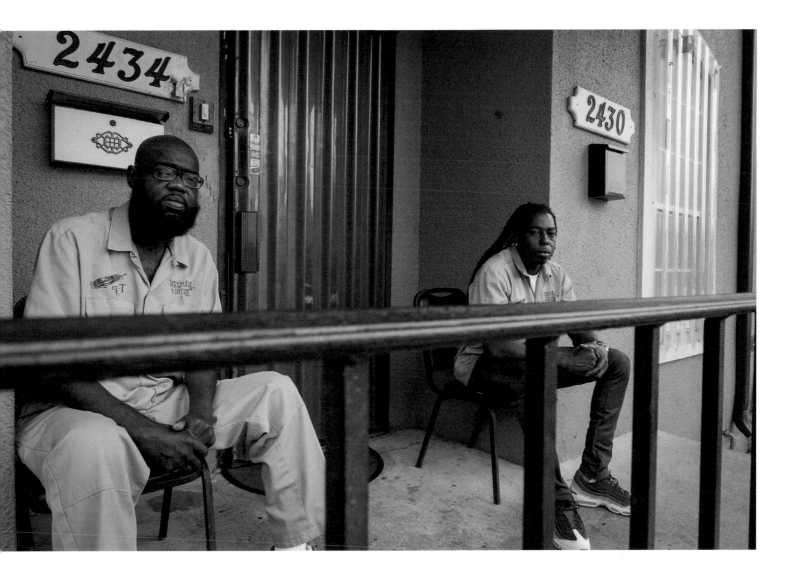

Tee and Rell.
Natural Roots Barber Shop in New Orleans, LA. 2018

23

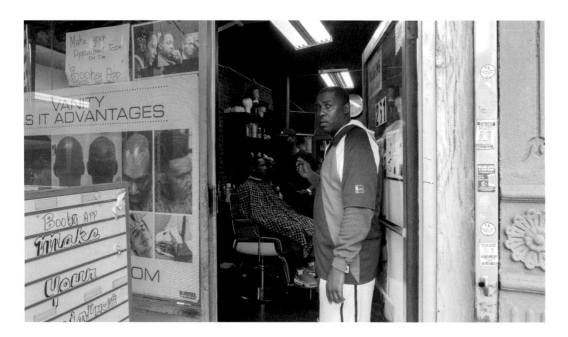

Love Da Barber.
Nothing But Love Barber Shop in
Brooklyn, NY. May 2019

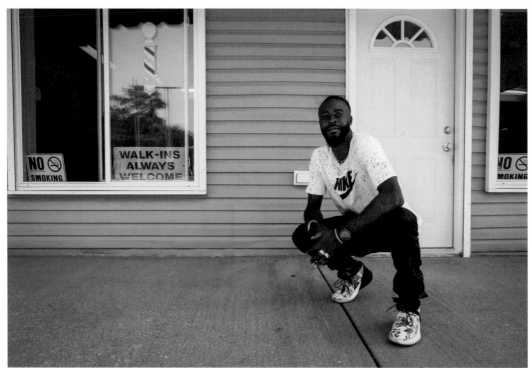

Corey Lackey outside of the
shop that he transformed
with his father.
Lackey's Barbershop in Gary, IN.
August 2018

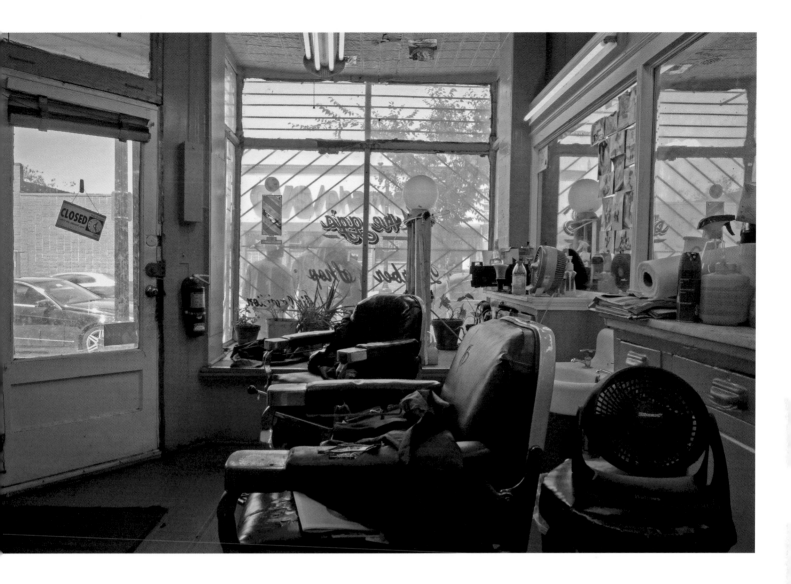

Frank Love has operated Gregg's Barbershop in
DC since 1961. Love protected the shop from the
DC riots of 1968 by spray-painting SOUL BROTHER on
wood panels and placing them in the windows.

Gregg's Barbershop in Washington, DC. July 2018

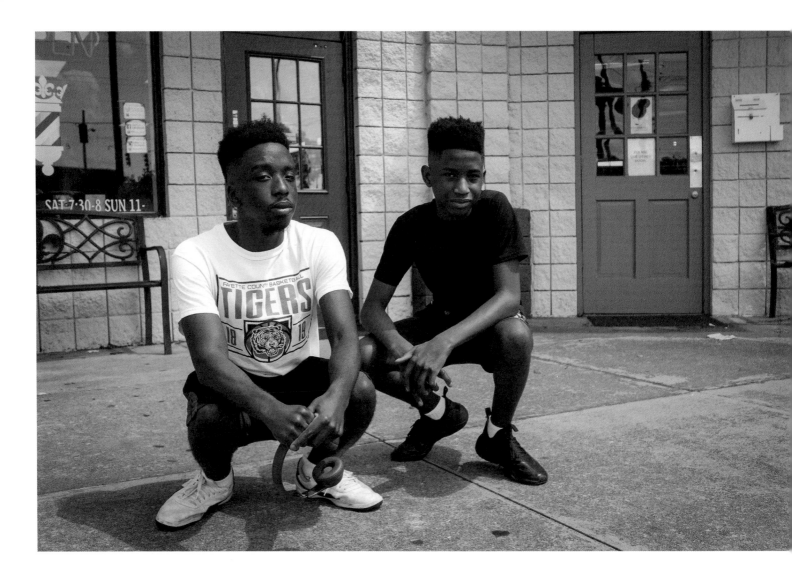

THE BARBER SHOP CHUGS ON, AN ENGINE FOR BLACK COMMUNITY AND COMMERCE UNDEFEATED

Two brothers show off their high-tops
CuttingKings Barbershop in Fayetville, GA. May 2019

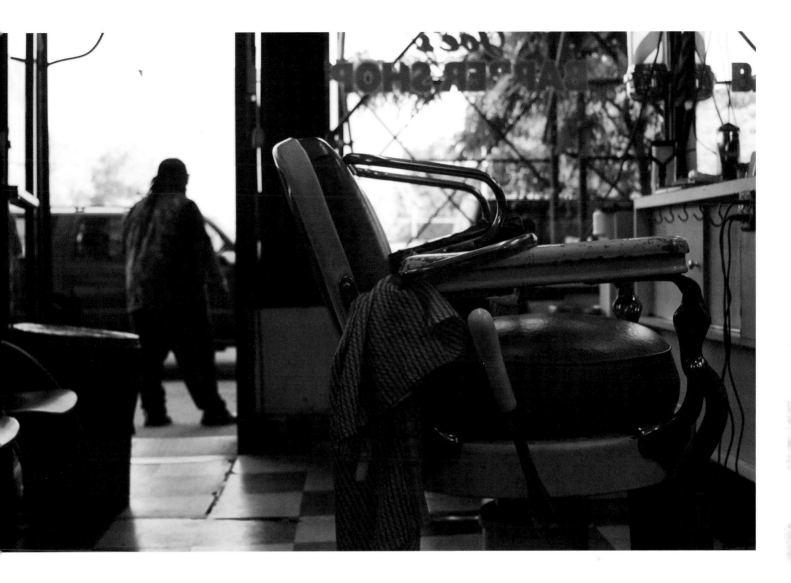

An empty old-school chair inside
Joe's, a Harlem barber shop.
Joe's Barbershop in Harlem, NY. 2017

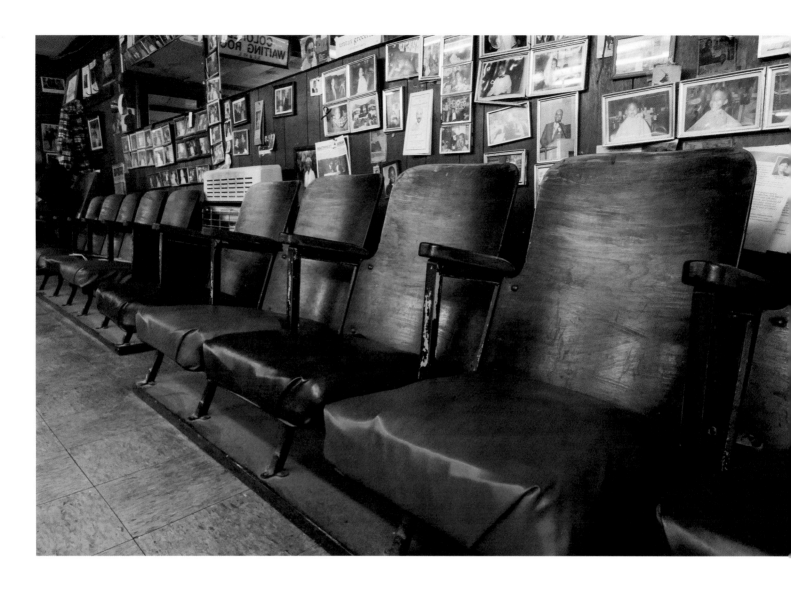

An empty waiting area filled with photos of
community members and patrons.
Malden Brothers Barbershop in Montgomery, AL. 2018

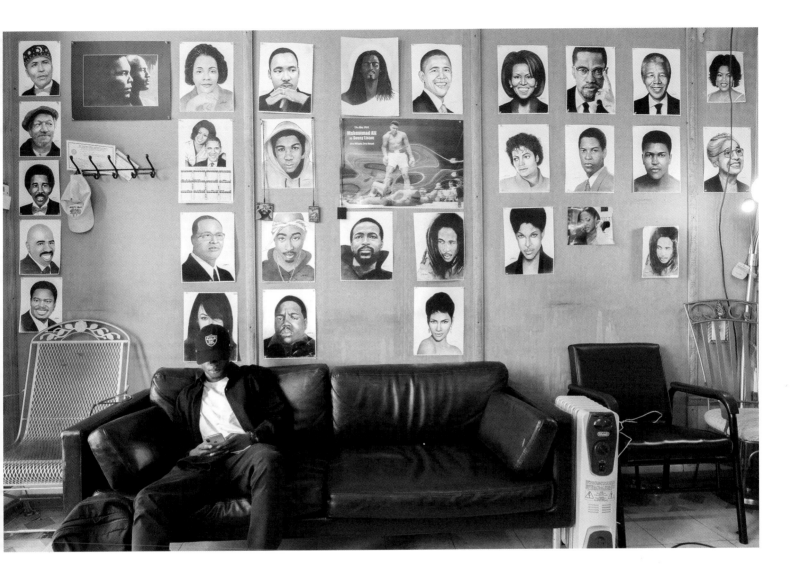

**A man sits while waiting to be called for a haircut in front
of a wall full of hand-drawn photos of celebrities.**
Pure Essence Barber Shop in Atlanta, GA. March 2019

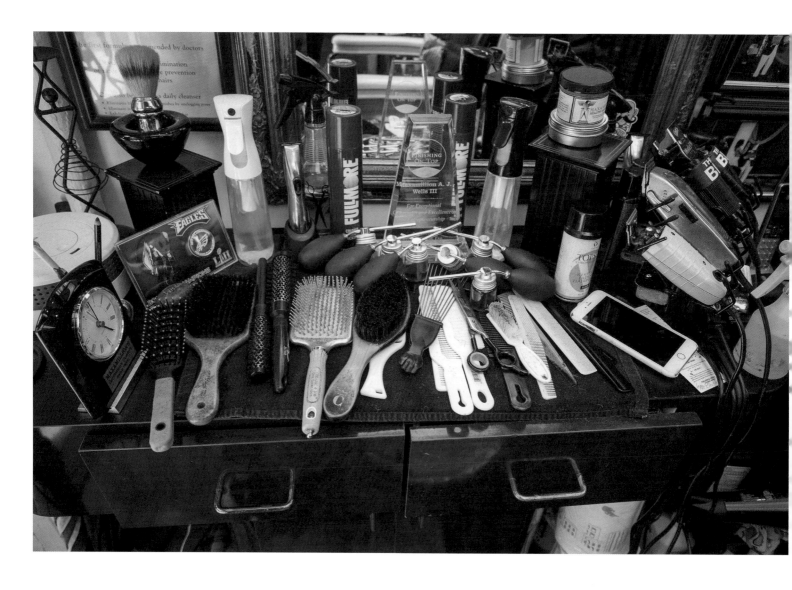

Tools of the trade.

*Maxamillion's Gentlemen's Quarters Barber Parlor in
Philadelphia, PA. June 2018*

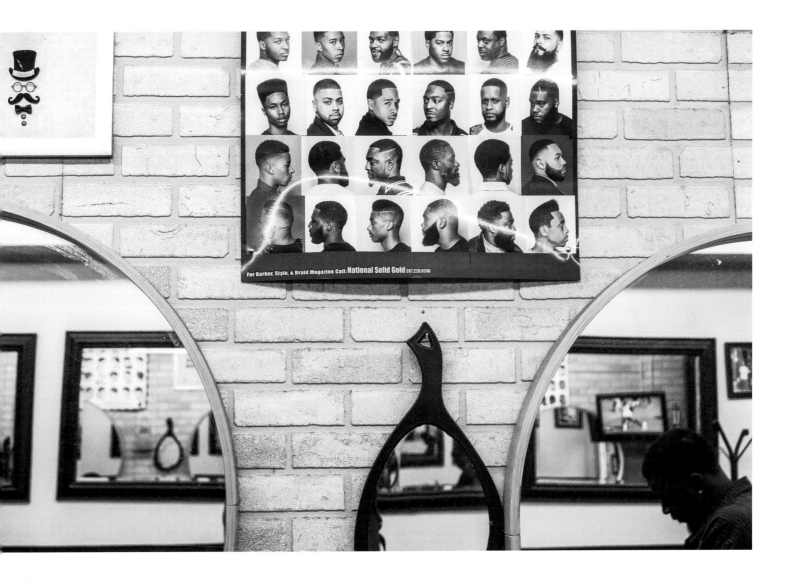

Style guide created and distributed by *National Solid Gold*, a
barber magazine created by Gregory Payne from Philadelphia.
Mella's Barber Shop in Chicago, IL. August 2018

Barber shop products
*Tommy's Barber Shop in
Washington, DC. June 2018*

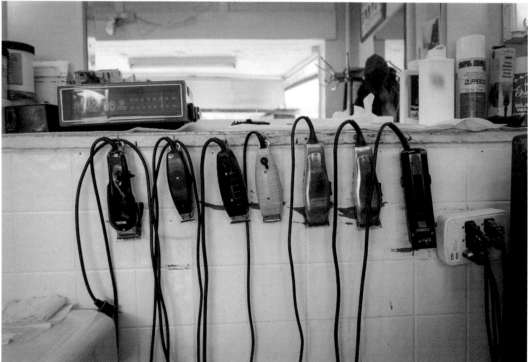

Clipper lineup
*Tommy's Barber Shop in
Washington, DC. June 2018*

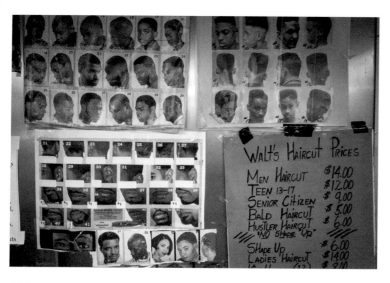

Old-school style guides and price chart.
Walt's Barber and Bike Shop in Philadelphia, PA. June 2018

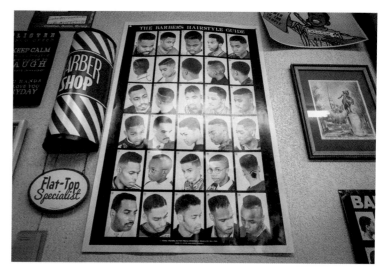

The Barber's Hairstyle Guide.
Cuts and Bends Barber Shop in Oakland, CA. October 2018

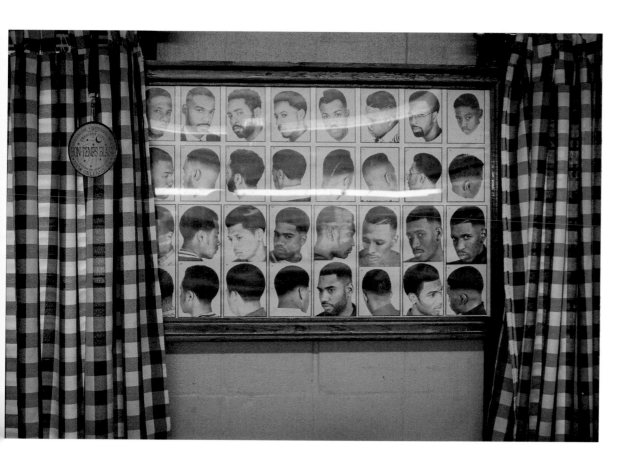

Old-school style guide.
*Harold's Barber Shop in
New Orleans, LA. 2018*

33

THE LANGUAGE

JASON PARHAM

Sometimes we speak love without knowing it. That is the trick, and really, the great wonder of language. An exchange is set in motion even when you—the speaker, the interlocutor, this prism of feeling, flesh, bone, and fantastic melanin—are not aware that language, let alone the language of love, has entered the room. But language, like all grand projects, is an unusual, imprecise endeavor: it is always showing up in one form or another and teaching us something as we labor to refine ourselves, unaware, but curious, aching, open.

What is less unusual, and less imprecise, about language, and particularly about love communicated, is how central it is to our being and becoming, to how we exist and breathe and pour joy onto the people around us. On Foothill Boulevard and Sixty-Second Avenue, just a rock's throw from Concordia Park, inside Cuts and Bends Barbershop—one of Oakland's last havens of complicated and necessary brotherhood—men, boys, uncles, cousins, neighborhood elders, grandnephews, and boys restless to be men, some broken, some lost, some too prideful to ever admit, many, if not all, seeking a higher plane of selfhood, fighting battles both titanic and small, have, since its opening, been greeted with love.

This love is spoken but rarely is it rendered via the tongue. In the hands of eighty-two-year-old proprietor Kenneth Hogan Sr., a former painter and father of two, this love is passed on in the form of a dark caesar or a high fade. Love, and the language in which it is extended, is the snap and whir of clippers gliding against the scalp. It's the precision and deep care that is the basis for a lineup. This language is sculpted from experience and history and tradition. It catches fire. It lights the breach. It offers a way. Love is not always an audible practice. Language does not always demand an ear. Especially in the barber shop, where you are held up by family, warmed by kin.

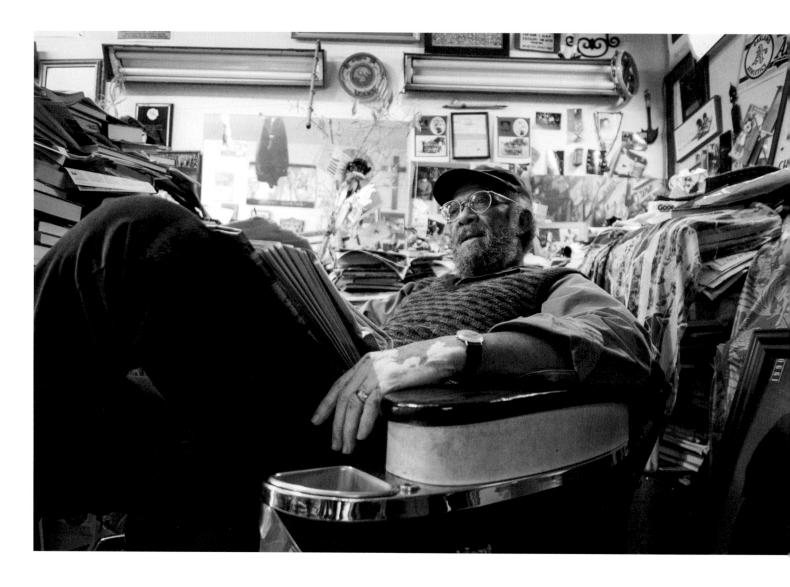

Kenneth Hogan.
Cuts and Bends Barber Shop in Oakland, CA. October 2018

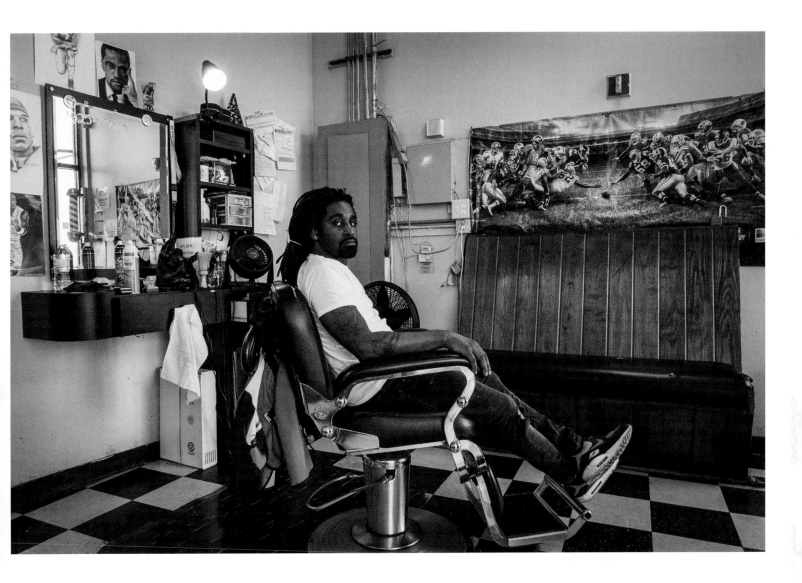

Nate.
Pure Essence Barber Shop in Atlanta, GA. March 2019

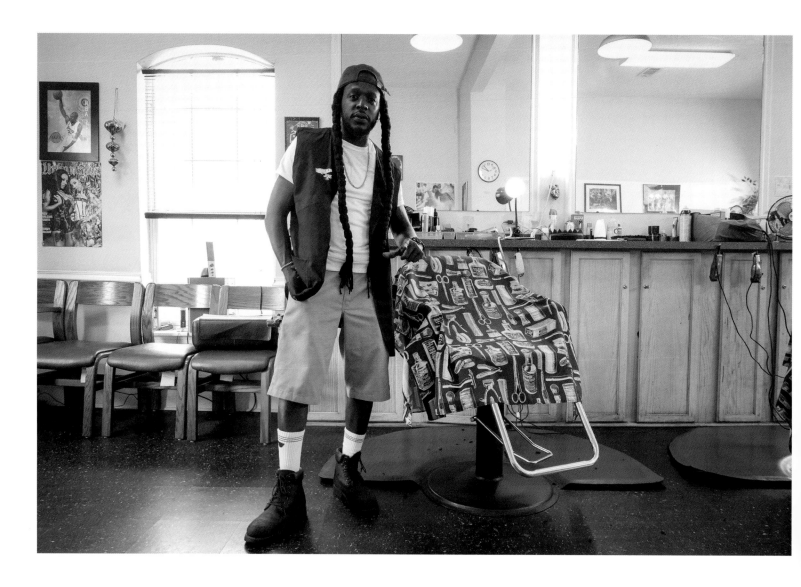

SOMETIMES WE SPEAK LOVE
WITHOUT KNOWING IT

Joe talked to me about all the ways Katrina hurt the people of New Orleans. He shared how, in the midst of the disaster, he helped by cutting the hair of those who'd been displaced by the storm.

Natural Roots Barber Shop in New Orleans, LA. 2018

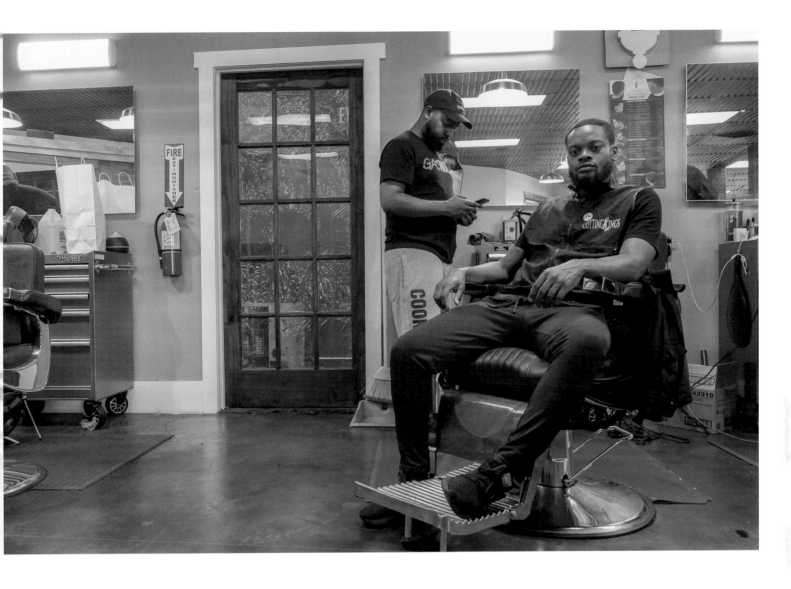

Lamont, also known as L Zeno,
poses in front of his cousin.
CuttingKings Barbershop in Fayetville, GA. May 2019

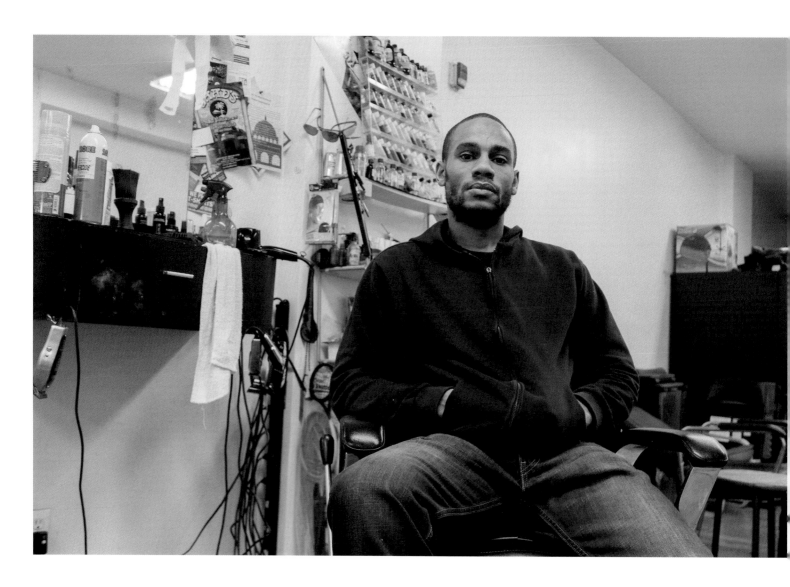

G. My barber since the eighth grade. From the first time in 2003 that I sat in G's chair I knew that he would be my barber for life. He's shaped how I see myself and how I show up in the world.
Gaming Cuts Barbershop in Philadelphia, PA. December 2018

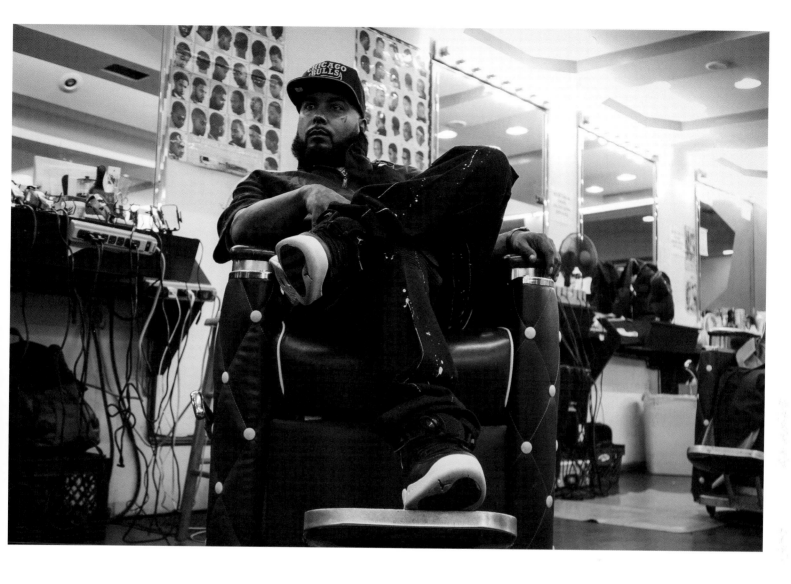

Billco's Barbershop in Gary, IN. August 2018

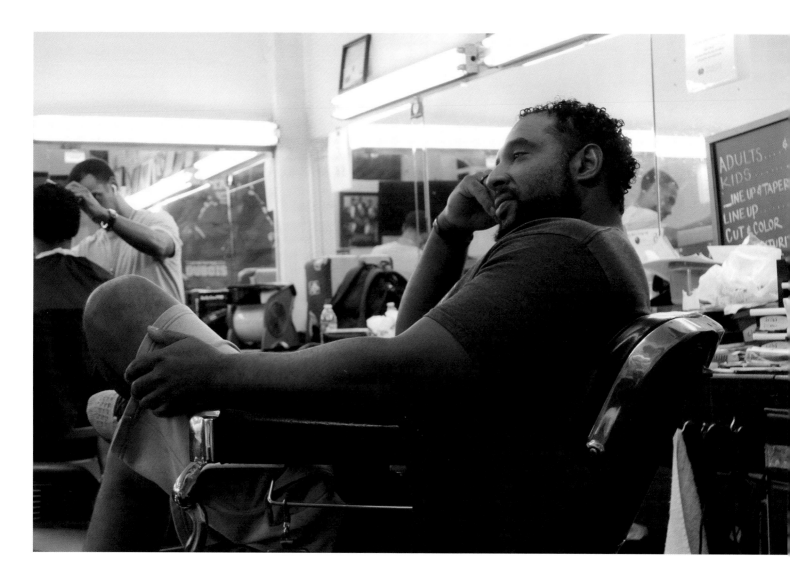

A reflective Eric Muhammad, in his shop, A New You, on North La Brea Avenue. After years of serving the community through cuts, Muhammad teamed with doctors at Cedars-Sinai Medical Center to test for hypertension or high blood pressure in patrons.

A New You Barbershop in Inglewood, CA. September 2018

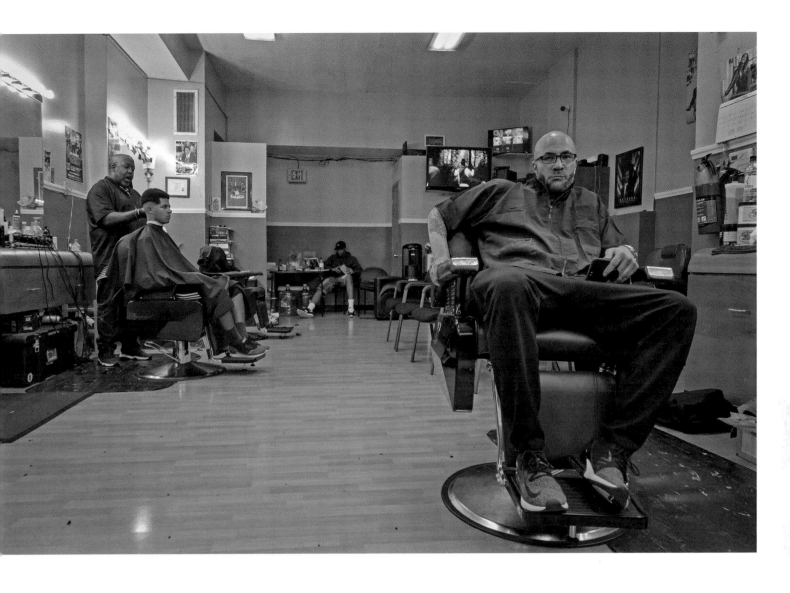

Mike teaching us how the cool pose is done.
A Sharper Image Barber Shop in Washington, DC. June 2018

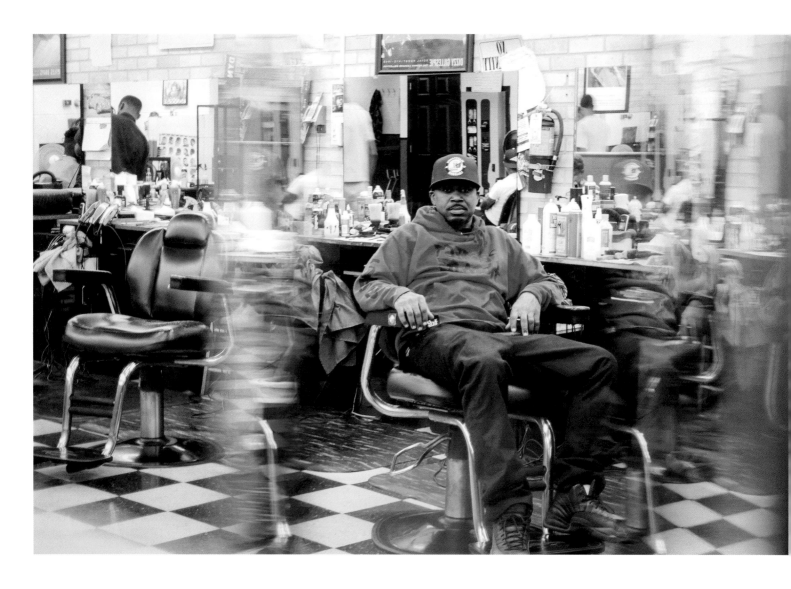

*Better Images Barber Salon in
Evergreen Park, IL. August 2018*

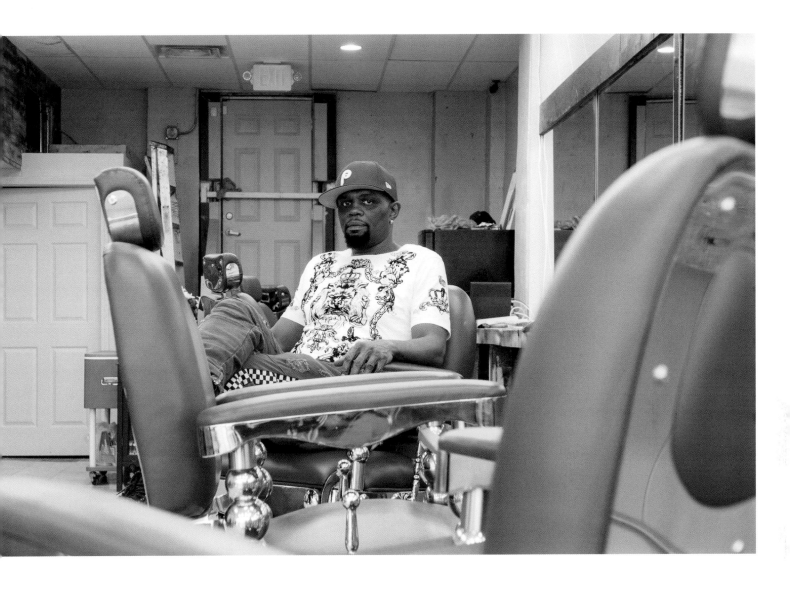

Inner City Cuts, Atlanta, GA. August 2018

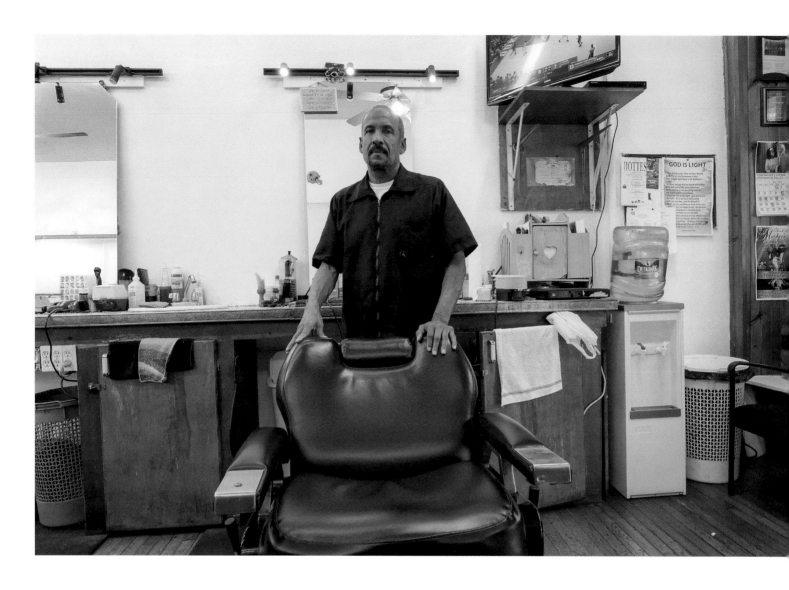

Michael Bighum, owner of
Philly's Finest in Philadelphia

Philly's Finest Barbershop in
Philadelphia, PA. May 2019

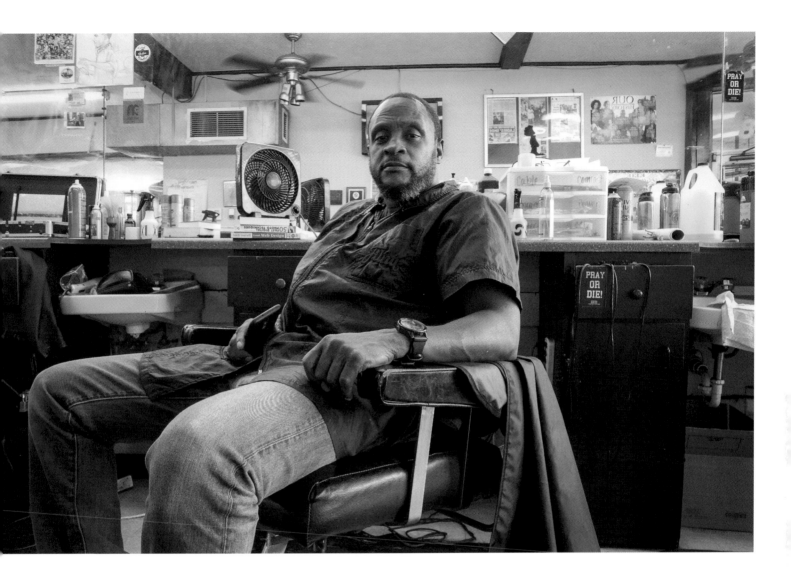

Keir Morris, owner of Philly's Finest in Atlanta. When Morris relocated from Philadelphia in the late 1990s, he opened his own shop, paying homage to the original Philly's Finest, opened by Michael Bighum.

Philly's Finest Barbershop in Atlanta, GA. 2018

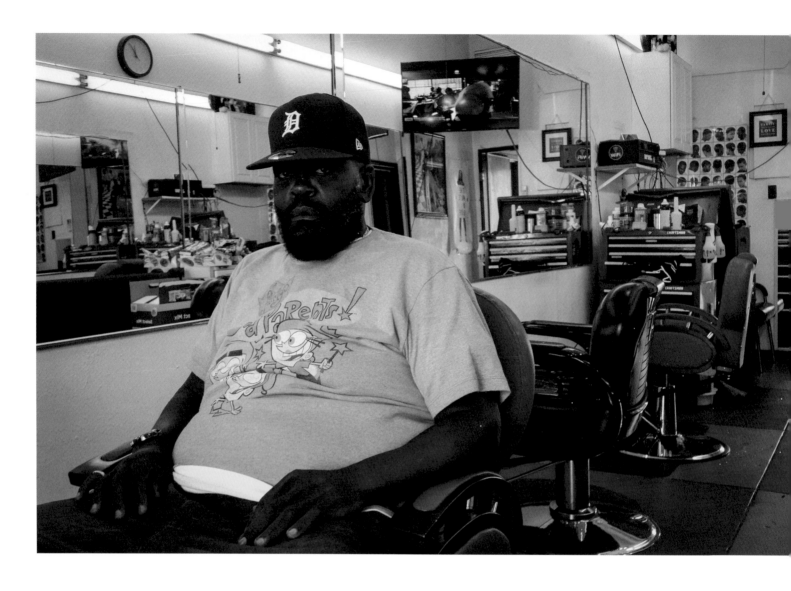

Greg, "LA's Best Barber."
Katie J's Barbershop in Los Angeles, CA. September 2018

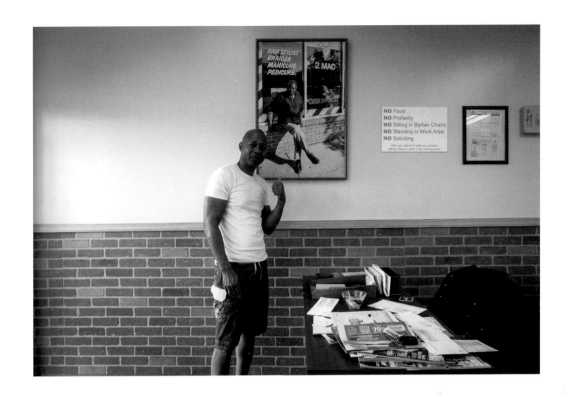

Two Mac's Barbershop in
Washington, DC. June 2018

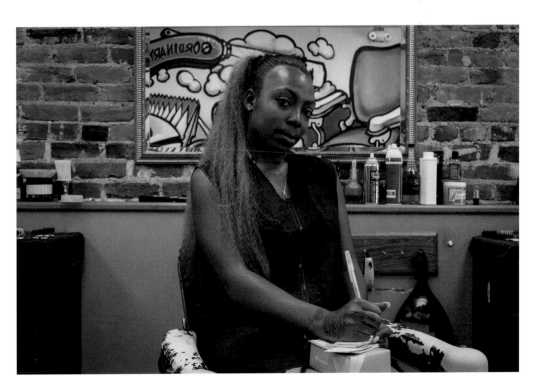

Ordinary People Barbershop in
Washington, DC. July 2018

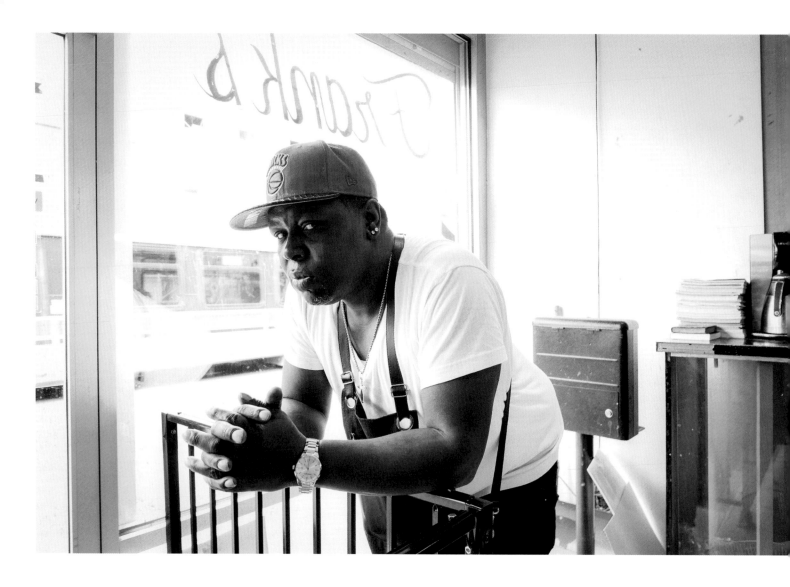

Frank's Place in Chicago, IL. August 2018

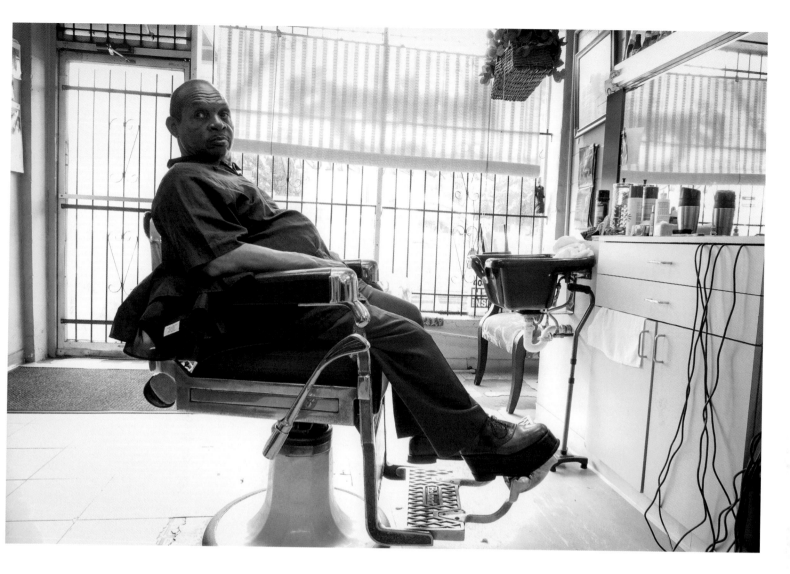

Bobby.
Bobby's Barber Shop in Atlanta, GA. August 2018

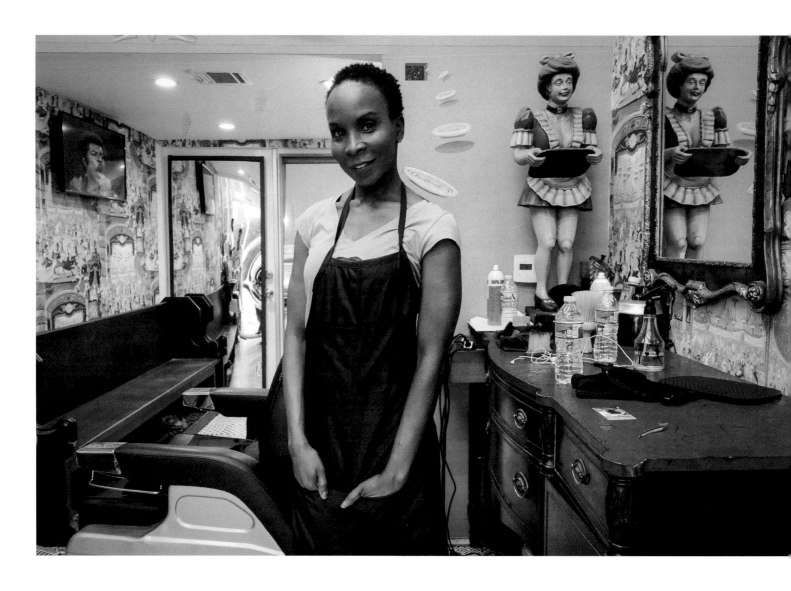

THIS LANGUAGE IS SCULPTED FROM EXPERIENCE AND HISTORY AND TRADITION

Kesia Brooke, an actress and barber in Los Angeles

The Funhouse Barber Shop in Los Angeles, CA. September 2018

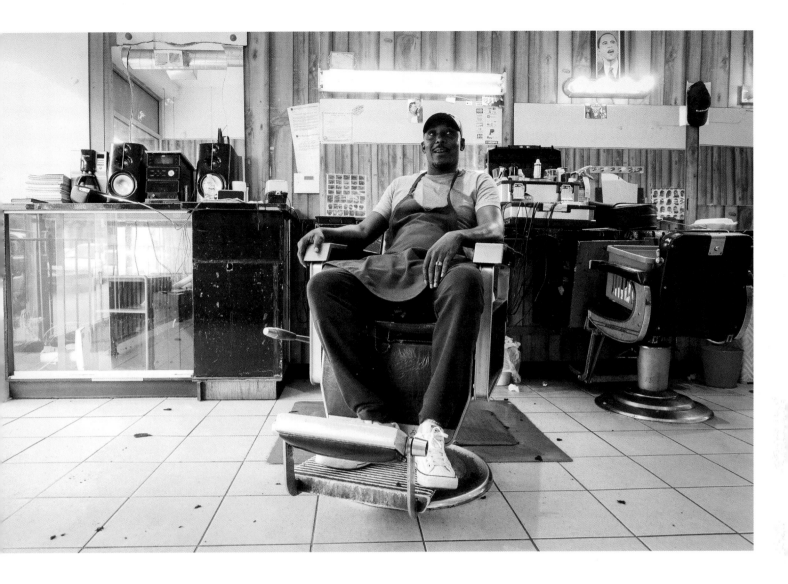

Earl Mondrell.
Frank's Place in Chicago, IL. August 2018

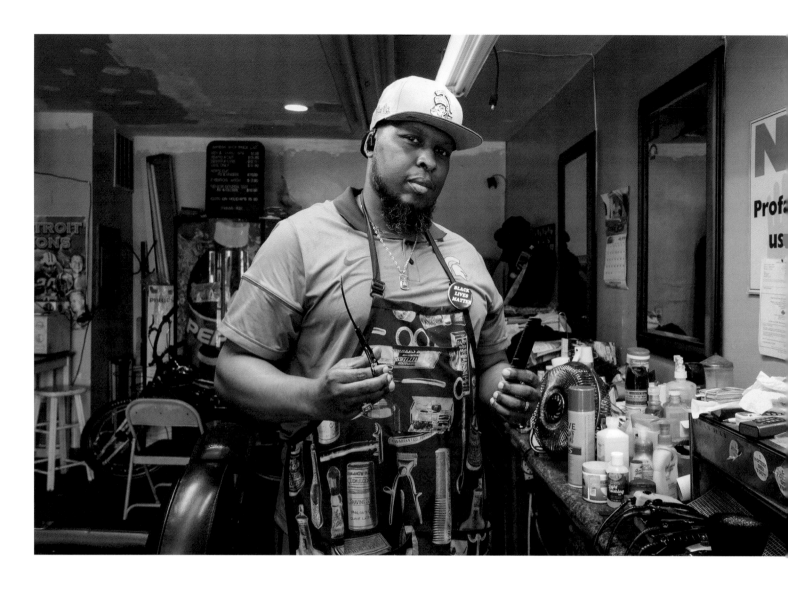

David Hardin Jr. owns and operates Heavy Weight Cuts, located on the northern edge of West Village in Detroit.

Heavy Weight Cuts in Detroit, MI. July 2018

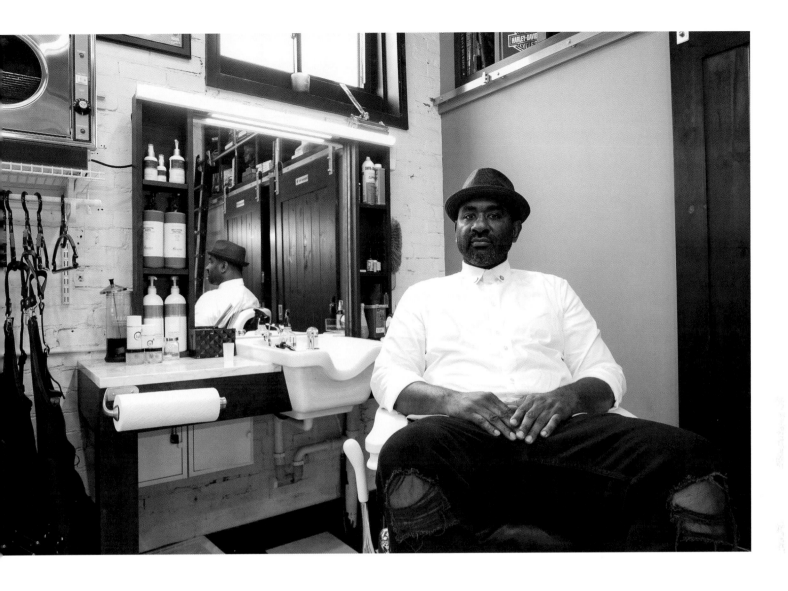

Glenn "Gee Da Barber" Wilson.
Groomzmen Gentlemen Refinery in Atlanta, GA. February 2019

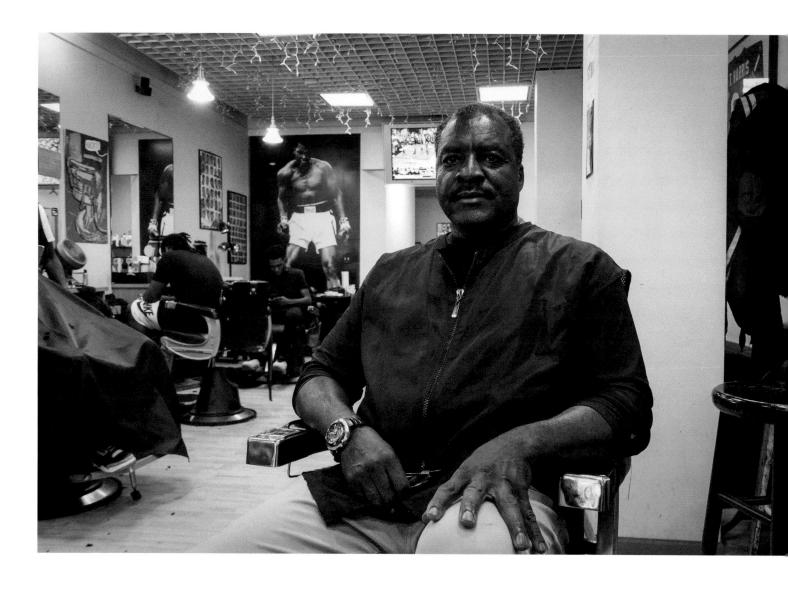

Zariff, the barber of former president Barack Obama, at the Hyde Park Hair Salon

Hyde Park Hair Salon in Chicago, IL. August 2018

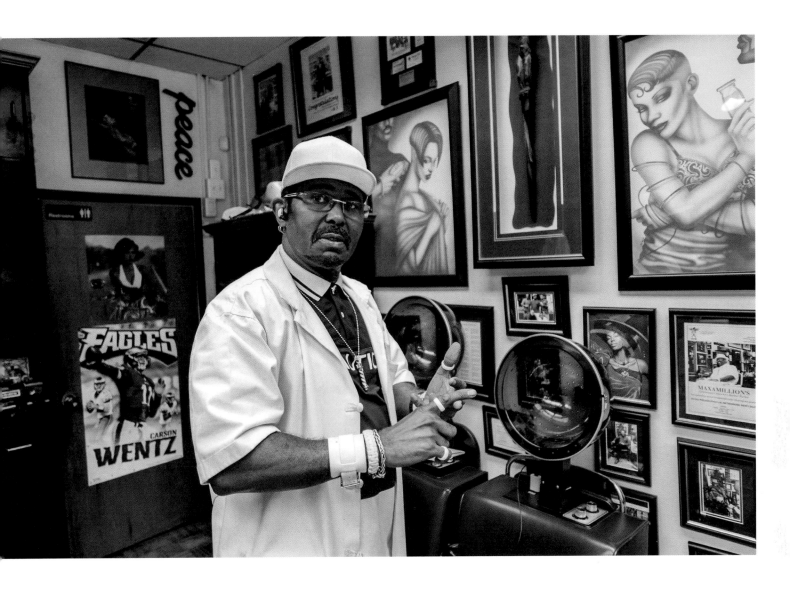

Maxamillion AJ Wells: "Being a barber has a spiritual element. Think about it."
Maxamillion's Gentlemen's Quarters Barber Parlor in Philadelphia, PA. June 2018

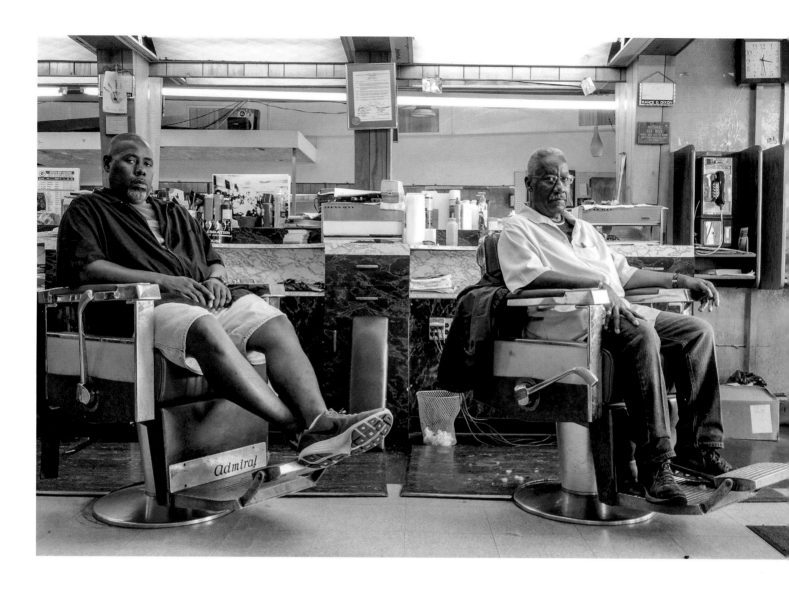

Father and son portrait in Dixon's Barber Shop.
Dixon's Barber Shop in Detroit, MI. July 2018

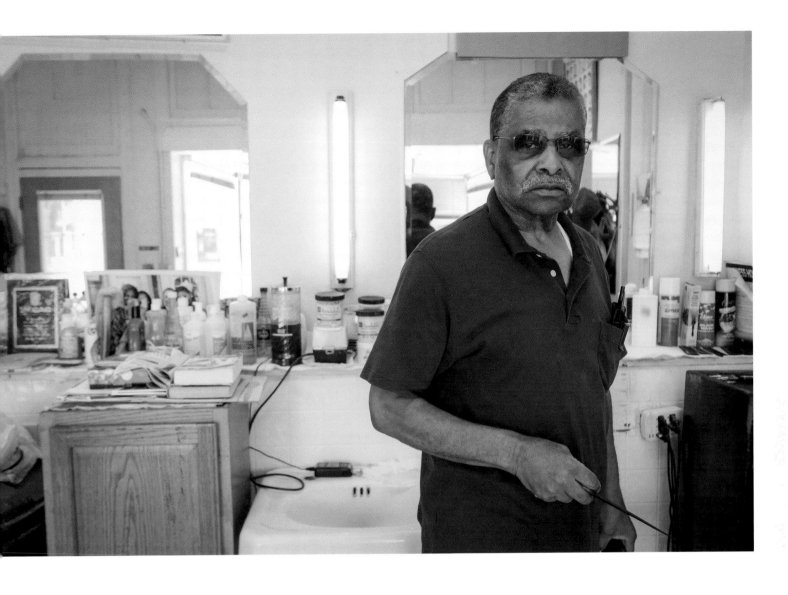

Mr. Tommy: "Keep your enthusiasm for life, young man."
Tommy's Barber Shop in Washington, DC. June 2018

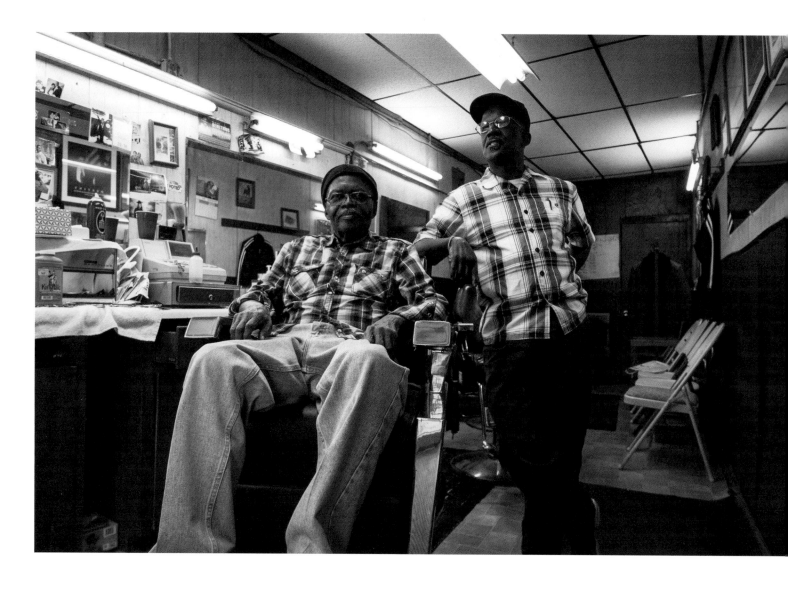

Mr. Howard and his son Eddie.
Howard's Barber Shop in Atlanta, GA. August 2018

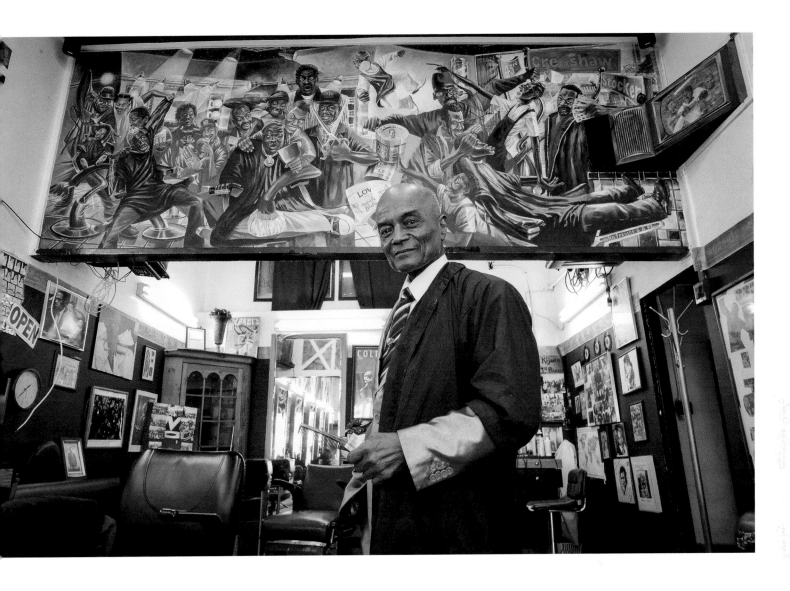

For more than four decades, Magnificent Brothers has been a staple in the Crenshaw area of Los Angeles. Kijana Mahdi learned to cut hair to supplement a career in music. Mahdi, standing below an Ernie Barnes—inspired painting of a barber shop, appears in a suit he wears both to cut hair and perform music for an evening show. In his hand he's holding a comb and cash.

Magnificent Brothers Barber Shop in Los Angeles, CA. September 2018

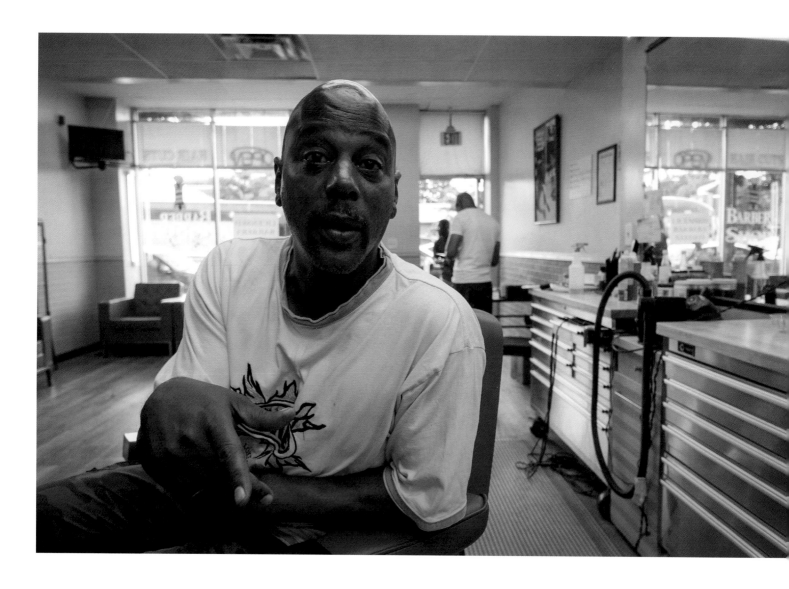

Two Mac's Barbershop in Washington, DC. June 2018

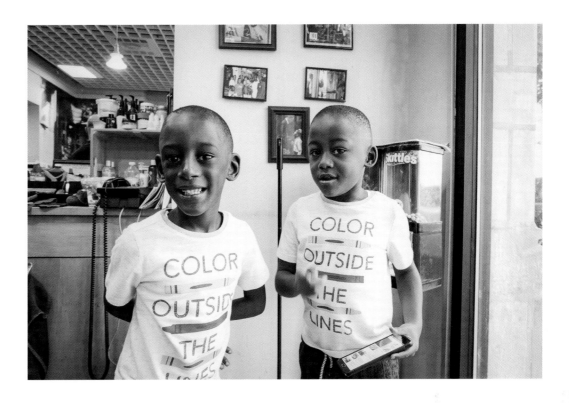

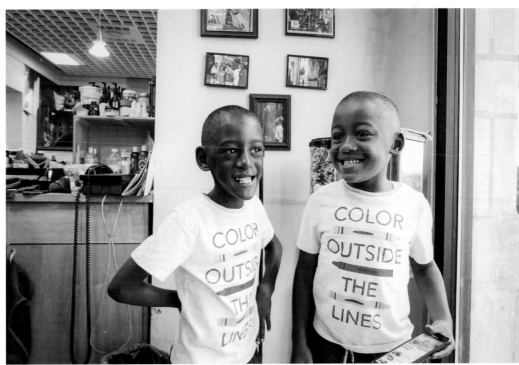

Brothers wait for their father to give them quarters for Skittles after their haircuts.
Hyde Park Hair Salon in Chicago, IL.
August 2018

AN AT-HOME BARBER'S DILEMMA

DILEMMA

ZAK CHENEY-RICE

By my count, I've saved close to $9,400 on haircuts since I stopped going to barber shops sixteen years ago. With three exceptions—my college graduation, my wedding, and the wedding of two close friends—I've gone my entire adult life and most of my teenage years without a professional touching my hair.

I stopped going, in part, because of money. At a certain point, I started getting the same cut every time—a number one all over—and my parents realized they could drop forty dollars on some Wahl clippers and do it themselves. But over the years it also became about pride. With only a blade, a wall mirror, a hand mirror, and some unearned confidence, I could create art, or what I thought was art, on my own head, for free.

Early results were mixed. I added a good inch to my forehead the night before eighth-grade graduation after overcompensating, repeatedly, for an uneven lineup. But years passed, YouTube tutorials proliferated, and Instagram gave some of the best barbers in the world a platform to showcase their work. I've spent hours watching them, learning. Today I can leave the house with a fresh fade and no one the wiser, or so I'd like to think.

This is a confession, not a boast. To my knowledge, I'm in the small minority of Black men in America who can count their barber shop stories on one hand. And given the tradition and mythos around barber shops that I've experienced in treasured bursts—the heated debates about which NBA player is actually trash, the vicious sting of alcohol getting rubbed into a freshly angled hairline—I know I'm depriving myself of something hallowed, a ritual that's honed Black language, affirmed Black community, and linked Black generations since time immemorial. On the rare occasion that I do visit a shop, I feel this loss. It makes sense, really. There's no way to duplicate that communal experience in front of a mirror at home.

But time brings new choices. My son is almost two years old and has never had his hair cut. This is divisive among those who know me: half say cut it yesterday, the rest say let it grow forever. I usually find myself somewhere in the middle.

I know it has to get done, like paving over a sidewalk cracked in fragments by the roots of a nearby tree, but I'm also hesitant to lose such a familiar marker of time's passage, an emblem of when decorum mattered less than marveling at nature taking its course. And the question inevitably follows: Will you cut it yourself, or take him to the shop? My best guess is that I'll do the honors at first. But choosing his tradition will be up to him.

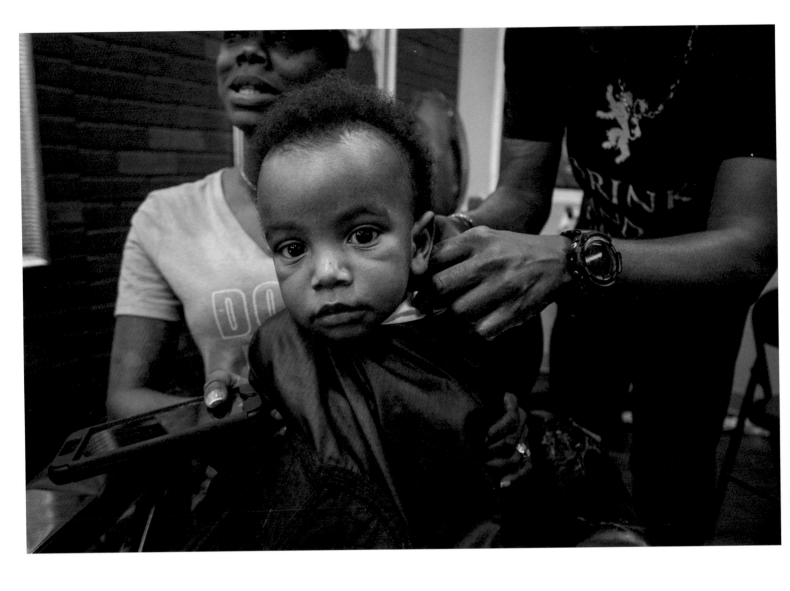

At the time of this photo, Lorde was ten months old
and just moments away from his first haircut.
The Beauty Boutique in Washington, DC. June 2018

A RITUAL THAT'S HONED BLACK LANGUAGE, AFFIRMED BLACK COMMUNITY, AND LINKED BLACK GENERATIONS SINCE TIME IMMEMORIAL

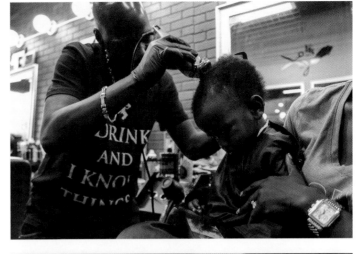

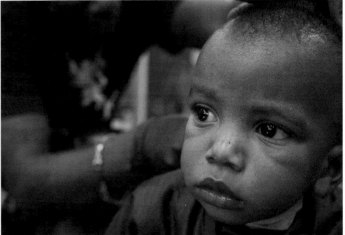

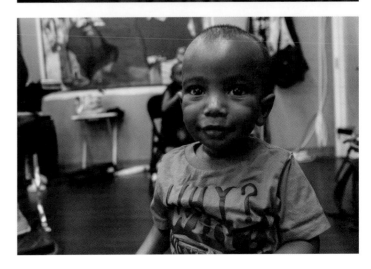

Lorde.
The Beauty Boutique in Washington, DC. June 2018

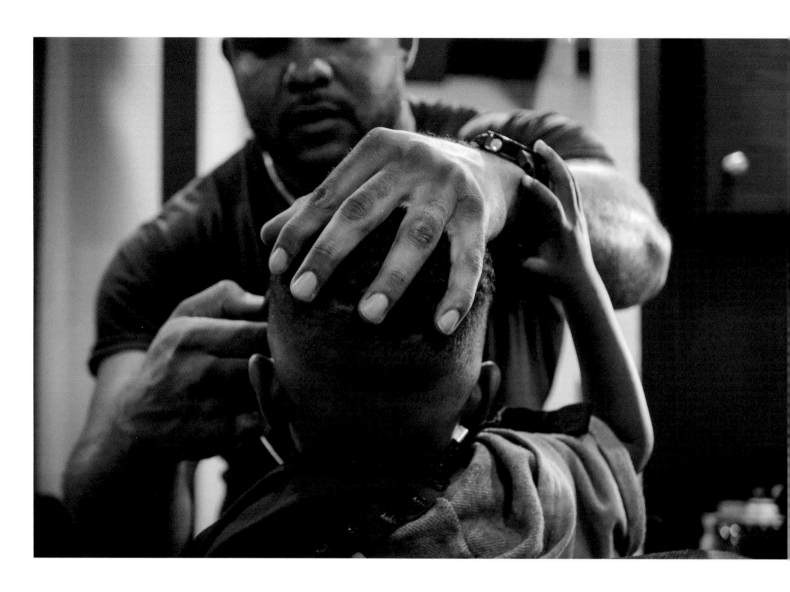

In Los Angeles, RVM Cutz is a popular shop where Queens, New York, native Don Pablito takes on a special client, his son Hendrix.

RVM Cutz in Los Angeles, CA. September 2018

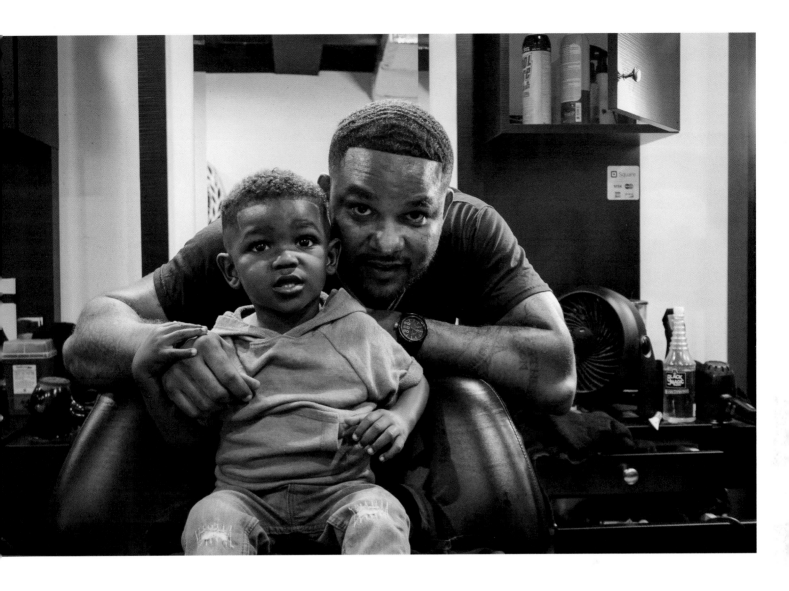

Don Pablito and Hendrix.
RVM Cutz in Los Angeles, CA. September 2018

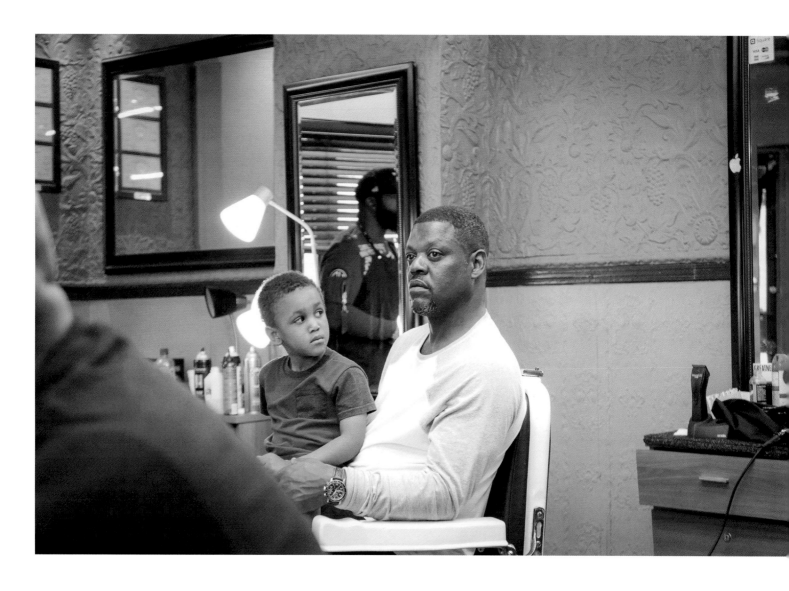

A father and son wait together
Faheem's Hands of Precision in Philadelphia, PA. June 2018

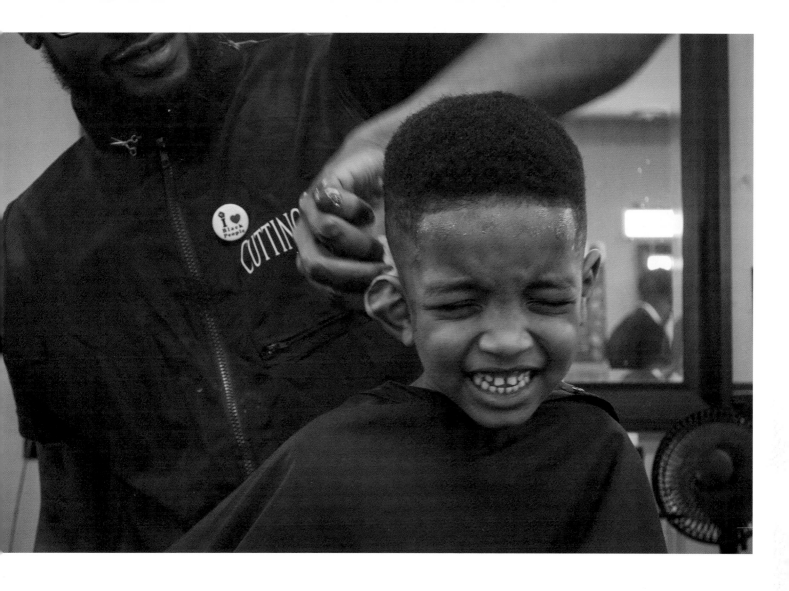

The burning of alcohol makes this boy cringe.
CuttingKings Barbershop in Fayetteville, GA. May 2019

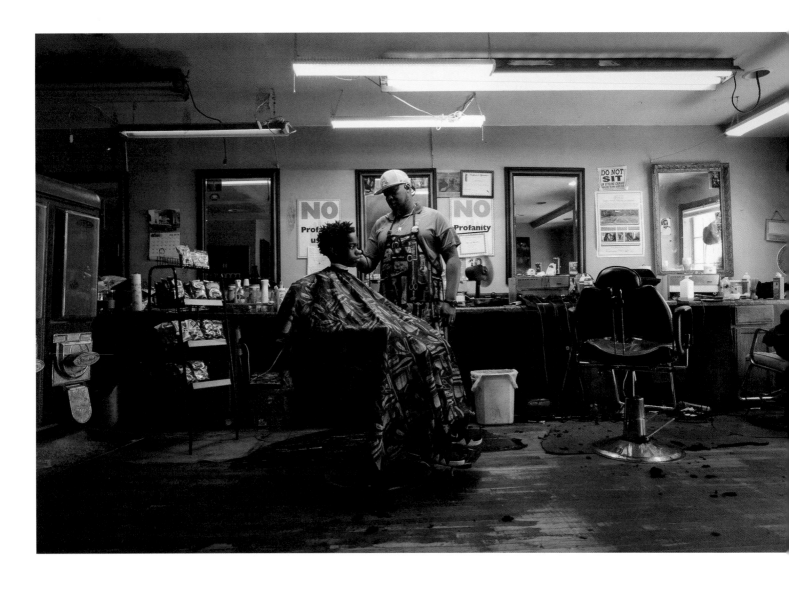

Young man
Heavy Weight Cuts in Detroit, MI. July 201

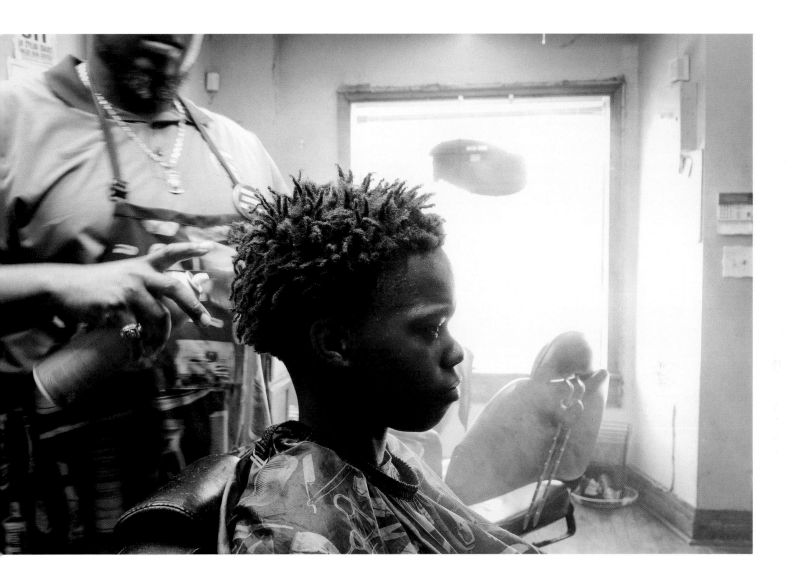

Oil Sheen.
Heavy Weight Cuts in Detroit, MI. July 2018

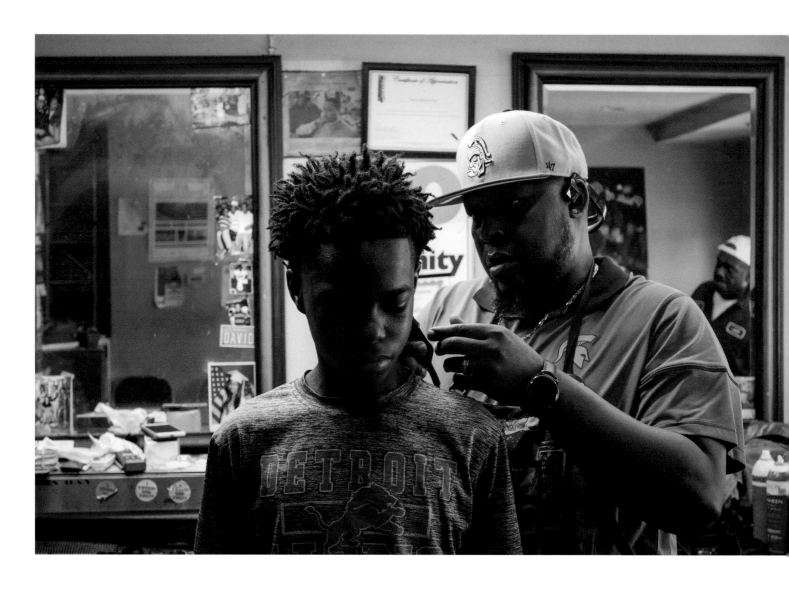

Final touches as Dad looks on.
Heavy Weight Cuts in Detroit, MI. July 2018

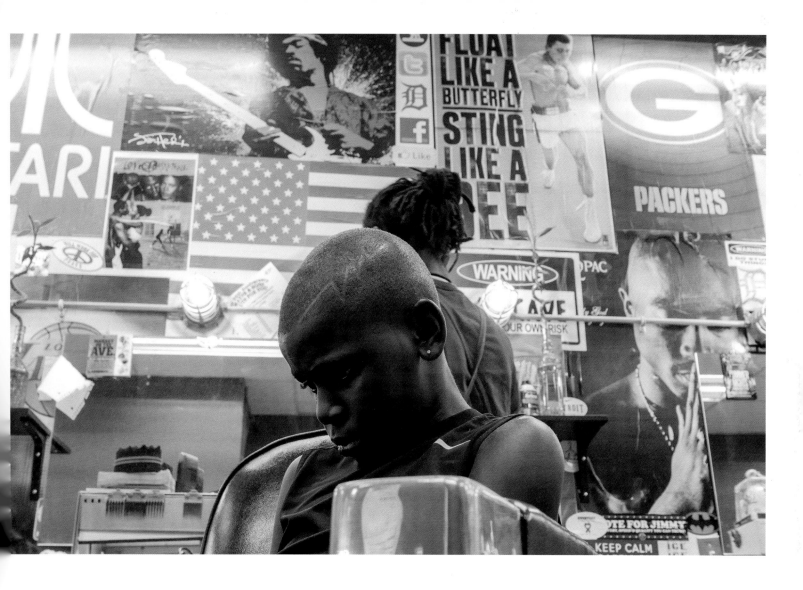

Detroit kid in front of shop posters.
Barber Station in Detroit, MI. July 2018

BARBERSHOP BOOKS

Barber shops are often one of the few Black-owned businesses in many of America's economically depressed Black neighborhoods. Wealthy Black men, women, and children sit alongside and converse with Black men, women, and children with a lot less money. Everybody's got to get a haircut, right? Black barber shops are a nexus of the Black community and often serve as a cultural center for Black males. It is an equitable and sacred space for Black men and boys, where all are welcome and all are equal. However, the culture of most Black barber shops caters almost exclusively to men. From the music blaring from wall-mounted speakers to the videos or movies on the big-screen TVs that have now become commonplace in many shops. Black boys begin going to the barber shop around age two or three, but it's rare to see space or activities geared specifically for Black boys.

The relationship that Black barbers have with young Black boys extends beyond the traditional relationship they have with other professionals such as doctors, dentists, or even teachers in some cases. Barbers tend to look like the boys they serve and they are often thought of as a member of the family. They know what's going on in boys' lives. Because of boys' monthly or biweekly trips to the barber shop, barbers know about everyday happenings and the major milestones that boys experience. Before something important happens in a boy's life, one of the first things he does is go get a haircut.

With more than half of Black boys currently being raised by single mothers, some boys see their barbers more than they see their fathers. Despite the negative implications of this sobering fact, the relationship that barbers have with boys creates a unique opportunity to positively impact the lives of Black boys. Since 2014, Barbershop Books, a community-based literacy program, has leveraged the cultural significance of Black barber shops to increase book access and out-of-school time reading among Black boys. Barbershop Books has created child-friendly reading spaces for boys ages four through eight in over two hundred barber shops nationwide. This innovative approach doesn't focus on reading skills like many traditional programs but aims to help Black boys identify as readers by connecting reading to a male-centered space and by involving Black men in boys' early reading experiences.

Barbershop Books works with shops that serve children, have space for a small bookshelf, and have owners willing to participate, regardless of whether people consider the barber shops family friendly or not.

As a national leader on the topic of Black boys and reading, Barbershop Books facilitates a ninety-minute early literacy training with barbers in cities with ten or more participating barber shops. Barbers learn about developmentally appropriate strategies to support early literacy and effective ways to engage children and families about reading. Barbershop Books doesn't encourage barbers to force children to read or to pay them. But rather, the program equips barbers with tools to create early positive reading experiences that cultivate the reading identities of Black boys. If Black boys identify as readers, they will read for fun, and pleasure reading improves reading performance. According to the US Department of Education, students who read for fun just once or twice a month have significantly higher reading scores than students who never or rarely read for fun. With the continued support from barber shop owners, barbers, and the communities they serve, this national movement will continue to grow.

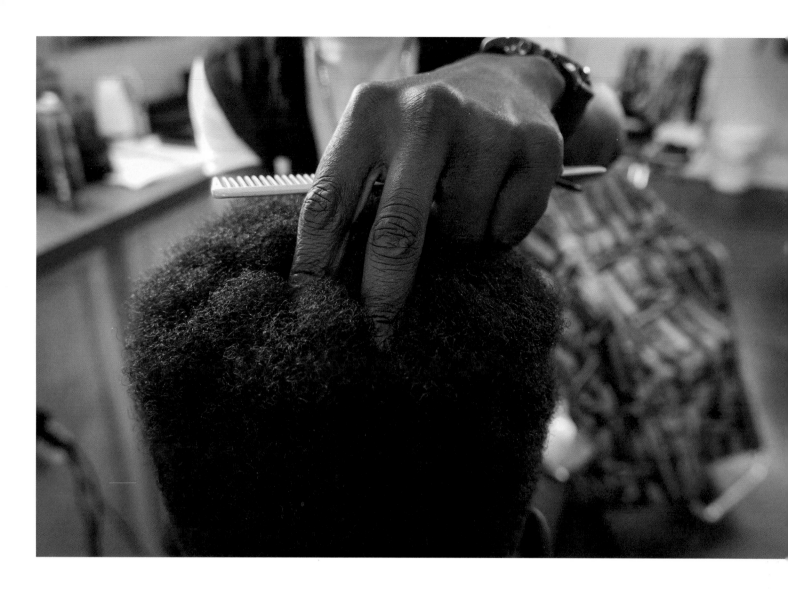

Fingers in a high-top
Natural Roots Barber Shop in New Orleans, LA. July 2018

BEFORE SOMETHING IMPORTANT HAPPENS IN A BOY'S LIFE, ONE OF THE FIRST THINGS HE DOES IS GO GET A HAIRCUT

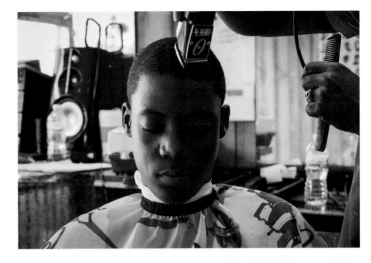

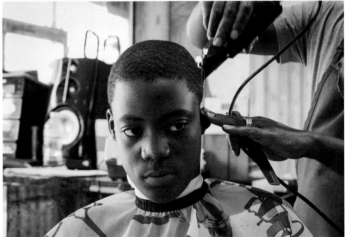

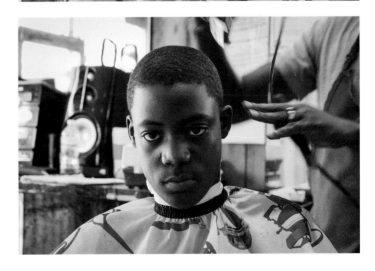

Chicago teen.
Frank's Place in Chicago, IL. August 2018

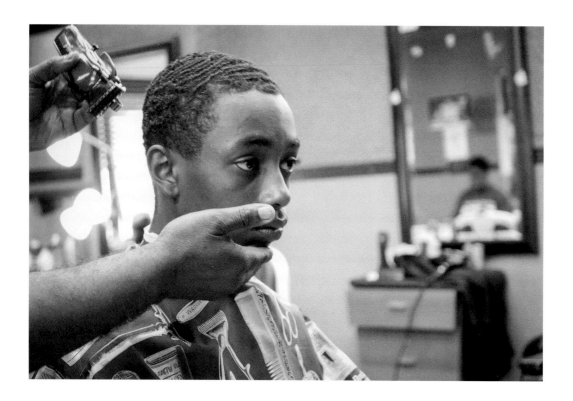

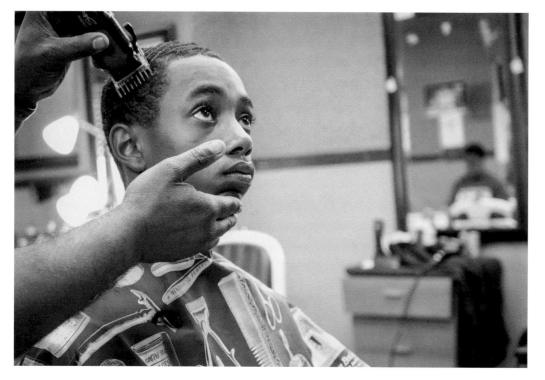

A young man gets his hair cut at Faheem's Hands of Precision in Philadelphia. He visited the shop on the afternoon before his eighth-grade dance.
Faheem's Hands of Precision in Philadelphia, PA. June 2018

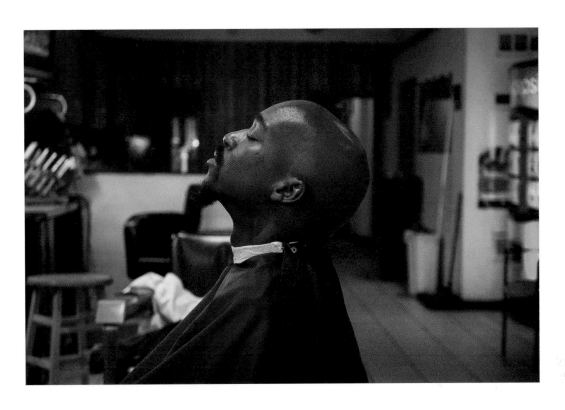

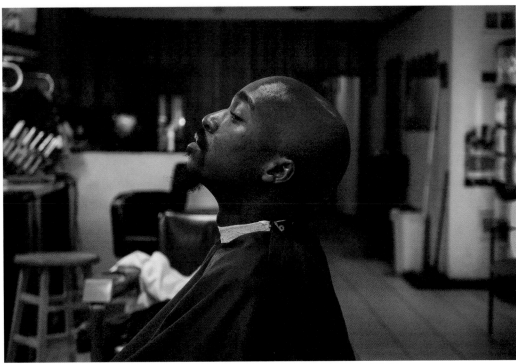

Chicago man rests his eyes.
Frank's Place in Chicago, IL. August 2018

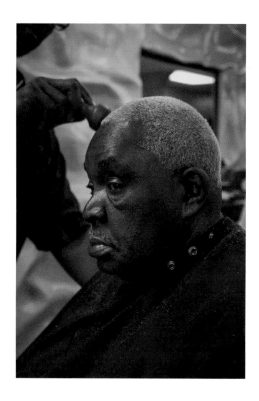

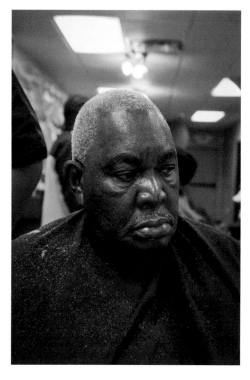

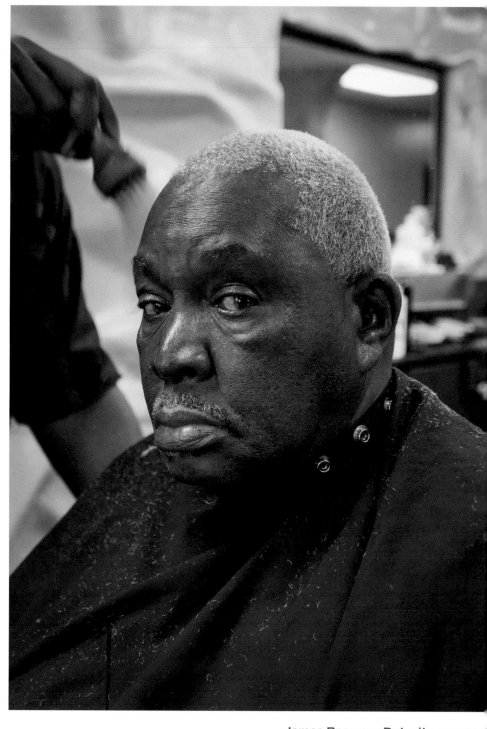

James Brown, a Detroit-area man
Executive Cuts and More in Detroit, MI. July 201...

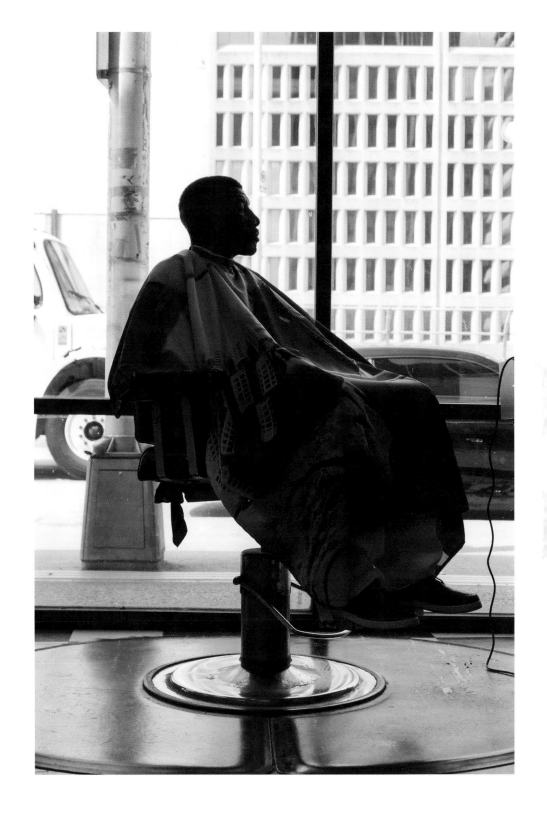

Thinking man.
Pure Essence Barber Shop in Atlanta, GA.
March 2019

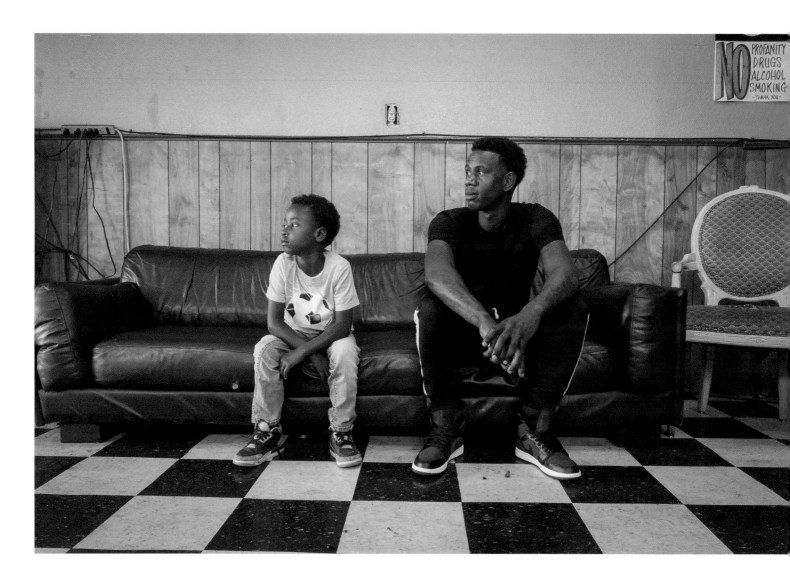

Father and son sitting in the same position.
Jackie's Cuts and Styles in Oakland, CA. October 2018

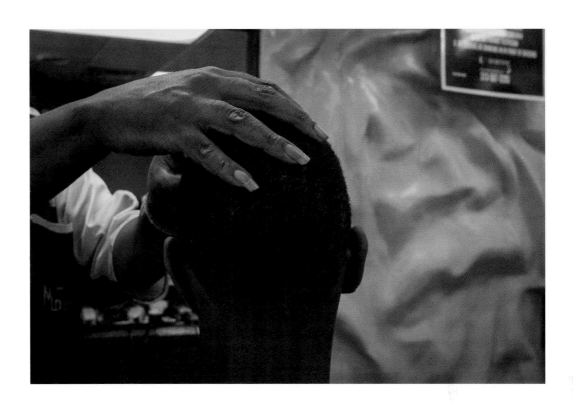

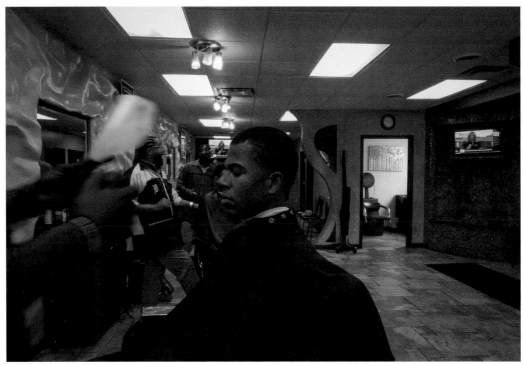

Executive Cuts and More
n Detroit, MI. July 2018

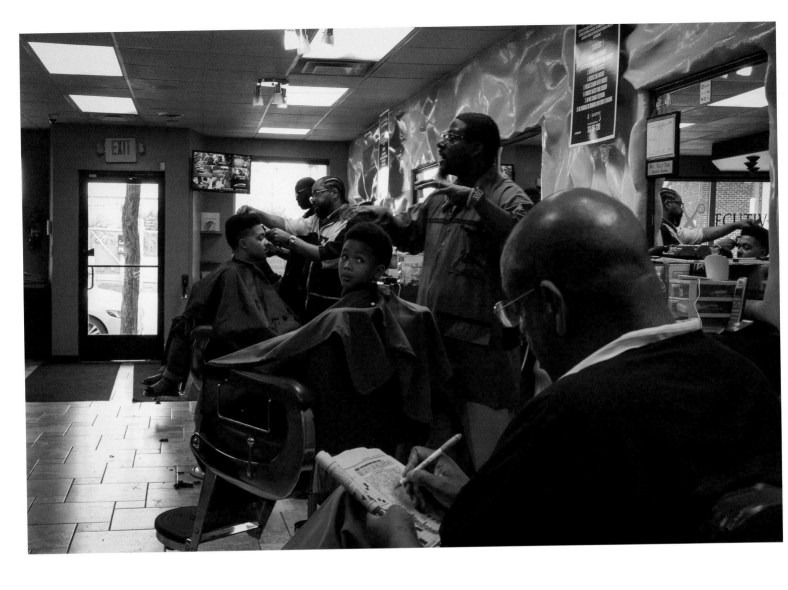

*Executive Cuts and More in
Detroit, MI. July 2018*

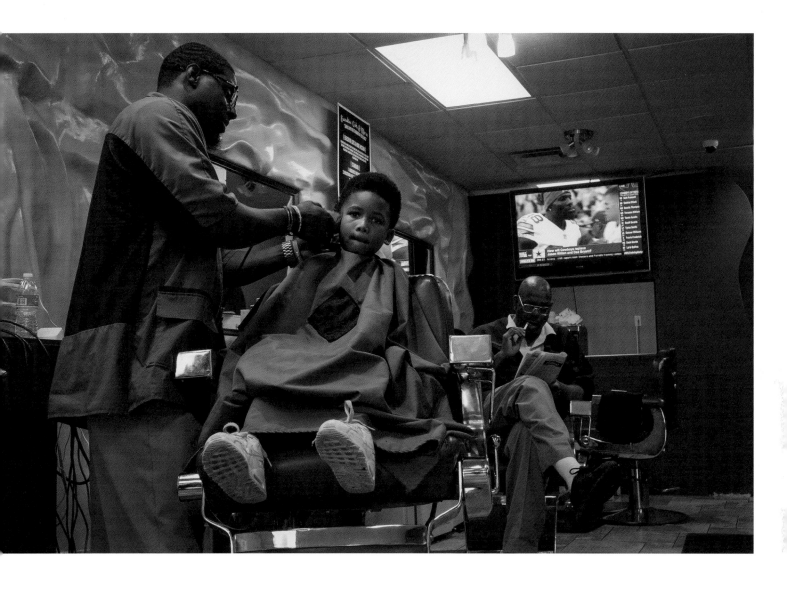

*Executive Cuts and More in
Detroit, MI. July 2018*

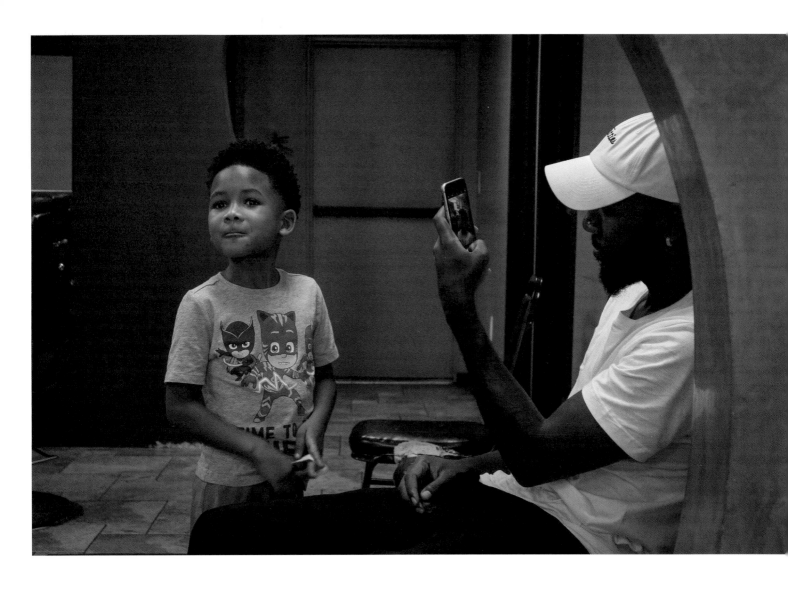

Dad takes a photo of his son's haircut.
Executive Cuts and More in Detroit, MI. July 2018

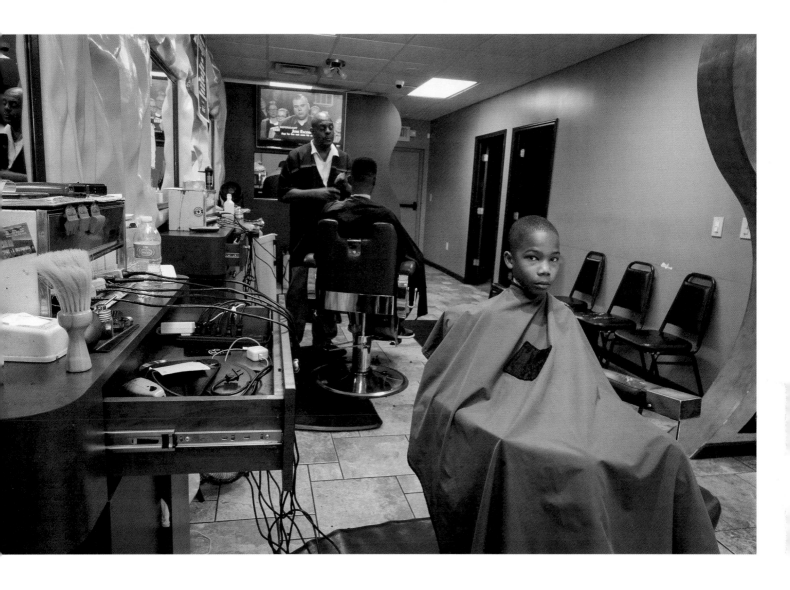

Executive Cuts and More in Detroit, MI. July 2018

BARBERSHOP BOOKS, A COMMUNITY-BASED LITERACY PROGRAM, HAS LEVERAGED THE CULTURAL SIGNIFICANCE OF BLACK BARBER SHOPS TO INCREASE BOOK ACCESS AND OUT-OF-SCHOOL TIME READING AMONG BLACK BOYS

CONVERSATION

MICHAEL TUBBS, MAYOR OF STOCKTON, CA

The interview has been edited and condensed.

Antonio M. Johnson: *Tell me a bit about your childhood barber shop.*

Michael Tubbs: So there's two. There was my Uncle John's—who wasn't really my uncle but we called him Uncle John. He used to cut my hair at his house when I was younger. And then he stopped when I was about ten because he got a job in manufacturing. So then we went to the best shop in the South Side, where I still go now, called Big Herks Clippers and Big Herks shop was super interesting.

AMJ: *What made it interesting?*

MT: It was super interesting because it was a small little house he converted to a shop; it was right next to a burger joint. You'll walk in there, and especially on a Saturday, it would be packed from room to room and you'd walk over the white-board to write where you were in line.

You had TVs playing, you usually heard some Prince—he loved Prince—and he would always laugh because I knew all the words. He would always ask me, how do you know this stuff youngin?

AMJ: *How long did you go to that shop?*

MT: So I went to that shop from ten to about sixteen and then he closed his own shop and moved to True Barber Styles. And True Barber Styles was an all-star shop of the best barbers in Stockton. So not only was Herk there, but my Uncle John was back there cutting hair. So then I started going back to my Uncle John for a couple of years before sticking with Herk. Now, Herk's in a nice upscale shop.

AMJ: *It's really great to have the same barber for so long. Tell me about your current hairstyle. When you sit down, do you ask for anything specific?*

MT: Herk fashions himself as my stylist, so he comes up with all my haircuts. When I ran for mayor at twenty-six years old, we had a very conservative, regular, even-all-over kind of cut, nothing flashy. And then last year, he says, "Let's grow your hair out." So I said, "Let's do it." So now we have the frohawk with the sponge thing—that actually takes a lot of maintenance. I put hibiscus oil in my hair now; it's fun.

AMJ: *Did Herk tell you the reason for switching up the cut?*

MT: He told me you're only young for a short time. Let's make sure you look like a young mayor. Which I appreciate.

AMJ: *How did the barber shop influence you growing up?*

MT: Many of my influences growing up were pastors and coaches, and although I never went to the barber shop with them, their hair was always cut.

The shop was my first exposure to hearing a lot of things from a male perspective, because so much of what I heard was from the women in my life, so that was really interesting to me. I mean, the conversation was very heteronormative in some ways, very problematic, but in some ways, also very affirming.

Particularly because of my education, given my position, and even when I was younger, I was placed in gifted and talented classes, so outside from sports or on the bus, there weren't really many spaces for me to interact with Black dudes with similar class status as me. But it's really cool to sit and listen and hear how much folks like me—who have radically different experiences, radically different orientations, radically different degrees of privilege—and how what do they see, where do they interact, what do they care about. I love it because, in the barber shop, no one is deferential. Every now and again, someone will let me cut if I'm in a serious rush. They'll say, you can you go ahead, Mayor.

AMJ: *What made you decide to run for mayor?*

MT: I was born and raised in Stockton. Growing up in Stockton, I thought to be successful meant to leave. So I thought when I got to college, I would leave; then I ended up coming back. I served four years on city council representing the

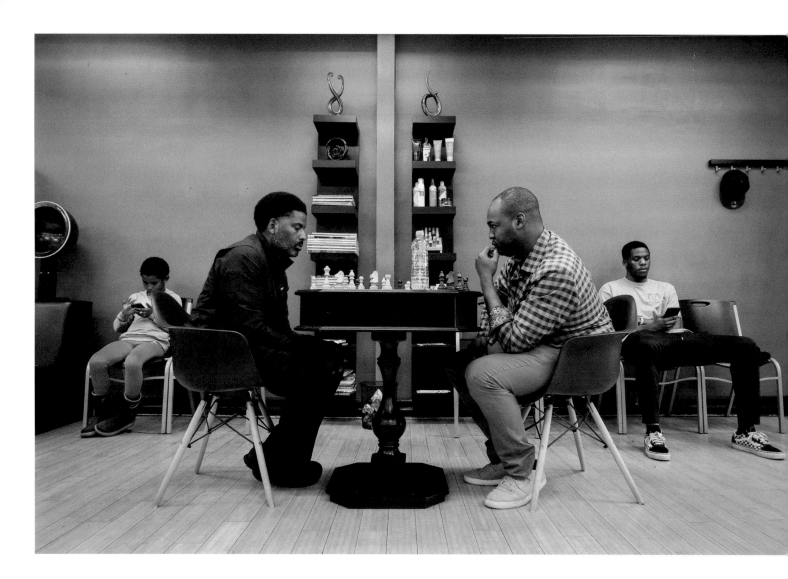

neighborhood I grew up in—the south part of the city. We did a lot of great things in that role. But I realized that the mayor's office provides such a bully pulpit and such a platform to really talk about the issues to set priorities and to really represent the city and illustrate to people what's possible, what we can be, and who we should be as a city. So I decided to run for mayor, to bring opportunity

to all of Stockton's neighborhoods, but also to change the face of the city so it's one that's much more progressive, forward-thinking, and inclusive.

AMJ: *Have you always been interested in politics?*

MT: I've always been interested in how policies and institutions affect people. I think that comes from my growing up in

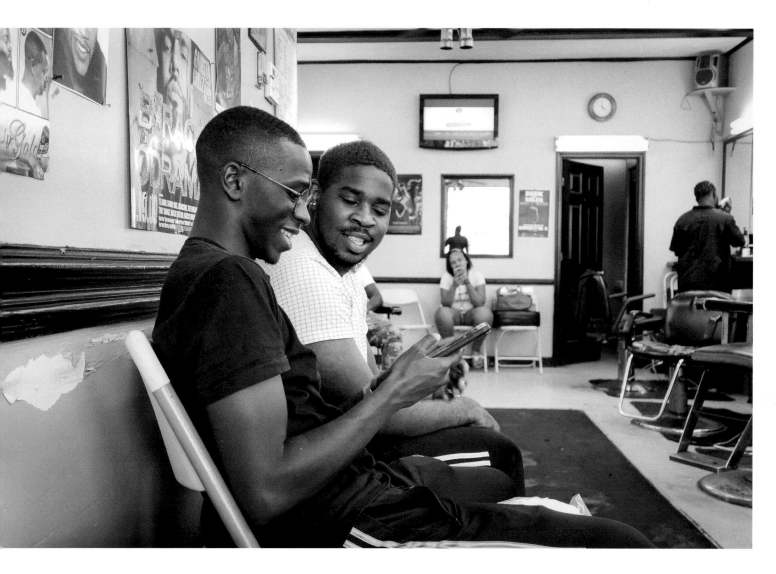

College students from the nearby Atlanta University Center share a moment at Philly's Finest Barber Shop in Atlanta.
Philly's Finest Barbershop in Atlanta, GA. August 2018

poverty, and it's so much of *How do we make things better?*

AMJ: *As mayor, do you find yourself discussing policies and what's going on in your administration in the barber shop?*
MT: I think for me, particularly now as mayor, I'm speaking all the time, and people are always listening. So in the barber shop, I try to reorient power and

sit there and just listen to unfiltered opinions from my community members. I get to see how they're perceiving the world and the things I'm doing. So, it's funny, I think the barber shop is probably the only space—literally the only space— where I'm not talking.

AMJ: *Has it always been that way?*
MT: I always enjoyed just being silent. I

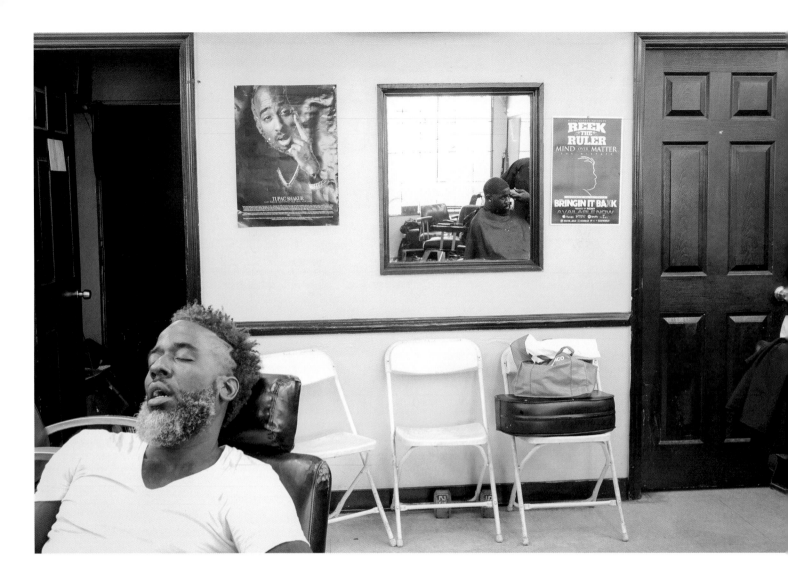

used to be super quiet in the barber shop and just take everything in and watch and listen, and kind of see how these men interact, speak, and what they speak about.

AMJ: *How would you describe Stockton?*
MT: Stockton, California, is 315,000 people. It's such a mix. It's incredibly diverse. It's a working-class city. It's a city of folks

who have been here. Their families have been here for several years. It's a city that definitely has challenges. But there's so much love so much pride, and so much community.

AMJ: *What are some of the initiatives your administration has for the city so far?*
MT: Well, I'm going to talk about the big

Juwaun sleeping
Philly's Finest Barbershop in Atlanta, GA
August 2018

98

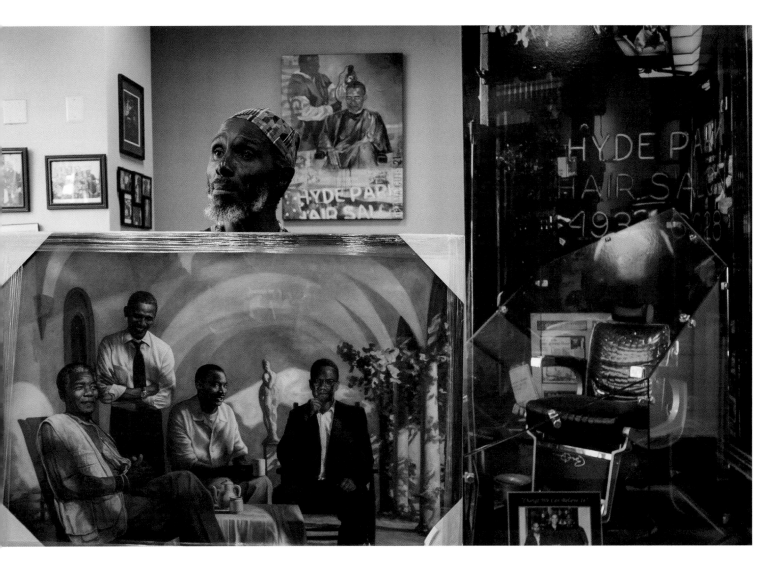

Man holding artwork of
Black political figures.
Hyde Park Hair Salon in
Chicago, IL. August 2018

three, as we call them. The first one is called Stockton Scholars and it's a program where for the next decade, every single student who graduates from our largest school district is guaranteed a scholarship to a four-year college, two-year college, or a trade school, which I am incredibly proud about.

The second program, our gun-violence reduction strategy, Ceasefire and Advance Peace, the idea is to really identify the men most likely to commit or be victims of violent crime and flood them with as many opportunities and resources as we can get them.

And then the third initiative is a program called the Stockton Economic Empowerment Demonstration (SEED), which is our basic income demonstration, where 130 families are given $500 a month.

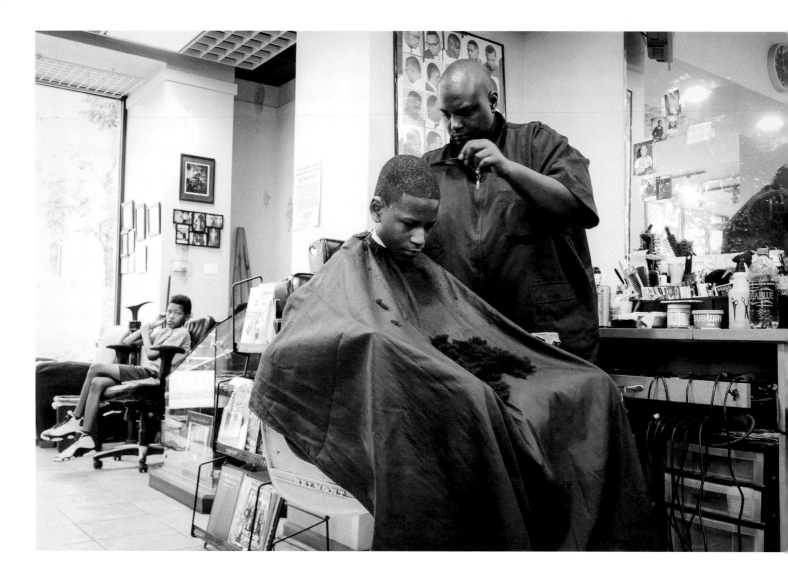

AMJ: *How can politics play a larger role in barber shops?*

MT: Educating barbers on facts on what's happening because they're mostly seen as authority figures. Particularly for reaching a demographic of folks who are in some ways most impacted by government policies. Especially ones around policing. We gather at the barber shop a lot, and I think we could use that time for voter education. That time could be a touchpoint for folks who wouldn't necessarily engage in government.

AMJ: *Have you talked to your barber about what's next for you politically?*

MT: Yes, so what's next is that I'll be running for mayor again, and that would be another four years. He talks about if there's an opportunity that comes up

A hair-filled cape
Hyde Park Hair Salon in Chicago, IL
August 2018

100

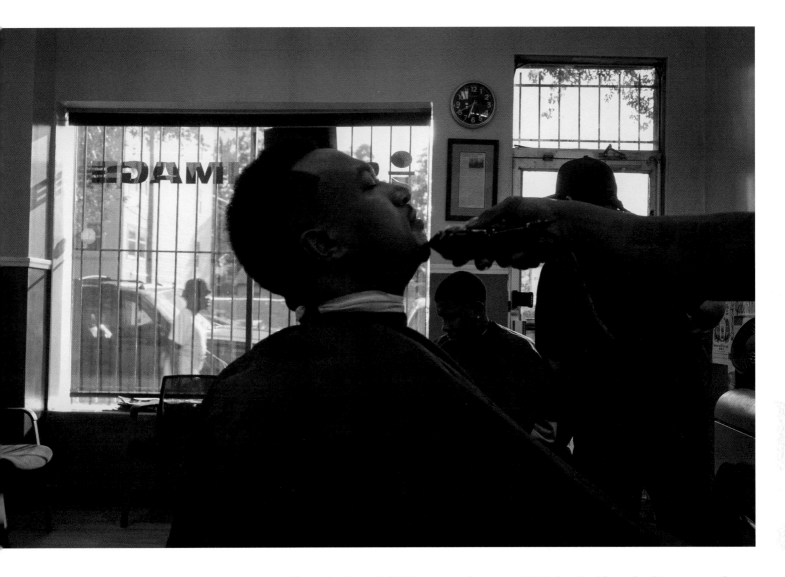

away from Stockton he'd like to travel with me. Which I'm open to. It would be nice to have a piece of home with me—that way I don't have to start over. Someone who knows me.

AMJ: *Lastly, If you had to sum up the barber shop, how would you?*
MT: It's a time to reset, recalibrate, remember why I do what I do. Going to the barber shop is an act of self-care.

A Thursday summer evening in 2018 at A Sharper Image.
A Sharper Image Barber Shop in Washington, DC. June 2018

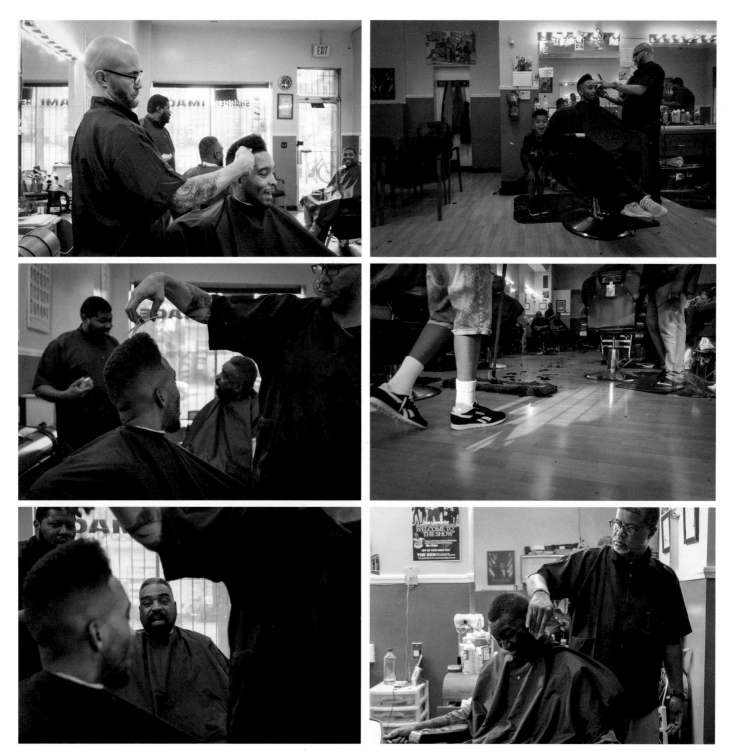

Sharper Image Barber Shop in Washington, DC. June 2018

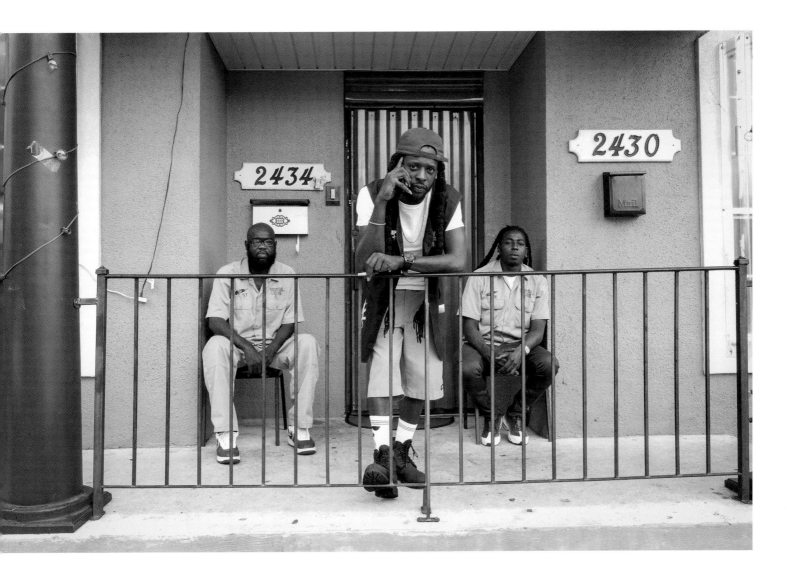

Natural Roots Barbershop in New Orleans, LA. July 2018

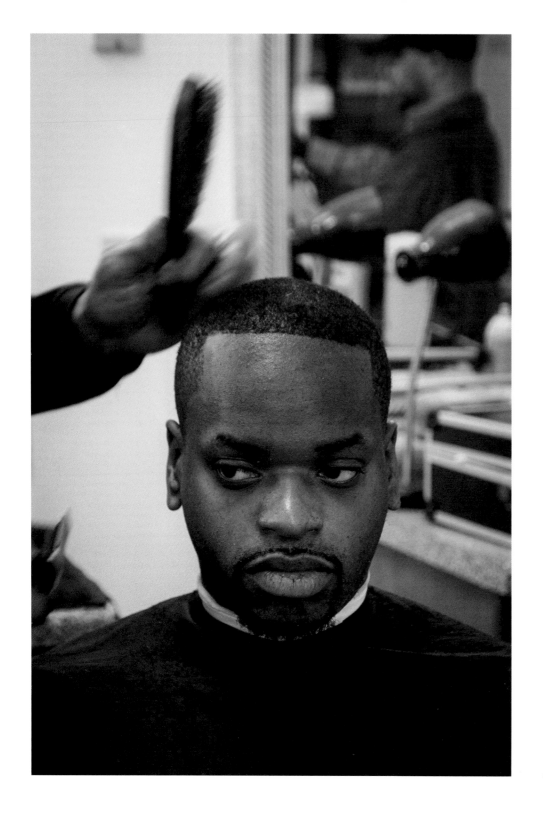

YOU'LL WALK
IN THERE AND
ESPECIALLY ON A
SATURDAY IT WOULD
BE PACKED FROM
ROOM TO ROOM

An unfortunate shape-up
Faith Barber Shop in Atlanta, GA. February 2019

104

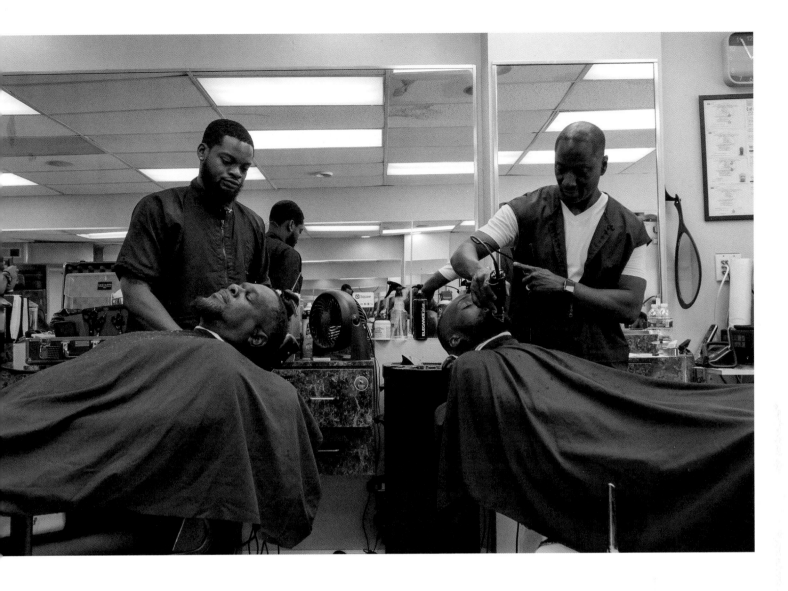

Best Cuts DC in Washington, DC. July 2018

Benny Adem Grooming Parlor in Oakland, CA. October 2018

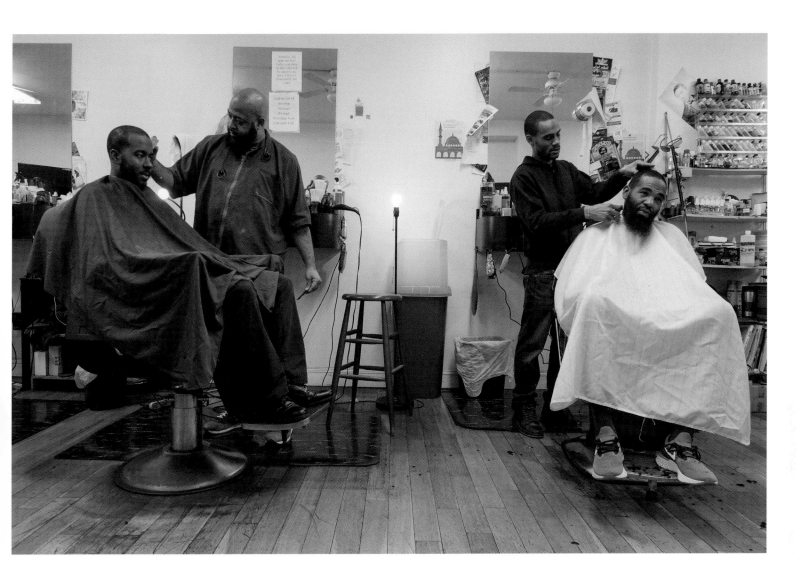

Gaming Cuts Barbershop in Philadelphia, PA. December 2019

IN THE BARBER SHOP NO ONE IS DEFERENTIAL

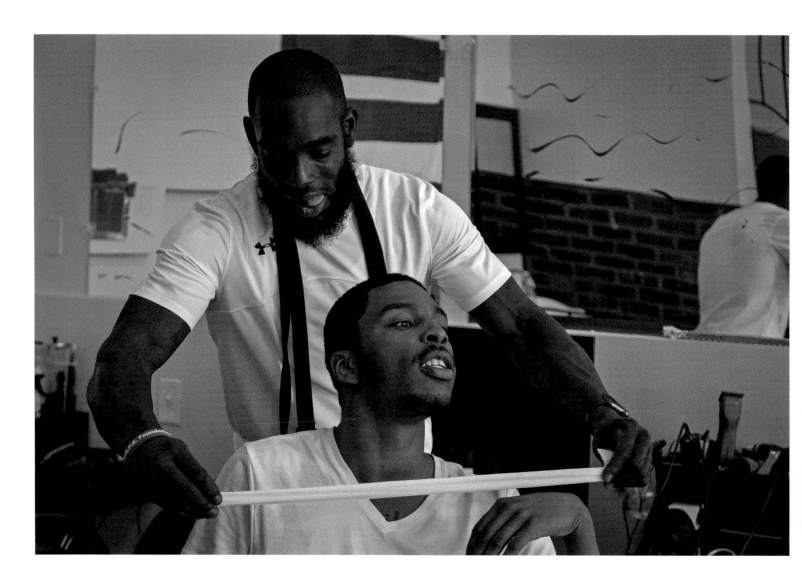

V&T Urban Hang Suits, Washington, DC. July 2018

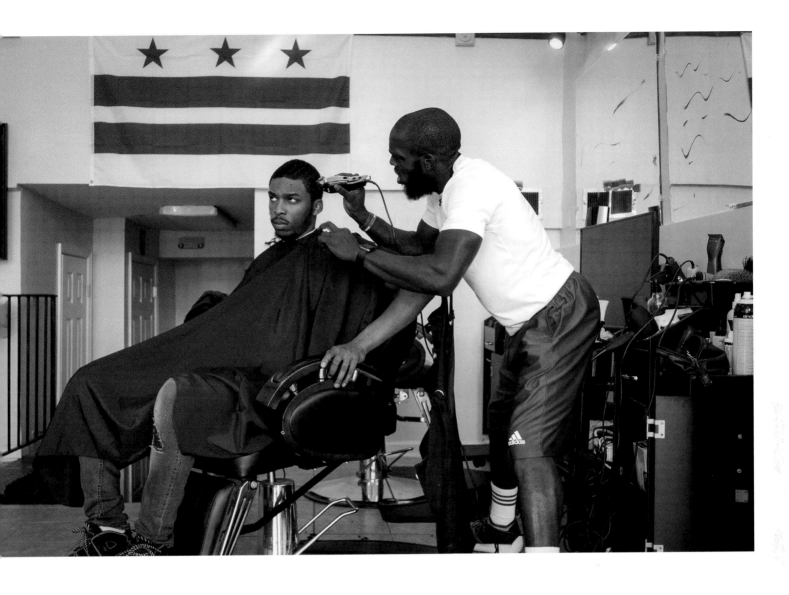

V&T Urban Hang Suits, Washington, DC. July 2018

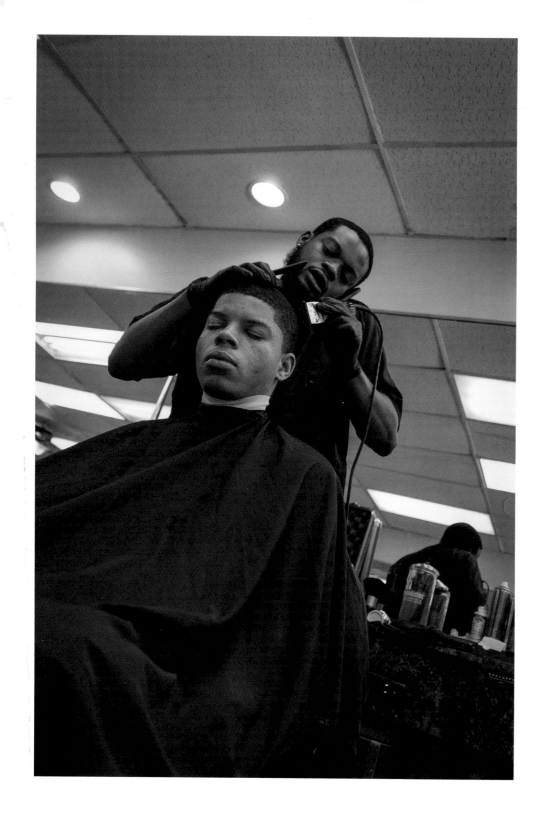

Best Cuts DC in Washington, DC. July 2018

GOING TO THE BARBER SHOP IS AN ACT OF SELF-CARE

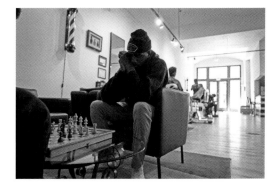

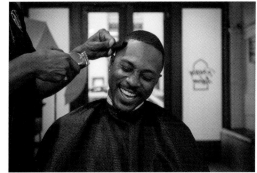

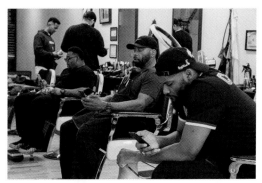

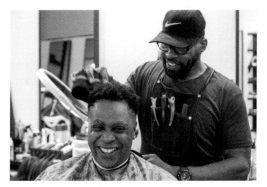

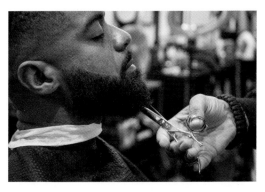

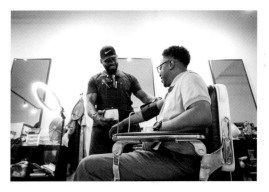

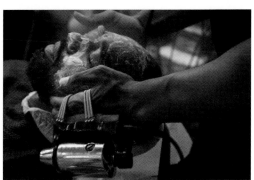

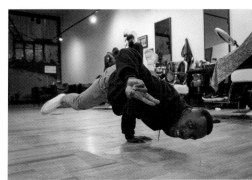

Benny Adem Grooming Parlor in Oakland, CA. October 2018

NO CAP

HANIF ABDURRAQIB

the old head strokes the winding forest of grey cascading
to cover the wrinkles sketched into the sides of his face
by the uneven desires of time & he asks me what on earth the kids

down the block mean when they rattle the summer puddles
with their laughter & slap hands at the end of a good ass story
& yell *no cap* & I admit I did find a single grey curling a cruel finger

out the depths of my beard's otherwise darkness but I still know the gospel
tucked underneath slang leaping from even the most decorated tongue
& this is meant to say *come closer* this is meant to say I have nothing left

to hide even with a congregation of the most fashionable shade I would never lie
to you, as I lied to my father at 16 with crisp bills lining my pocket
as he searched the house for the grocery money

he left on the table the night before. *no cap* I would not betray you
now, as my father's own hairline betrays him. retreating to the shadows
from which it was born. his dome a nation with no cap-

-ital but still glistening with any season say *no cap* & mean you will stand
at attention for your own undoing – the percussion of the knee's interior
& the bed that grows harder to get out of & the lover

who is no longer beside you in it. the news says everything is receding.
the ice caps will eventually be what swallows the living. A long braid
of heat. *no cap.* dear friends the moment for deceptions has long passed

so it must be said: I praise the thick hair that once coiled high on the crown
of my mother & I praise the ancestor who tore handfuls of his burly
& blooming afro out at my mother's funeral, littering a procession

of discarded black wool in front of the open casket & howling his way
towards madness. this happened. *no cap.* praise my barber who tilts
my head towards the sunlight coughing its way in the barbershop window

praise my barber whispering *you've got a hairline I would kill for* with a blade
to the edge of my temple. praise the cap cocked backwards & bowing
towards the drowning earth even on days my cut looks too good

to conceal. I would not lie to you about this.
praise that I've never loved anyone enough to unravel
the blessing of my own hair upon their leaving.

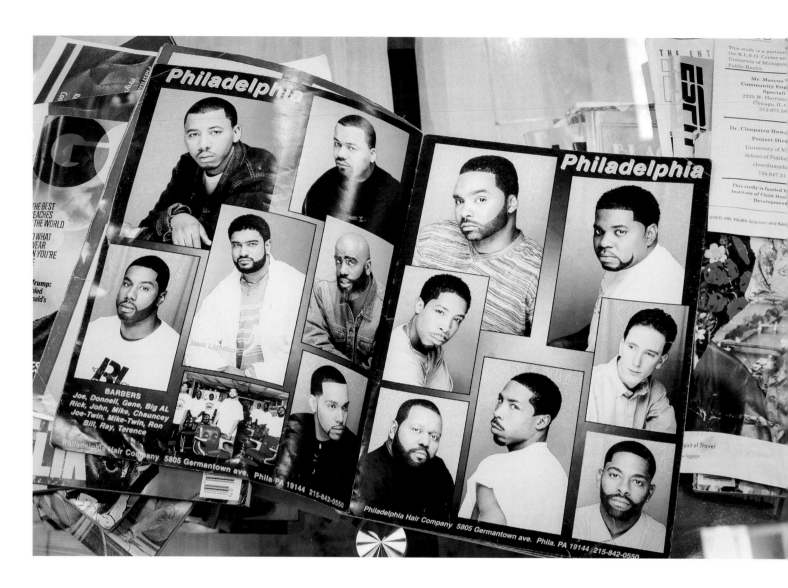

Pages from *National Solid Gold* magazine showcasing the work of Philadelphia barbers.

Hyde Park Hair Salon in Chicago, IL. August 2018

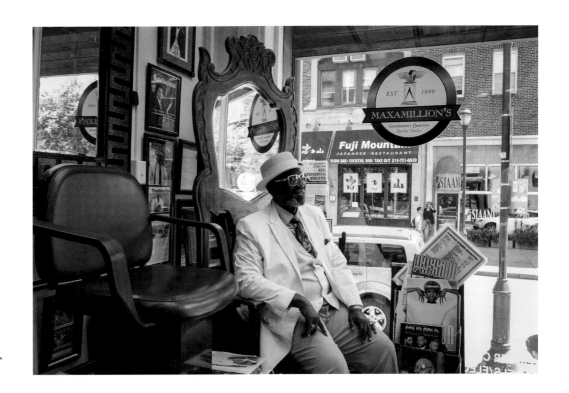

Maxamillion's Gentlemen's Quarters Barber
Parlor in Philadelphia, PA. June 2018

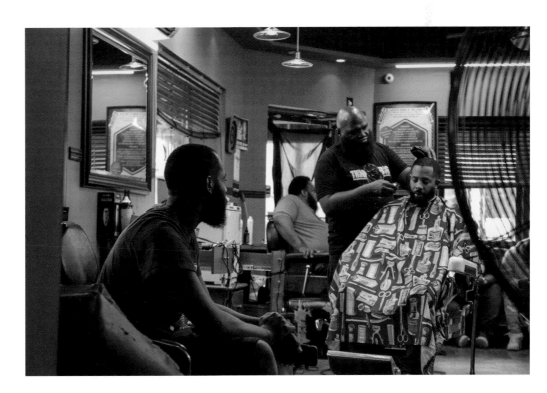

Faheem's Hands of Precision in
Philadelphia, PA. June 2018

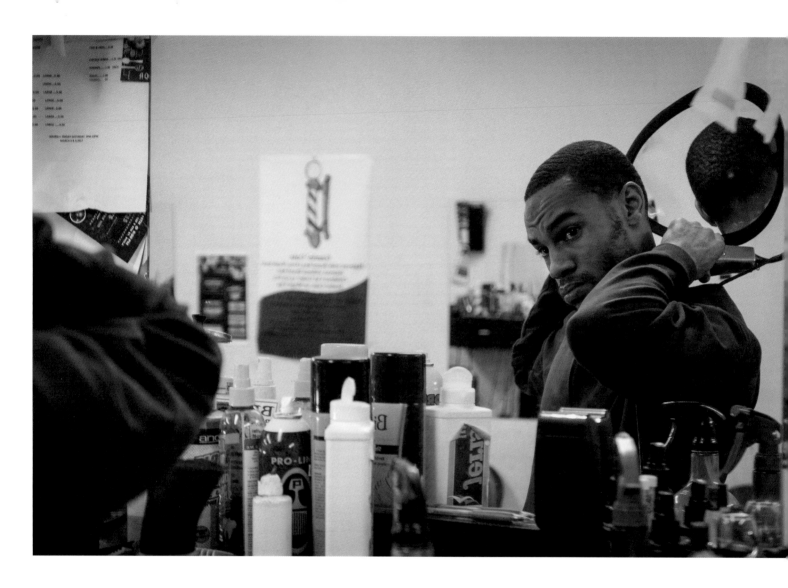

Gaming Cuts Barbershop in Philadelphia, PA. December 2018

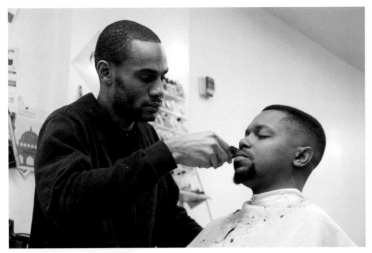
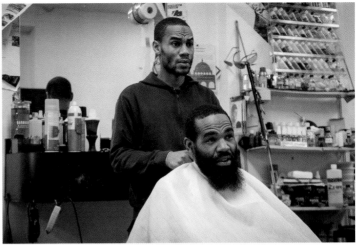
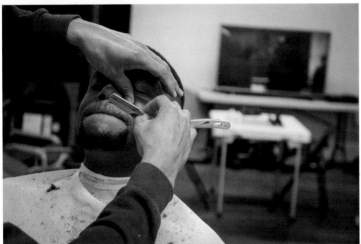
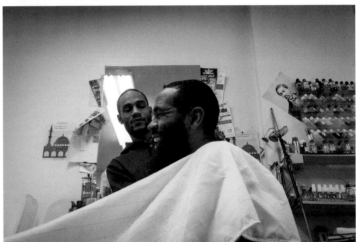

Gaming Cuts Barbershop in Philadelphia, PA.
December 2018

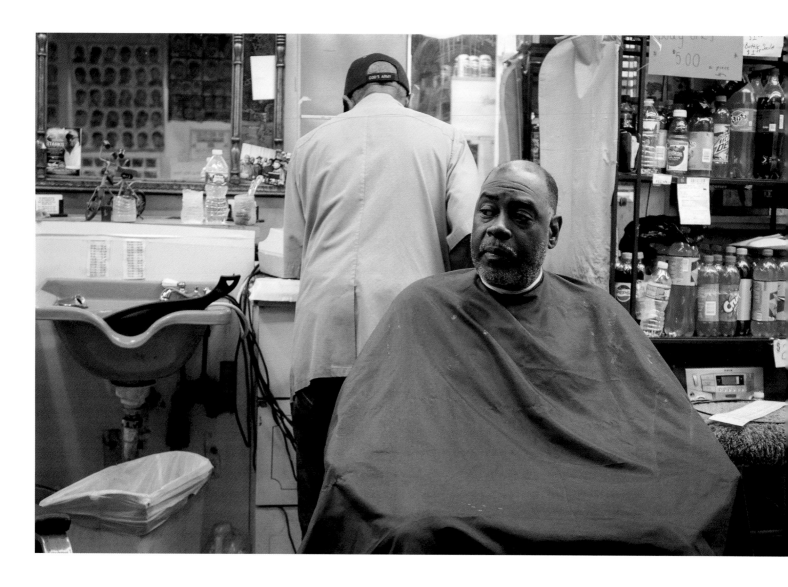

Walt's Barber and Bike Shop in Philadelphia, PA. June 2018

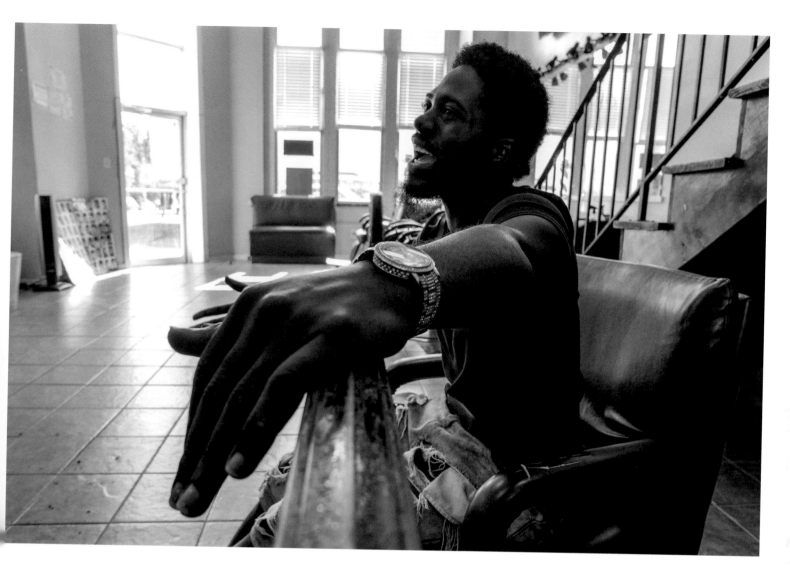

V&T Urban Hang Suits, Washington, DC. July 2018

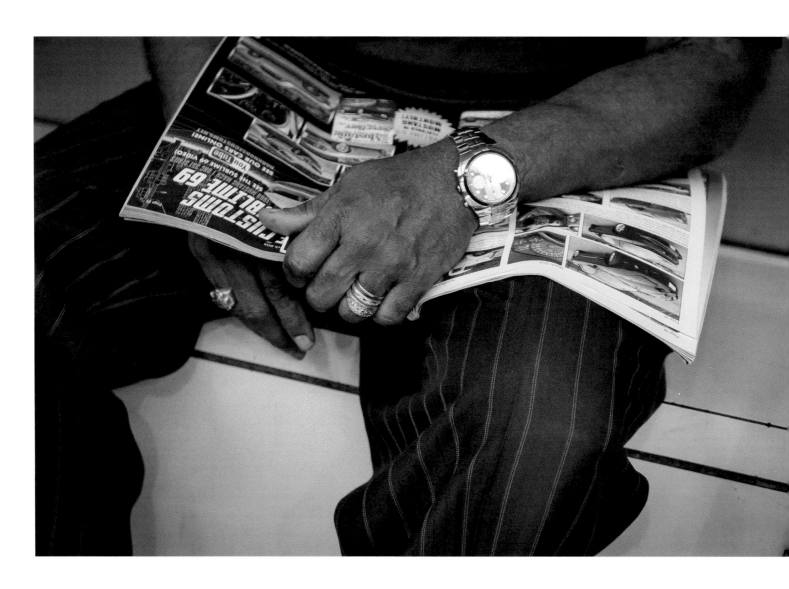

Walt's Barber and Bike Shop in Philadelphia, PA. June 2018

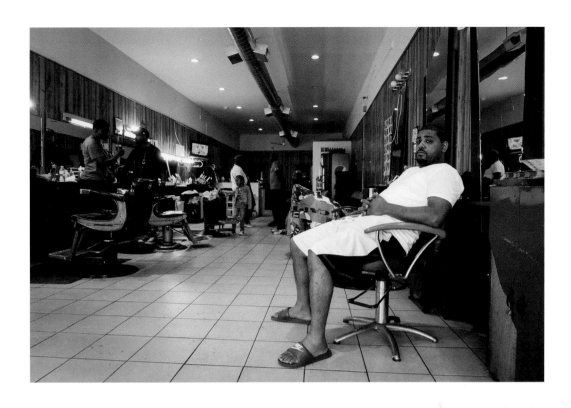

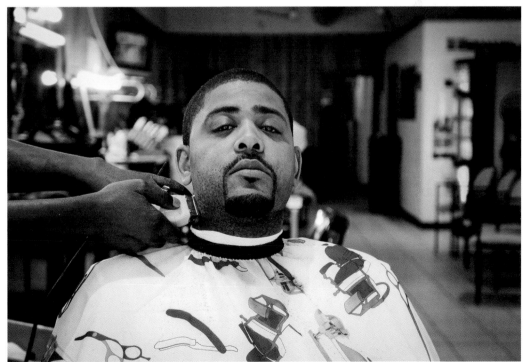

Frank's Place in Chicago, IL. August 2018

Maxamillion's Gentlemen's Quarters Barber Parlor in Philadelphia, PA. June 2010

Barbershop kicks.
Salon Ramsey in Atlanta, GA. August 2018
Barber Station in Detroit, MI. July 2018
A Sharper Image Barber Shop in Washington, DC. June 2018

CUT DAY AT THE FULTON COUNTY JAIL

ANTONIO M. JOHNSON

had no idea what to expect as I walked into Atlanta's Fulton County Jail. By the grace of God, I'd never been incarcerated, so all I had as reference were the same Hollywood depictions everyone has seen—cement walls, metal bars, barbed wire. Nonetheless, I felt drawn to the place.

That pull began when I first heard there was a barber shop inside. Or more precisely, that jail administrators designated one room every few weeks as a temporary barber shop and deputized one of the incarcerated men to cut hair. It's an obvious thing—people need haircuts wherever they are—but it never occurred to me that a jail might have such space and provide such a service.

For the past few years, I've been traveling across the country and photographing the communities that exist in barber shops. I've seen all kinds of shops. Each one is special in its own way, but most share a certain kind of magic. They hold within them the thrill of transformation. I had to see for myself if that charm could exist within the confines of incarceration. To my surprise, the makeshift shop in the Fulton County Jail had it in spades.

Sheriff Ted Jackson put me through the ringer before granting me access. We talked at length about my work, about security and jail protocols. Still, I was a ball of nerves as I entered the jail through a narrow corridor of metal detectors, was handed a visitor pass and guided to the room where the men get cuts.

It was a large all-purpose room with a cement floor and concrete walls. There were a couple of cafeteria-style folding tables on one side. At them sat a handful of men. Some were bright-eyed and youthful. Others had faces lined hard by time. Almost all were Black. They sat quietly—seemingly in meditation—as the barber on the other side of the room called them over one by one.

The scene was jarring at first. It felt worlds apart from the barber shops I was used to visiting, where the walls were adorned with Muhammad Ali posters, style guides, and price lists. The sound of a radio was also noticeably absent, as were the voices of the men themselves. It wasn't a barber shop, I thought, couldn't be.

Talking to the men changed my assessment. The barber, for example, explained to me how he first picked up a

pair of clippers while incarcerated more than nine years ago. It made him feel like an artist, he said. He also explained just how important a fresh cut can be when a guy is before a judge and jury. He takes extra time, he said, when he cuts the hair of someone with a court date.

One of the men getting cut, a twenty-seven-year-old named Marquez, told me that he'd been locked up for three months. It had been ninety days since his last haircut. He was at his lowest point and feeling even lower as his shape-up disappeared. He said, "I don't feel like a human being."

These were sentiments I had heard in other shops—barbers propelled by a sense of purpose, men made whole through the ritual of a haircut. They hint at the magic I came to the Fulton County Jail in search of, an alchemy I finally witnessed when it was Marquez's turn in the chair.

His face softened as the barber trimmed off layers of his budding Afro. His eyes brightened and he sat up higher. He turned back into himself.

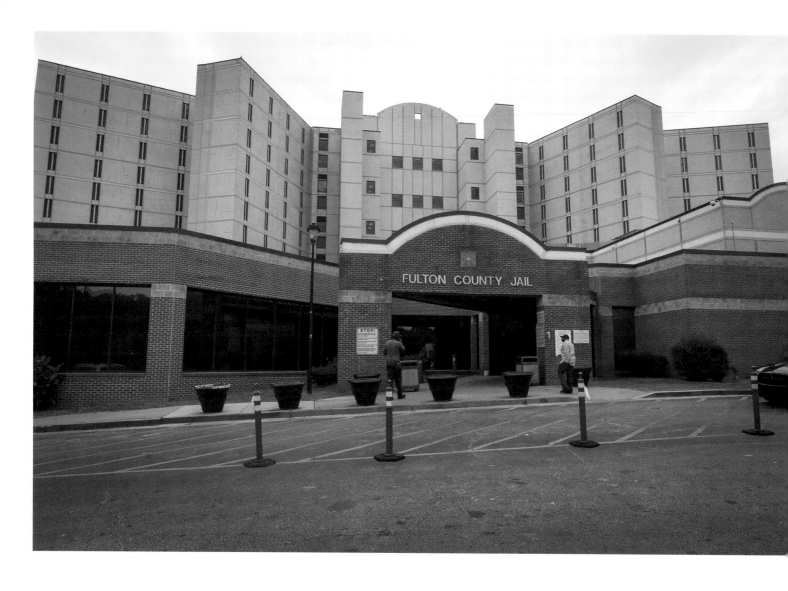

Fulton County Jail in Atlanta, GA. June 2019

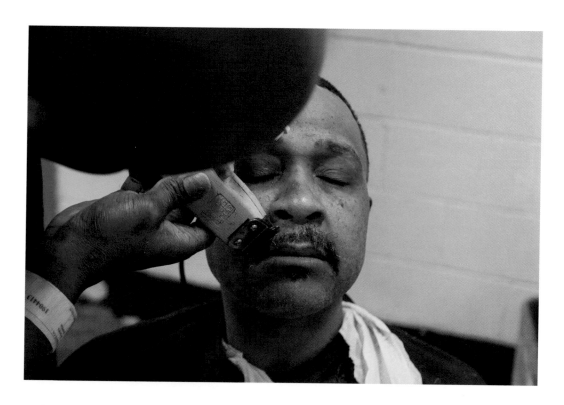

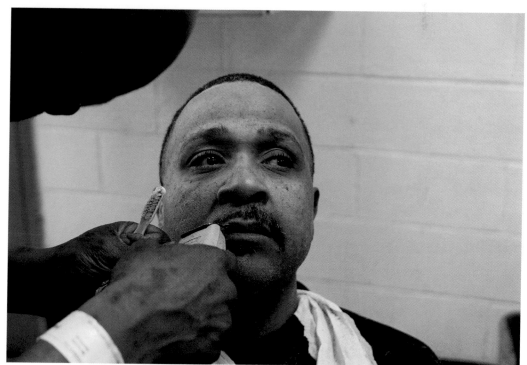

Fulton County Jail in Atlanta, GA. June 2019

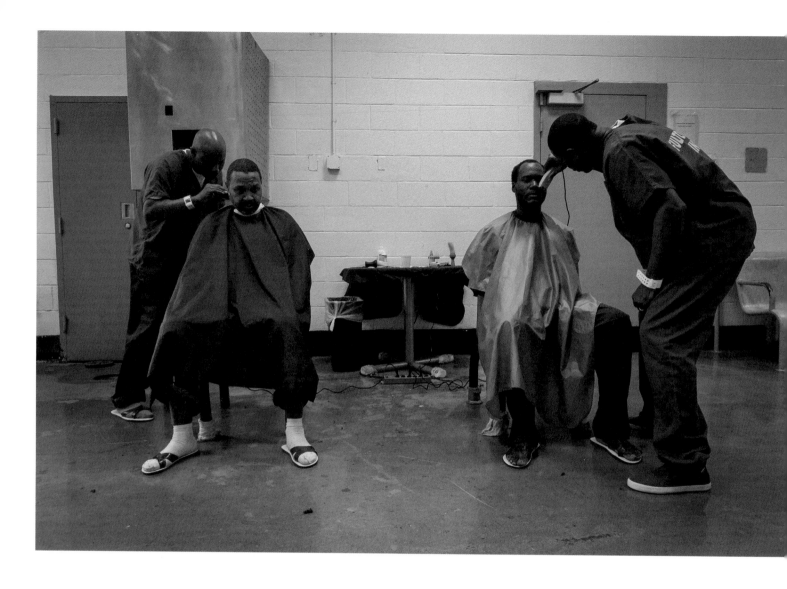

THEY HOLD WITHIN
THEM THE THRILL OF
TRANSFORMATION

Fulton County Jail in Atlanta, GA. June 2019

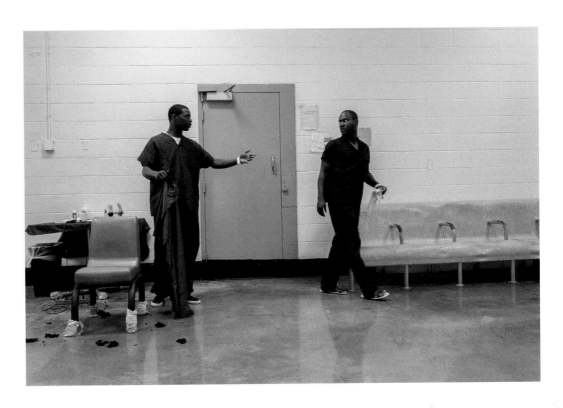

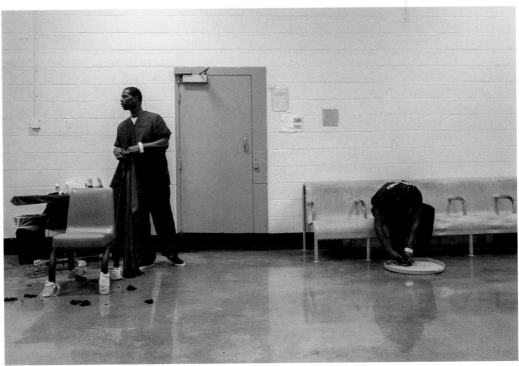

Fulton County Jail in Atlanta, GA. June 2019

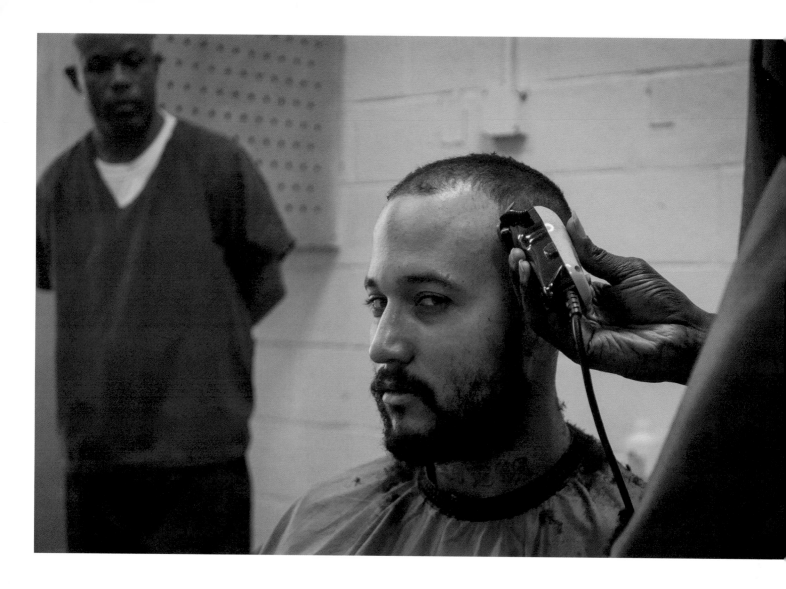

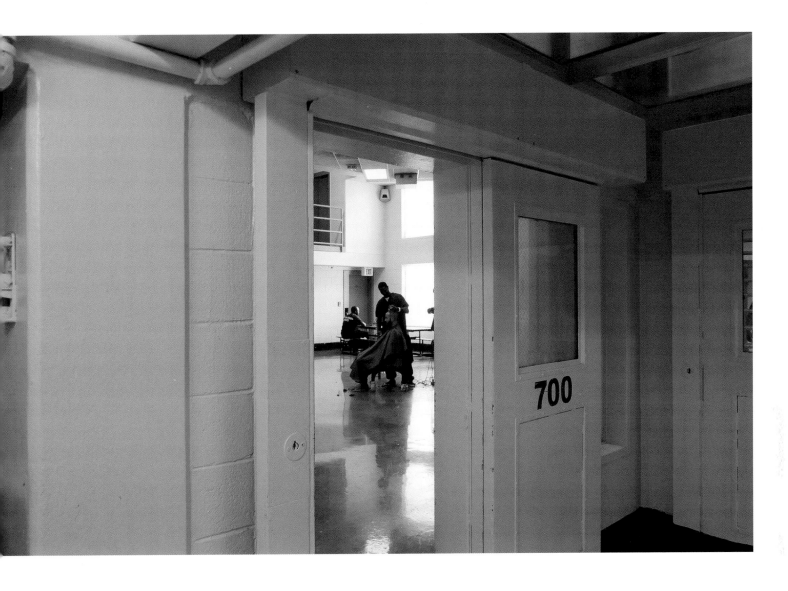

Fulton County Jail in Atlanta, GA. June 2019

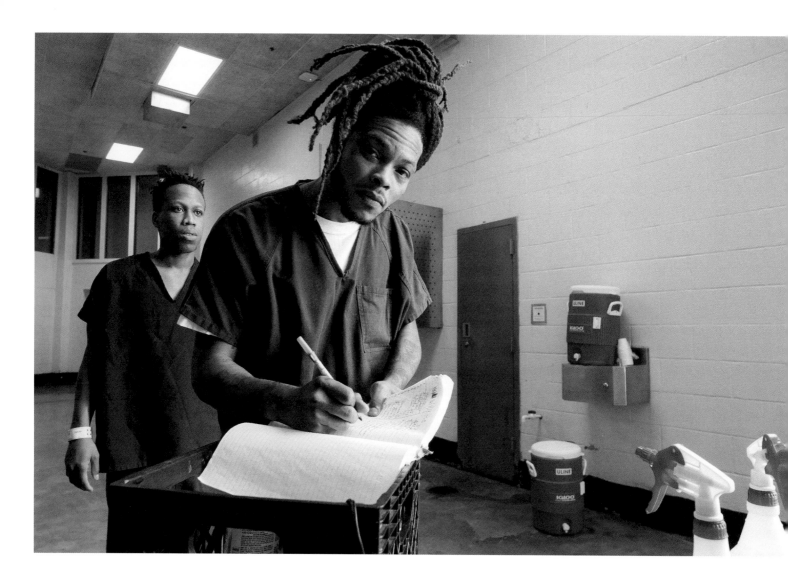

Fulton County Jail in Atlanta, GA. June 2019

MEN MADE WHOLE THROUGH THE RITUAL OF A HAIRCUT

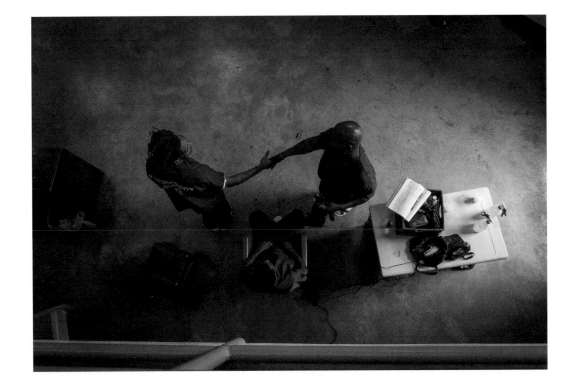

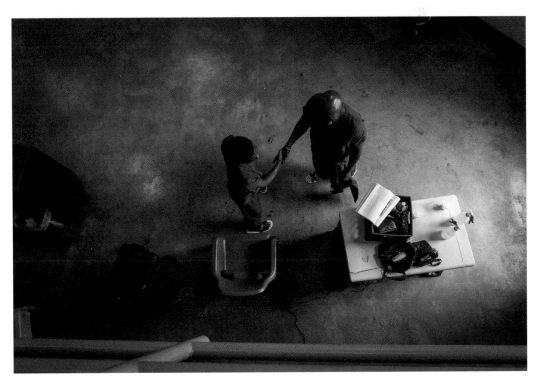

Fulton County Jail in Atlanta, GA. June 2019

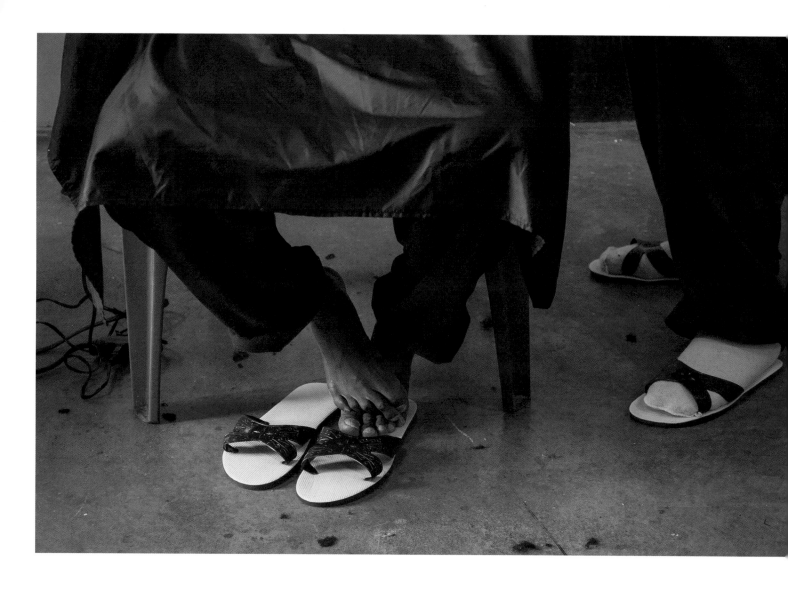

Fulton County Jail in Atlanta, GA. June 2019

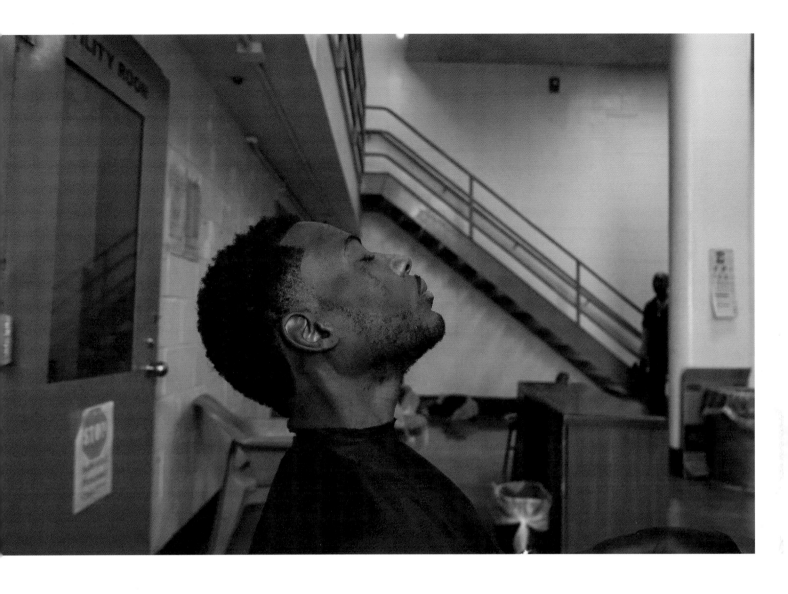

Fulton County Jail in Atlanta, GA. June 2019

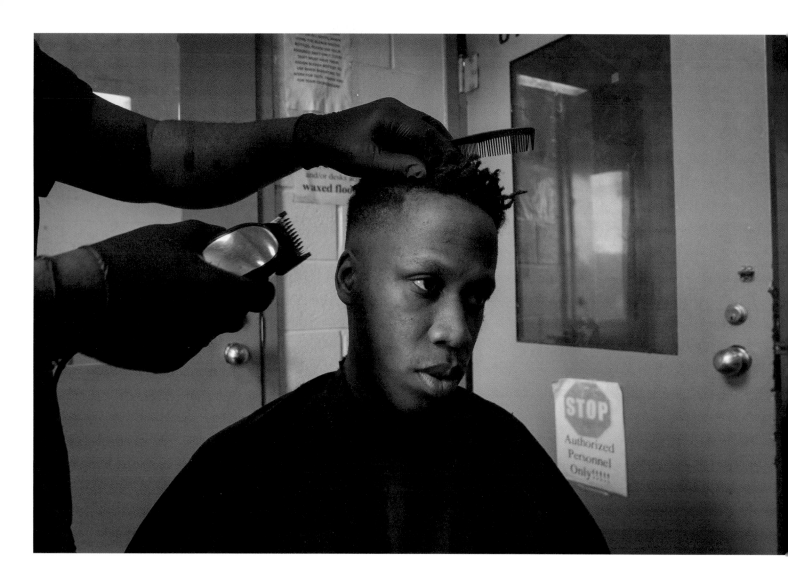

HE TURNED
BACK INTO
HIMSELF

Fulton County Jail in Atlanta, GA. June 2019

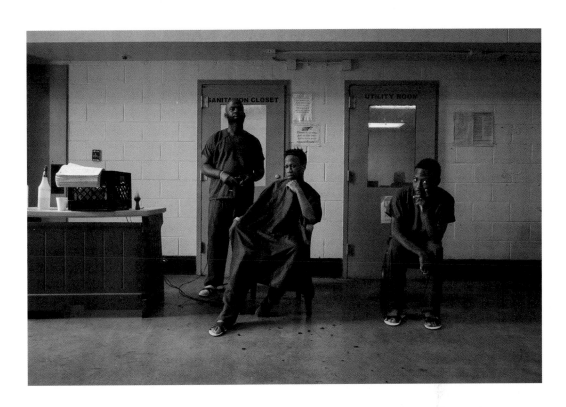

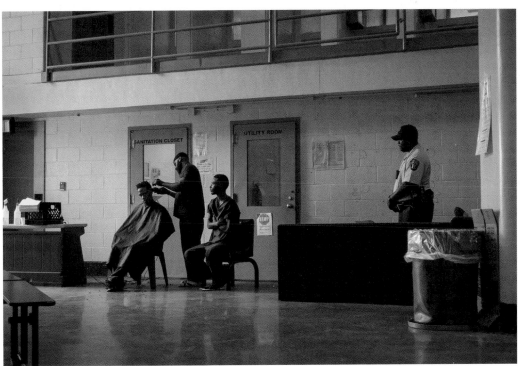

Fulton County Jail in Atlanta, GA. June 2019

137

2+2=5

JULIAN KIMBLE

"**B**ILL COSBY INNOCENT!!!"

These are the words of Kanye West, shared just days before his seventh album, *The Life of Pablo*, was released in 2016. They were delivered via Twitter but were reminiscent of what you'll hear in many a barber shop any day of the week. Barber shops are thought of as sanctuaries where people feel free to speak their minds. That sense of freedom leads to several instances where faithful members of every barber shop's community offer their honest opinions, despite being as loud and wrong as Kanye. Barber shop talk is unfiltered and, alas, often fueled by barber shop logic. And barber shop logic is particularly frustrating because even though you know it's rooted in nonsense, it's still polarizing enough to reel you in.

Barber shops are, for the most part, peaceful places. There's the welcoming lighting, the calming hum of the clippers, and the distinct smell of a fresh cut. Some shops play the radio, while others opt for CDs, playlists, or just let whatever's on TV ride. There are always several conversations going on at once: What happened at work the previous day; what happened the night before; who you cheated on your barber with, because surely they didn't do that to your hairline. The latter can certainly be awkward but won't disturb the serenity. But a terrible opinion with an even worse supporting argument can shatter the peace immediately.

Things you may hear: R. Kelly can't really be a serial predator because women are still in love with him. LeBron James can never be considered one of the greatest basketball players the sport has seen because he got swept in the finals. Homosexuality or women's rights are "agendas." Black women don't support Black men enough. You'll sigh because you know that even after someone challenges the nonsense, someone else will surely cosign it. You know whoever started the discussion will double down and keep going unless someone can show them they're incorrect. Even if you think you can put an argument to bed, you know better than to get involved because adding to the conversation will only extend it. In most cases, you just want the debate to end before the worst case scenario occurs: Your barber gets dragged into it and you're stuck waiting impatiently, sporting half a haircut, all while he argues over the validity a YouTube video that claims to reveal the true origins of President Obama's first term.

Much of this boils down to comfort. Barber shops are places of business that are set up to be inviting. Barbers want return customers, so they want people to feel comfortable. (You have to have a certain degree of faith in someone to entrust them with your hairline, right?) Because barber shops foster a certain sense of community, customers are comfortable sharing their thoughts on a variety of issues. However, the barrage of nonsense sometimes reveals discomfort with the world at large. For example, if you feel genuinely threatened by, say, feminism, you and whatever you've been taught might be the problem.

The best course of action, aside from tuning all barber shop debates out, is to take them with a grain of salt. They're occasionally entertaining, often regressive, and largely inevitable. Sometimes, that's the only thing that adds up.

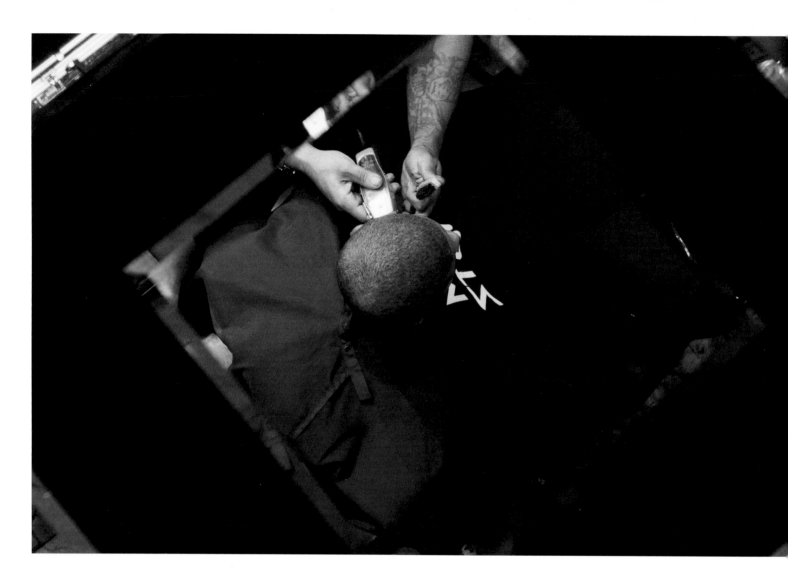

RVM Cutz in Los Angeles, CA. September 2018

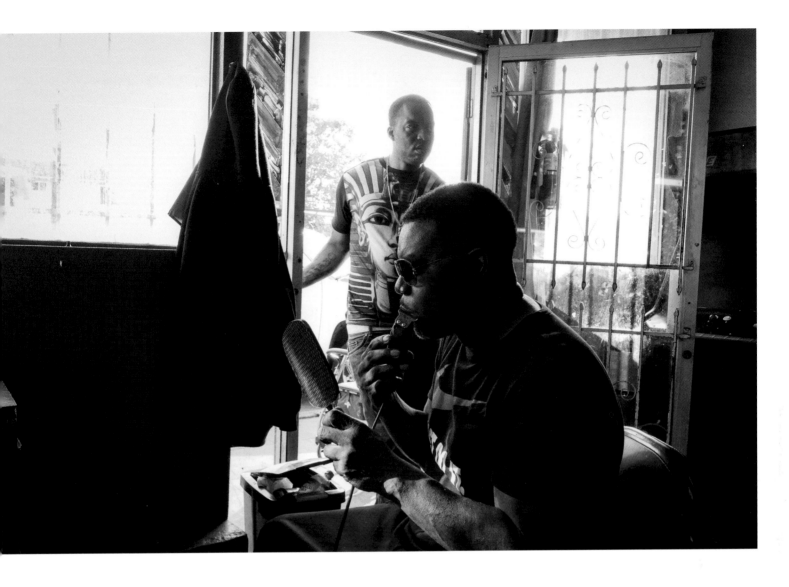

Jackie's Cuts and Styles in Oakland, CA. October 2018

BARBER SHOP TALK IS UNFILTERED

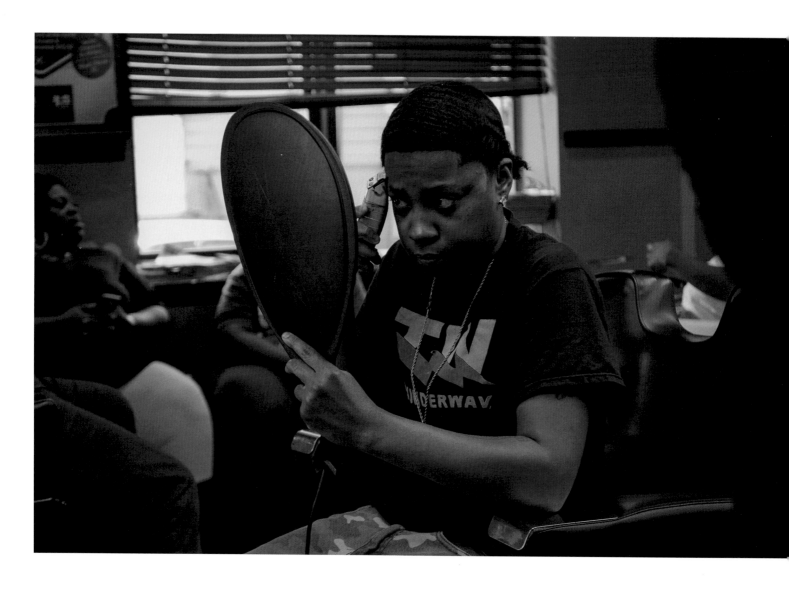

Na The Barber.
Faheem's Hands of Precision in Philadelphia, PA. June 2018

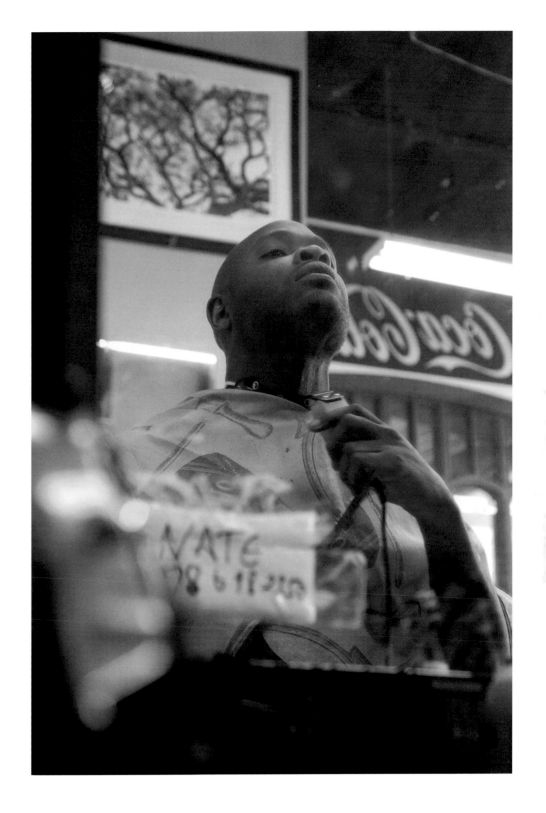

Nate working on himself.

Vintage Barber Shop in Atlanta, GA. March 2019

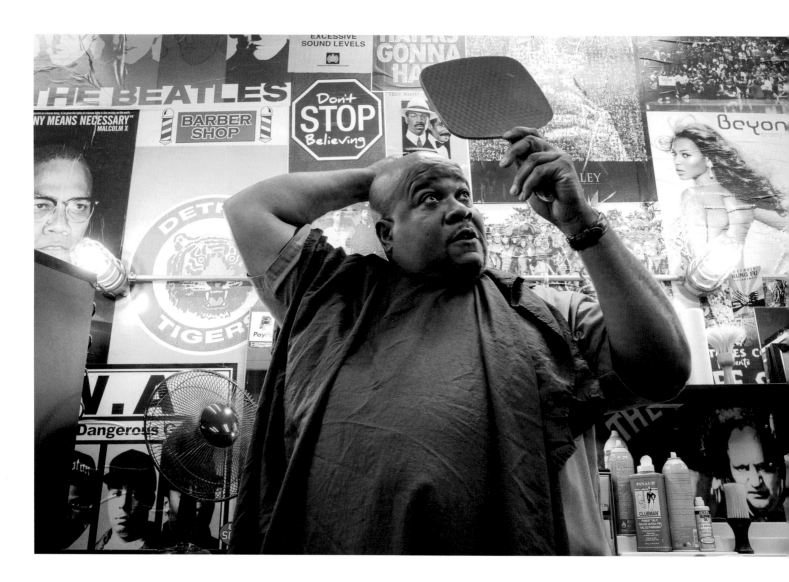

Bradley Lester uses downtime to shave his head
Barber Station in Detroit, MI. July 2018

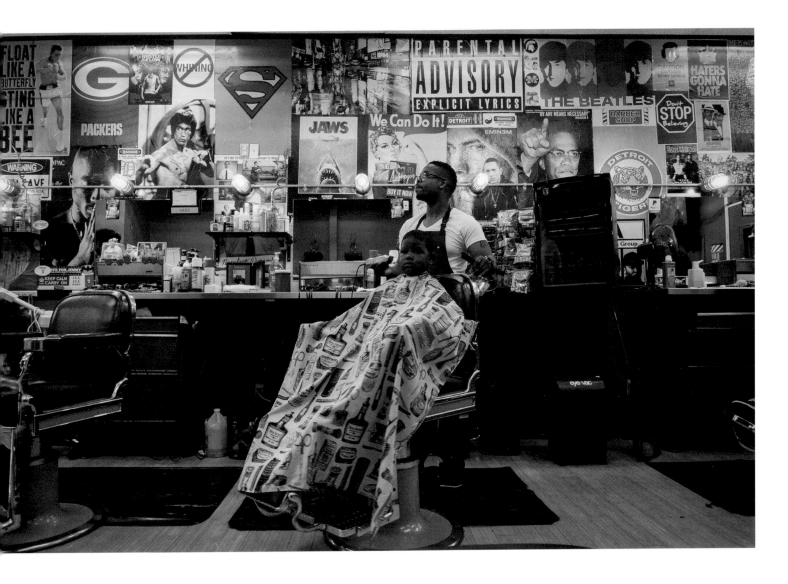

When I set out to work on this series exploring the Black
barber shop, I always imagined finding a shop like Barber
Station. Incredibly inviting, magnetic personalities, lively
discussions, and a refuge—even if only for a few hours.
Barber Station in Detroit, MI. July 2018

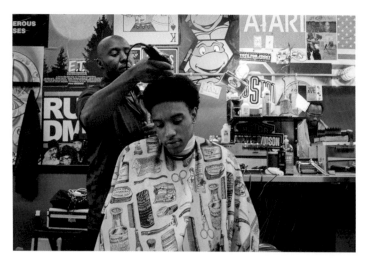

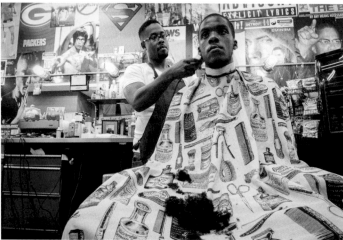

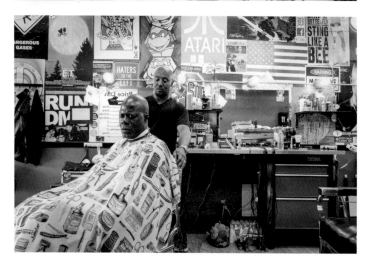

Barber Station in Detroit, MI. July 2018

146

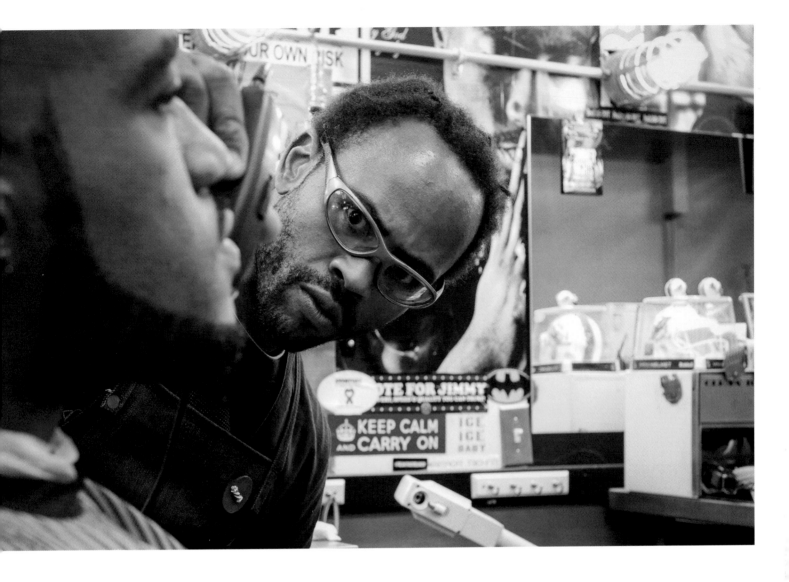

Barber Station in Detroit, MI. July 2018

YOU HAVE TO HAVE A CERTAIN DEGREE OF FAITH IN SOMEONE TO ENTRUST THEM WITH YOUR HAIRLINE

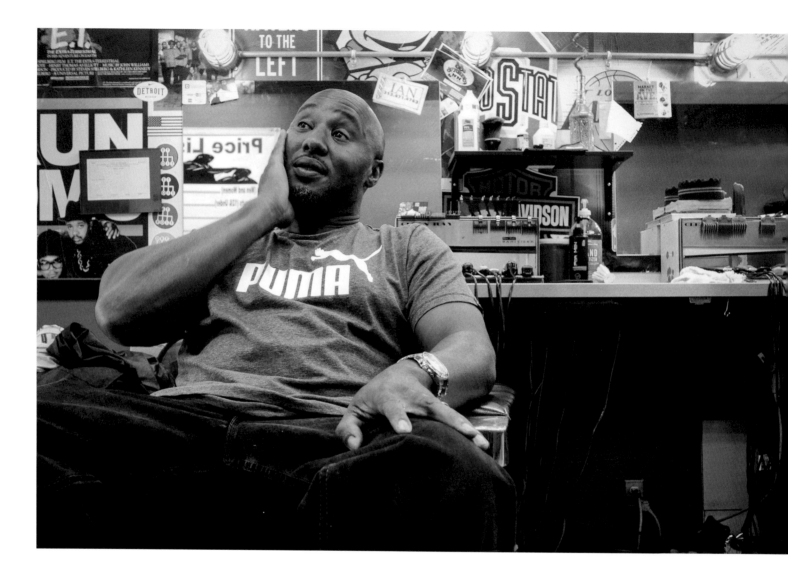

Barber Station in Detroit, MI. July 201

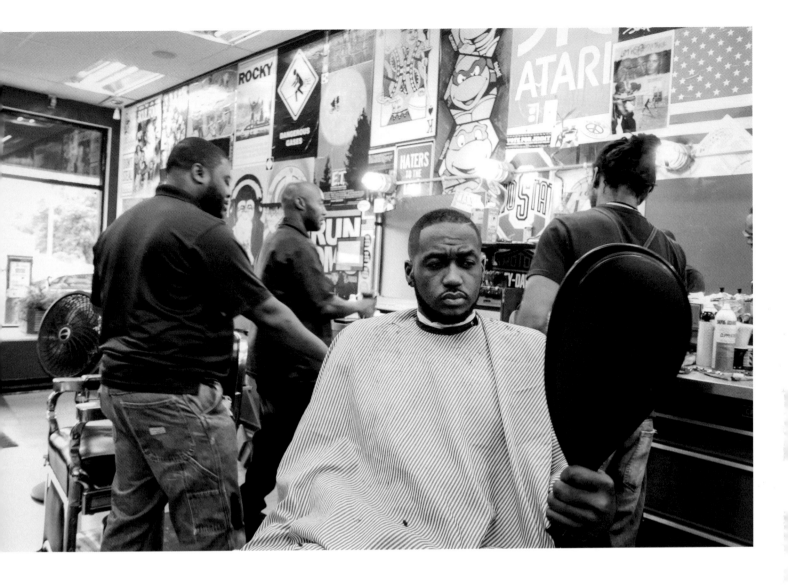

Barber Station in Detroit, MI. July 2018

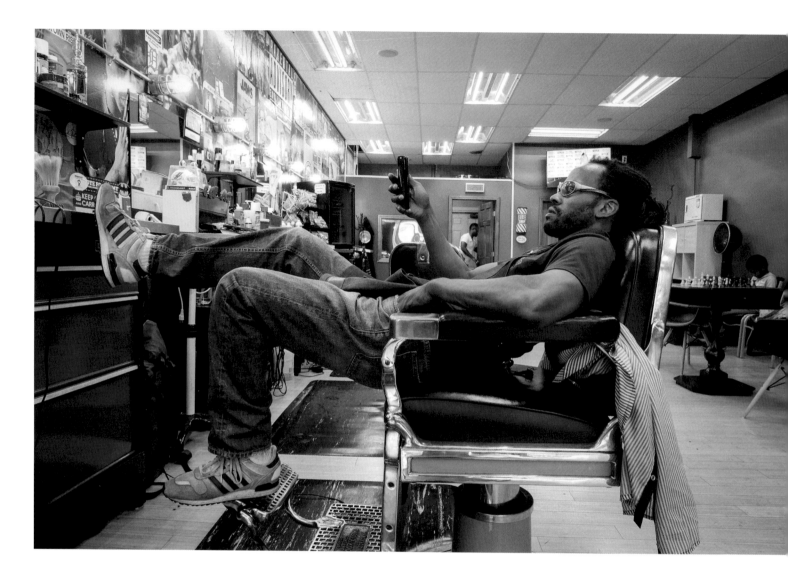

Barber Station in Detroit, MI. July 2018

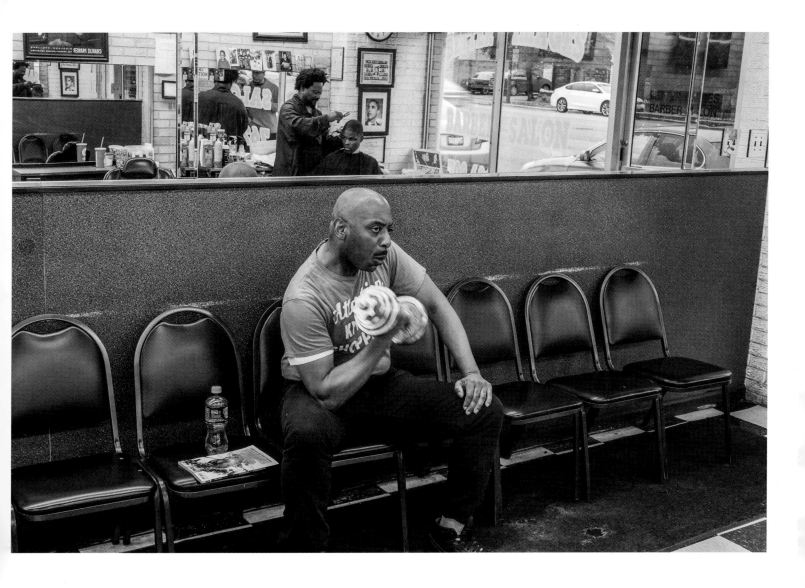

This man made a shop in Chicago's Evergreen Park his personal gym.
Better Images Barber Salon in Evergreen Park, IL. August 2018

LACKEY'S

DONOVAN X. RAMSEY

n a political climate in which the working class is front and center, people like Corey Lackey are often overlooked. Despite living in a Rust Belt city, he has a steady job. His community has seen better days, but he isn't, as pundits might put it, "disaffected." Mr. Lackey, thirty-two, a slight guy who rocks a low fade and full beard, owns Lackey's Barber Shop, where he is also the head barber. It's the kind of business that does well in any economy.

His clients, men who similarly defy perceptions of who lives in the American heartland, get their hair cut about once a week. They frequent the shop not just for precision cuts but also because it represents what's still possible in the city.

The shop comes alive around noon, and by 1:00 PM there's a small queue of men waiting. They pass the time with small talk—jokes, football, and family updates. Many are there on lunch breaks. A handful are employees of Gary Works, a steel mill operated by U.S. Steel.

To Mr. Lackey, the mill represents much of what's gone wrong with Gary. "It's what everybody ends up doing," he said, securing a cape around the neck of a customer. "When you're coming up, guys are just like, 'I'm going to just work at the mill and I'm going to be straight.' That's cool. You can make some real money at the mill, but why not do your own thing? Why not create something?"

Mr. Lackey turned off his clippers to emphasize the last point, his eyes widening a bit. He asked the question as if it was the most important in the world, the key to unlocking the future of a city whose population has declined by more than half from its peak in 1960 and where residents grapple with unemployment, decaying infrastructure, blight, and crime.

Gary's history, intertwined with the major industry in town, is something Mr. Lackey knows intimately. He comes from four generations of steelworkers. His father retired after forty years with U.S. Steel. The job, Mr. Lackey said, allowed his father to provide for twelve children but it took a toll. Soon after retiring, he was diagnosed with stage four colon cancer, the result of decades working around asbestos, Mr. Lackey suspects.

Instead of following his father into Gary Works, he decided on barbering. "It's a service people can't go without," he said. "Everybody needs a haircut."

Mr. Lackey started practicing on one of his brothers at eleven and discovered he was pretty good. He continued to cut hair through high school, earning a little money here and there from guys in his neighborhood until, at twenty-eight, he went to barber college. In 2010, he got the idea for Lackey's.

"It don't cost much to get started in Gary," Mr. Lackey said. "My daddy and I bought this building and the four lots surrounding it for just $1,500.

"We remodeled it together and took it from a garage with big garage doors and everything to this," said Mr. Lackey, motioning around the shop with his free hand. "And I got a two-bedroom apartment upstairs."

Though Lackey's Barber Shop is a rather modest small business, its proprietor has reason to be proud. He has steady income and his own home at a time when other young adults with backgrounds like his, in Gary and elsewhere, are struggling.

Mr. Lackey grew reflective as he put the final touches on his client's shape-up and handed him a mirror to check it out. "Gary used to be a nice town at one point in time, but it seems every day like it's going down," he said. The room responded with nods and murmurs of agreement. "Having this shop is about the business and making money, yes, but it's not just that for me. It's also about creating jobs and being an example."

Despite benefiting from the new tariffs on imports, U.S. Steel has yet to announce any new jobs at Gary Works,

a loud signal that the mill may not be the future of work in the city. Increasingly, residents will have to either relocate or create a new economy with new industries and, hopefully, a more robust small-business community.

"I tell people to start small and build slowly," Mr. Lackey said, before seating another client in his chair. "It may not be a lot when you get started, but, at the end of the day, at least you can control your own fate."

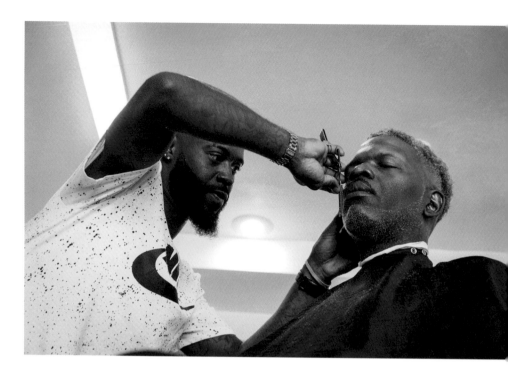

Corey Lackey using a straight razor for a precise shape-up on a client.
Lackey's Barbershop in Gary, IN. August 2018

154

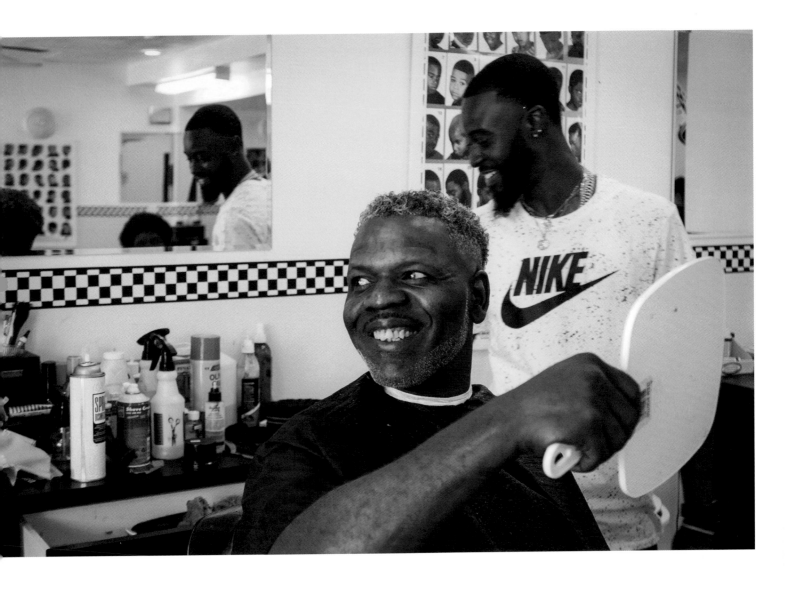

"EVERYBODY NEEDS A HAIRCUT."

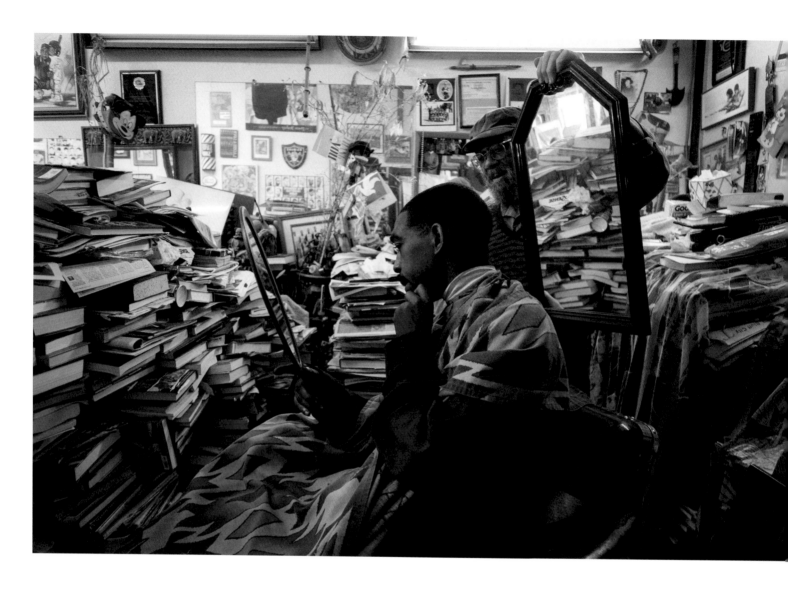

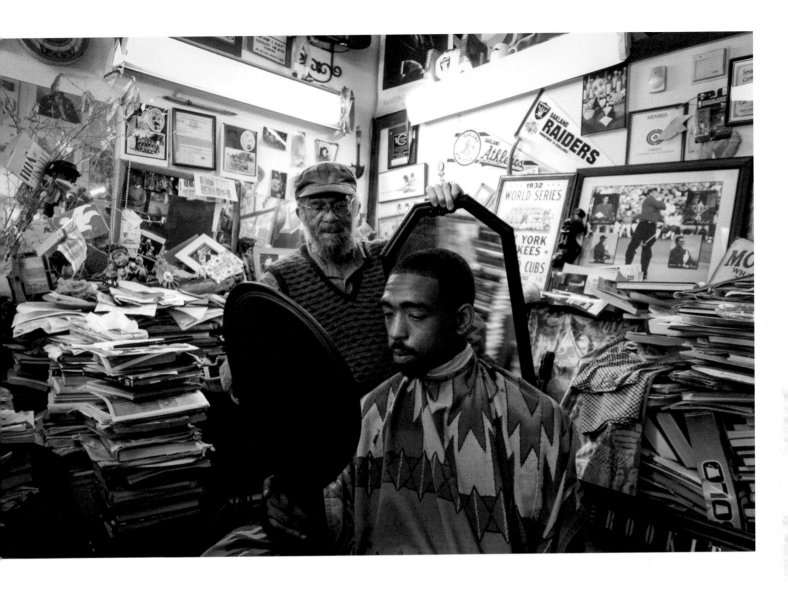

**While surrounded by towers of books, seventy-eight-year-old
Kenneth Hogan shows a customer his haircut.**
Cuts and Bends Hair Center in Oakland, CA. October 2018

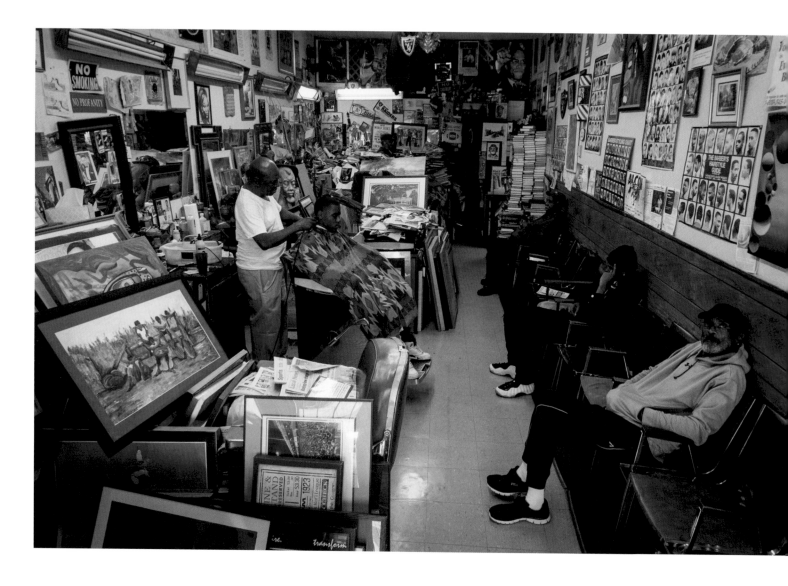

IT'S THE KIND OF BUSINESS THAT DOES WELL IN ANY ECONOMY

Inside Cuts and Bends.
Cuts and Bends Hair Center in Oakland, CA. October 2018

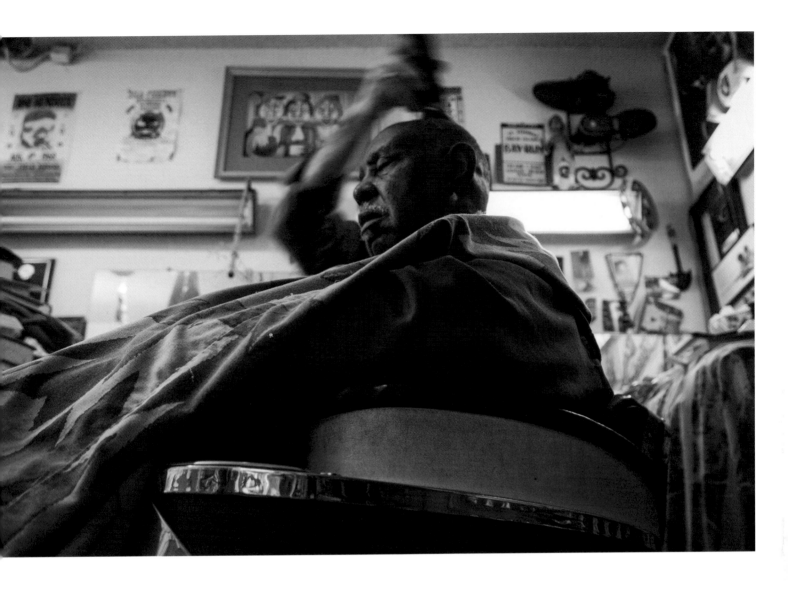

Cuts and Bends Hair Center in Oakland, CA. October 2018

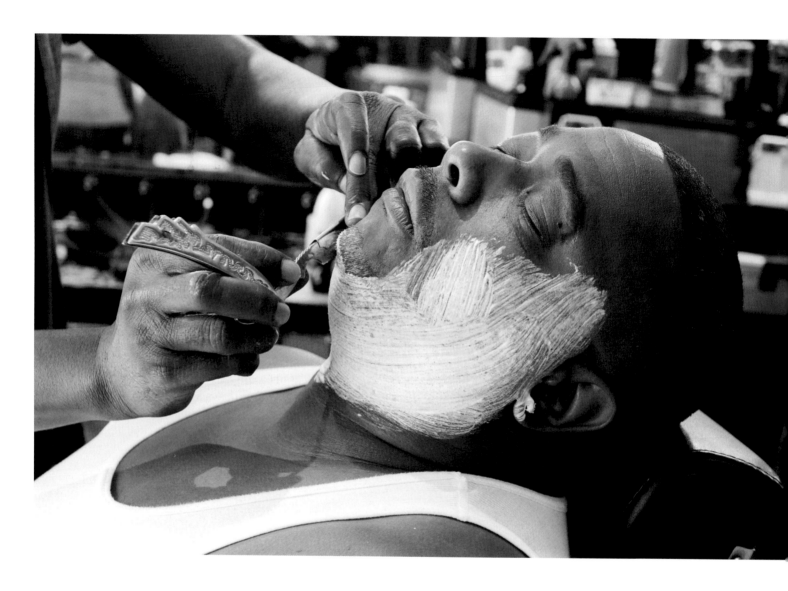

Man asleep while being shaved.
Frank's Place in Chicago, IL. August 2018

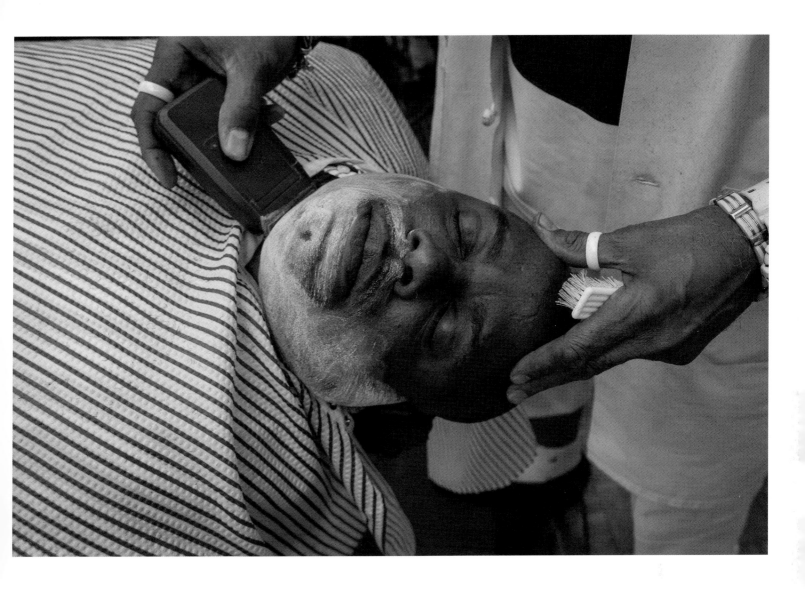

A man receives a dry shave by Maxamilian A. J. Wells, a renowned
Philadelphia-based barber of more than fifty years.
Maxamillion's Gentlemen's Quarters in Philadelphia, PA. June 2018

BELOVED

DAVID WALL RICE

We shared the same name—David, beloved.

He was a dude from Brooklyn who moved into a live-work space next door to us in Atlanta. Mikki was pregnant, and toxic fumes were seeping through the brick wall we shared with him in the authentic A&P Loft space just off I-20 and the Beltline. That was his introduction to us. He was the young brother who hired an aerosol artist to tag up his exclusive salon, literally choking us out of our home. Dave apologized that we had to spend a few nights in a hotel so that the baby would be all right. And the baby was all right, and David and I became friends, though I was his client first, begrudgingly so.

I desperately needed a cut and Dave said as much to me in the hallway, bluntly. Getting a cut was always a chore, since high school. No one could get the fade quite right so, mostly, I'd grow my hair out or cut it super short and be done with it. But Dave could cut heads. I went to him frequently; I mean, he was next door to me. And we talked a lot. He had a cool clientele, but at first, in the early days, it was mostly just us rapping about life when I swung through.

Dave was about ten years younger than me, so he was cool to spit game to about being an adult. He thought it impressive that I was a college professor and sincerely asked for advice about everything. He was most keyed in when we talked about the real stuff, like divorce, his pop passing, his falling in love and getting married again, and his first kid, then his second, and then his baby boy. I saw Dave grow up. And in many ways he validated my being grown. He told me I was a good father and he wanted to be like me. He said I was a good husband and asked how I did it. I was there when he got married; talked with him about the scare with his youngest—prayed for and with him.

Dave was a real one.

Oh, and we talked wild trash to each other too. Mostly he liked to say how I abused my boys by giving them "wack" cuts, bringing the older one by but never letting Dave cut his hair. As he moved shops, and moved up, he thought it hilarious to scream on me in front of folks, calling me "Dr. Rice" after making whatever grand point he was convinced of as genius. I'd give as good as he gave, almost always ignoring whatever point, reminding him that he could never cut my beard right and complain about that line that was always still showing. He would argue it was from my glasses.

Dave had me come to the shop at odd hours, mad early or crazy late. He'd always fit me in. It was a Thursday in May. I was at the shop at 7:00 AM, irked that he wasn't there at quarter past. I called him three times and his wife picked up on the third call. I asked for him in my super polite voice, and she said, "He's not here anymore" and apologized. I don't remember what I said in return. I was shook. David had died of a massive heart attack the day before. He was thirty-seven years old.

There is so much more to say about Dave, to be sure, but to me, the most important centers on when we got close. It was about six years into knowing each other. It was after he had his first daughter. I was proud of him. I told him I loved him. He said the same to me, and that's how we left each other from then on. The last words we shared were, "I love you, Brother. Peace to the family." He responded, "Love you too, Bro. Tell Mikk waddup . . . and the boys need a real hair cut."

David Paul Sheriff, beloved.

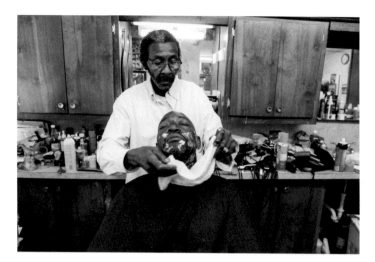

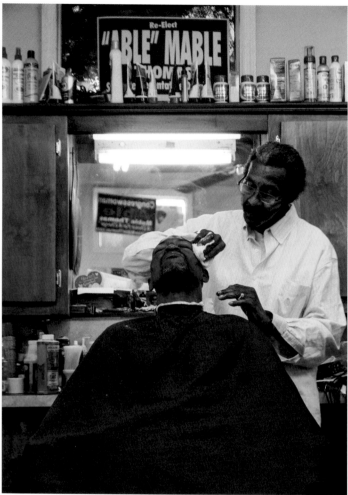

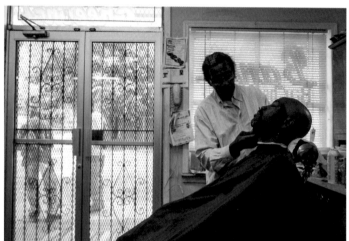

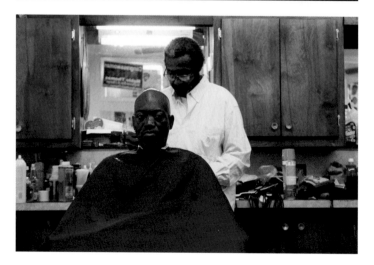

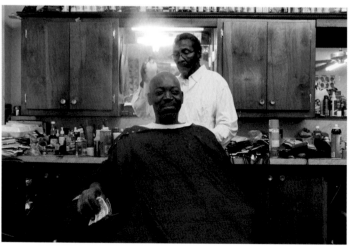

Bank's Barber & Style Shop in Atlanta, GA. May 2019

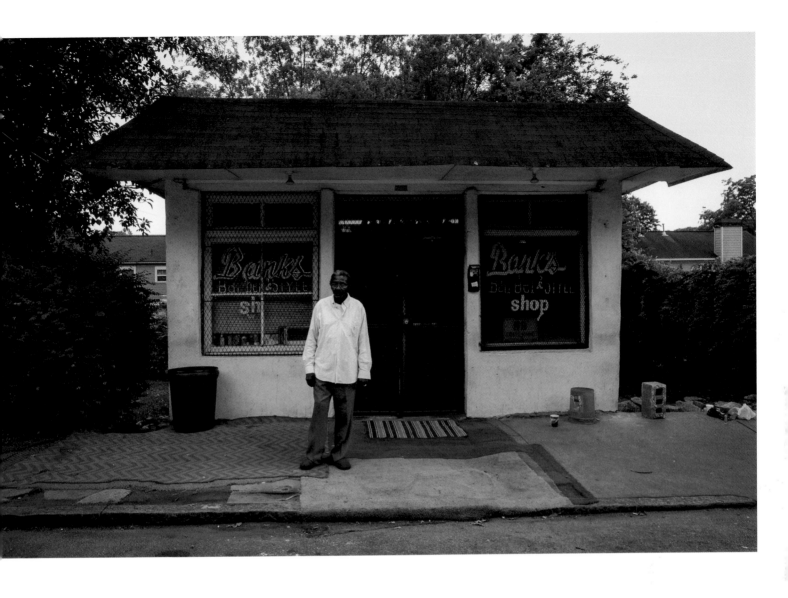

Mr. Willie Banks stands in front of his barber shop.
Bank's Barber Shop in Atlanta, GA. May 2019

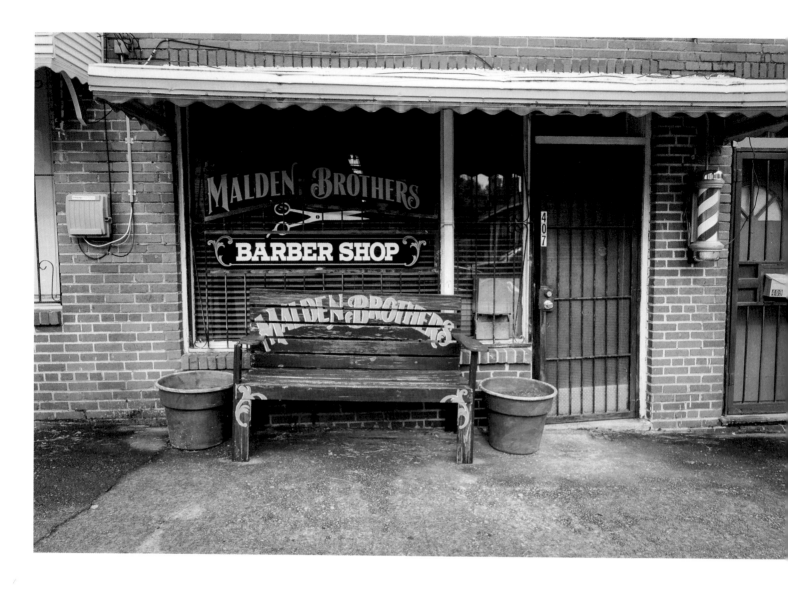

Before leading the Montgomery bus boycott, a young
Martin Luther King Jr. was a frequent patron of the Malden
Brothers Barbershop in Montgomery, Alabama. Barbers
at Malden Brothers serve a new class of young men today
but still make time for the elders of the community.
Malden Brothers Barber Shop in Montgomery, AL. August 2018

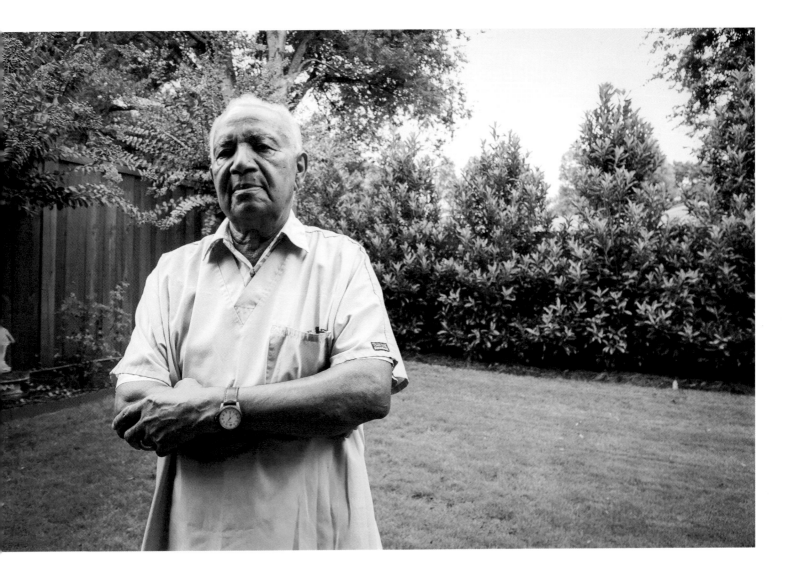

Portrait of Nelson Malden, eighty-six years old, standing in his home garden.
Home of Nelson Malden in Montgomery, AL. August 2018

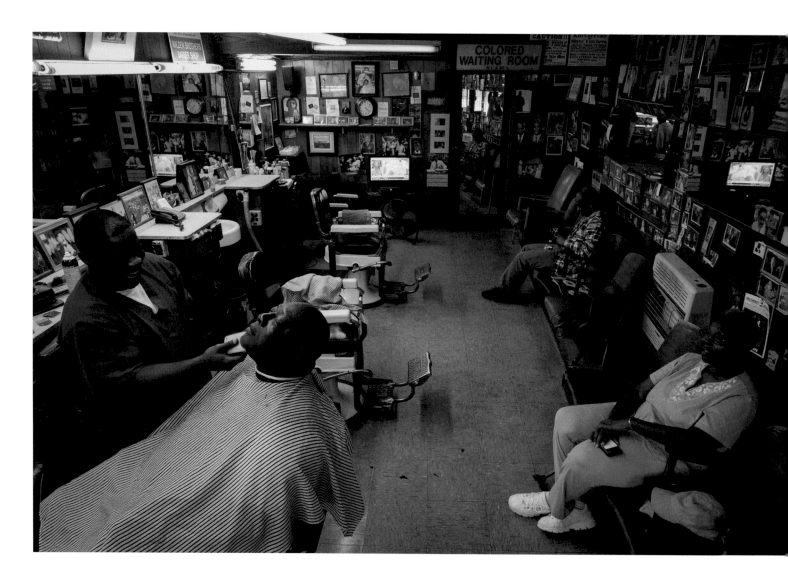

Malden Brothers Barber Shop in Montgomery, AL. August 2018

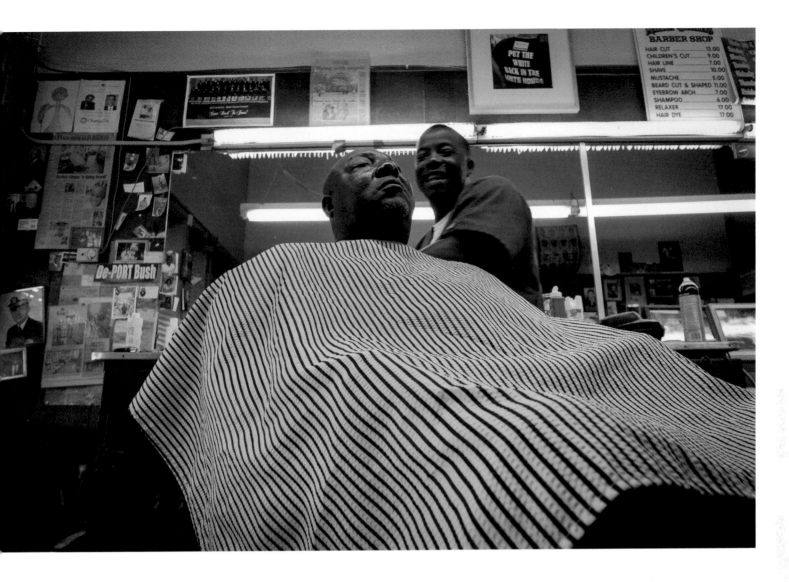

Malden Brothers Barber Shop in Montgomery, AL. August 2018

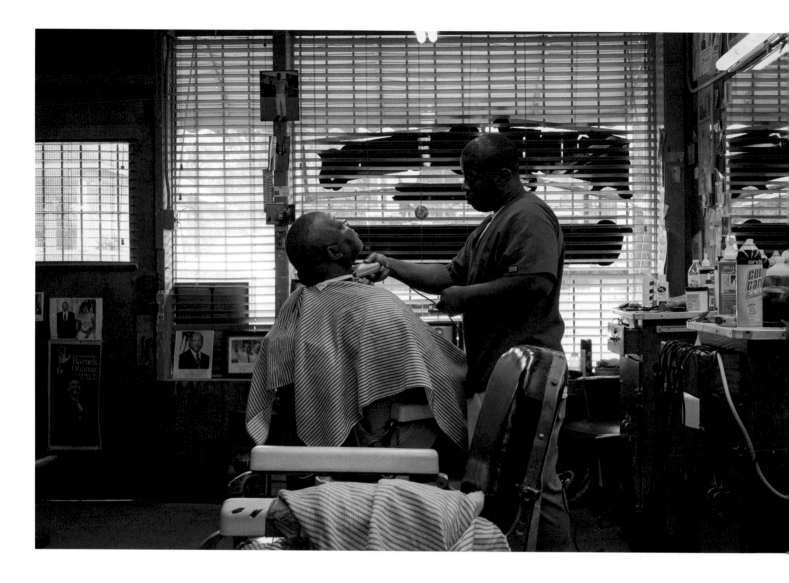

Malden Brothers Barber Shop in Montgomery, AL. August 2018

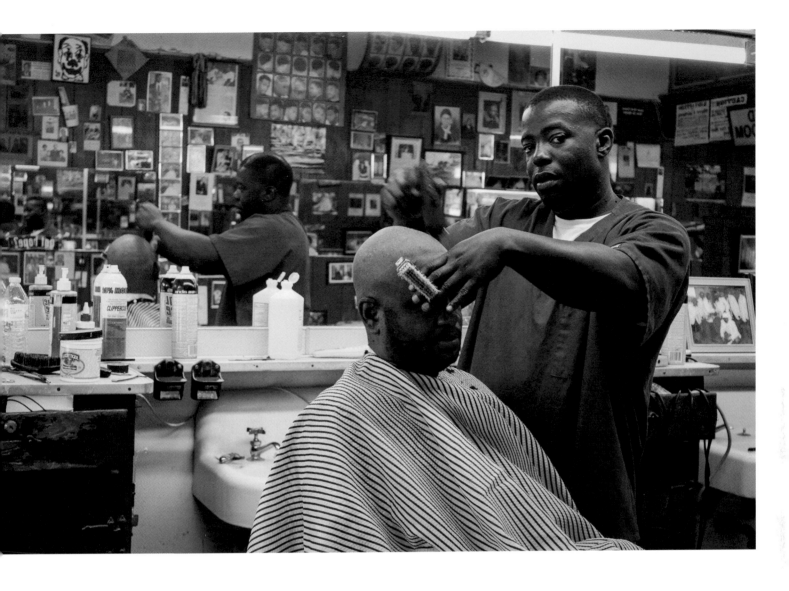

Malden Brothers Barber Shop in Montgomery, AL. August 2018

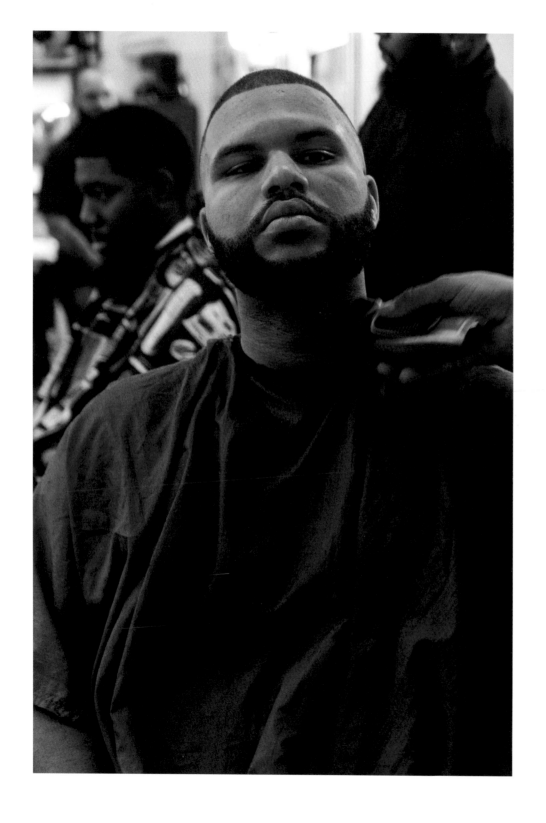

A young man gets the
perfect beard treatment.
*Faith Barber Shop in
Atlanta, GA. March 2019*

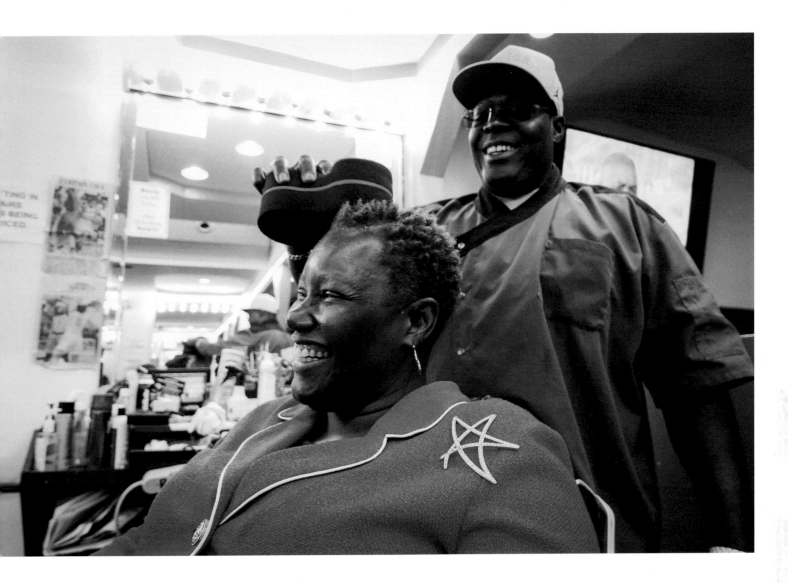

The former mayor of Gary, Indiana, Karen Freeman Wilson, gets the final touches on her cut with the curl sponge. The curl sponge is a tool used to curl or twist hair in just a few minutes. The sponge was created by Youseff Barber in Atlanta.
Billco's Barber Shop in Gary, IN. August 2018

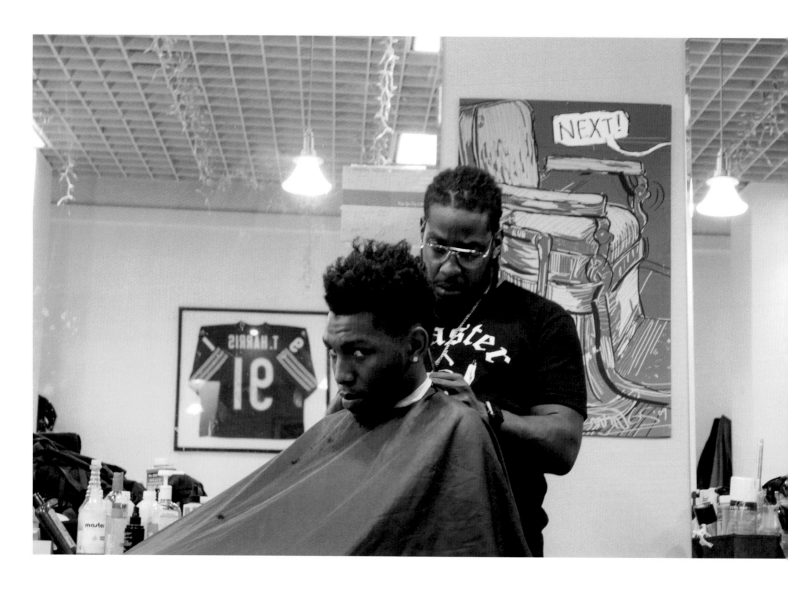

A man makes eye contact while getting a cut in front of a poster that reads NEXT!

Hyde Park Hair Salon in Chicago, IL. August 2018

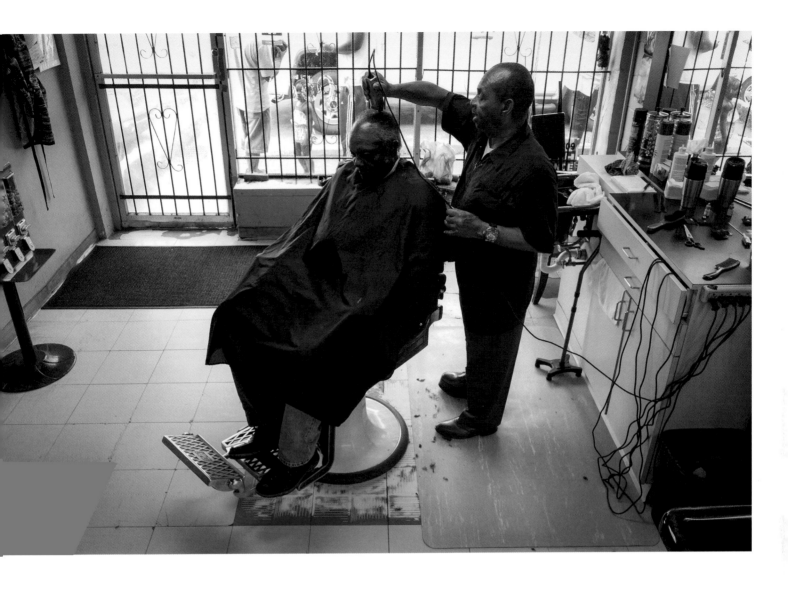

Bobby cutting an elderly man.
Bobby's Barber Shop in Atlanta, GA. August 2018

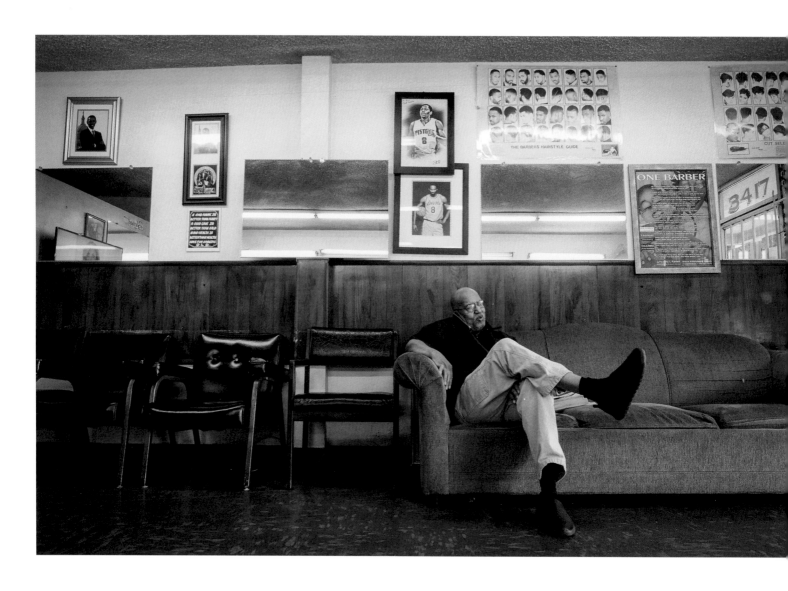

The owner of Chief's Economy Barbershop takes a phone call
while sitting on the couch during downtime in the shop.
Chief's Economy Barber Shop in Los Angeles, CA. September 2018

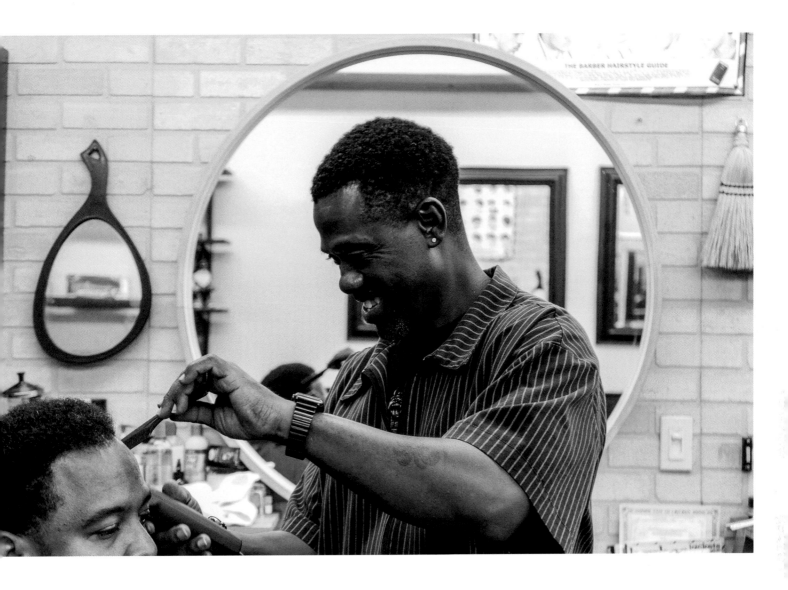

The owner of Mella's smiles while cutting a client's hair.
Mella's Barber Shop in Chicago, IL. August 2018

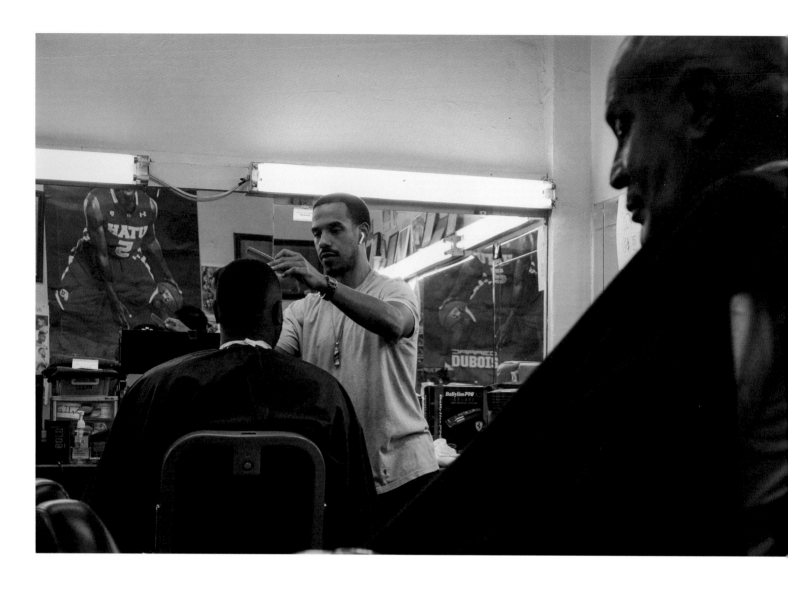

Scene from A New You Barbershop

A New You Barbershop in Inglewood, CA. September 2018

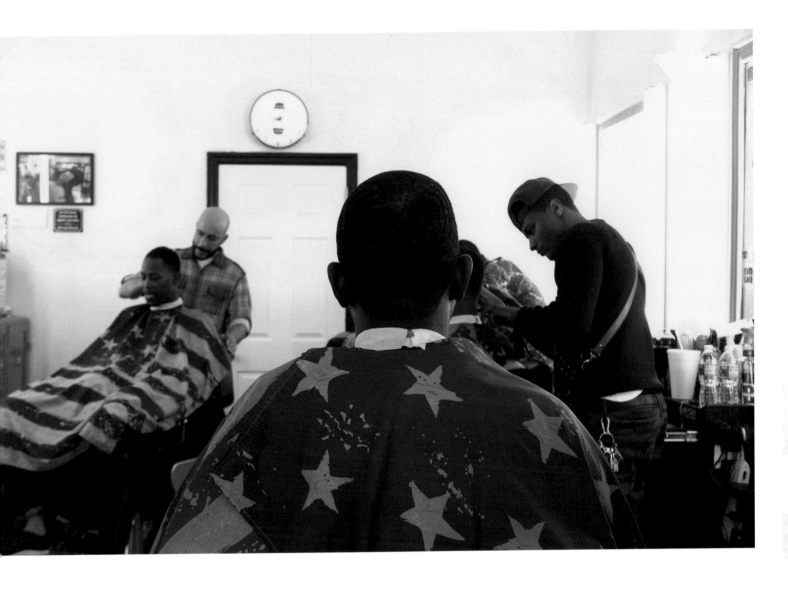

American flag capes drape clients.
Freddy G's Barbershop in Brooklyn, NY. March 2018

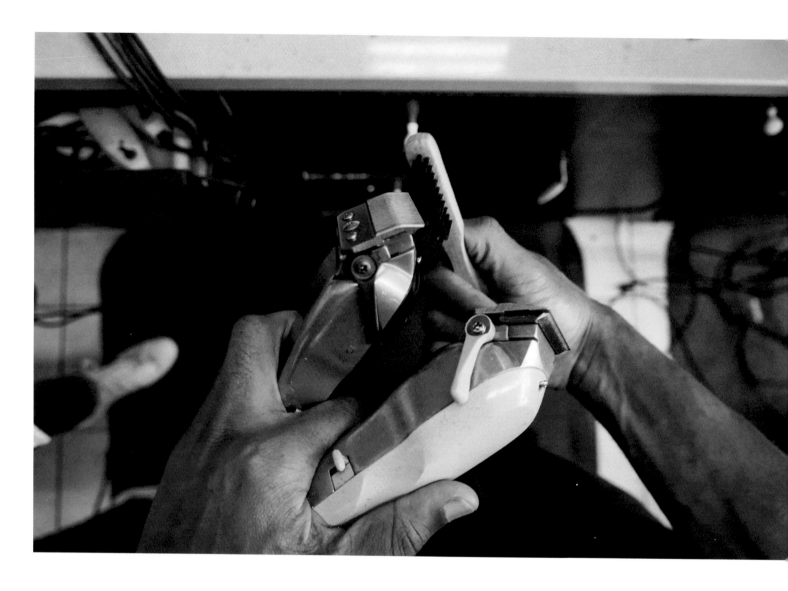

Nate cleans and conditions clippers.
Vintage Barber Shop in Atlanta, GA. March 2019

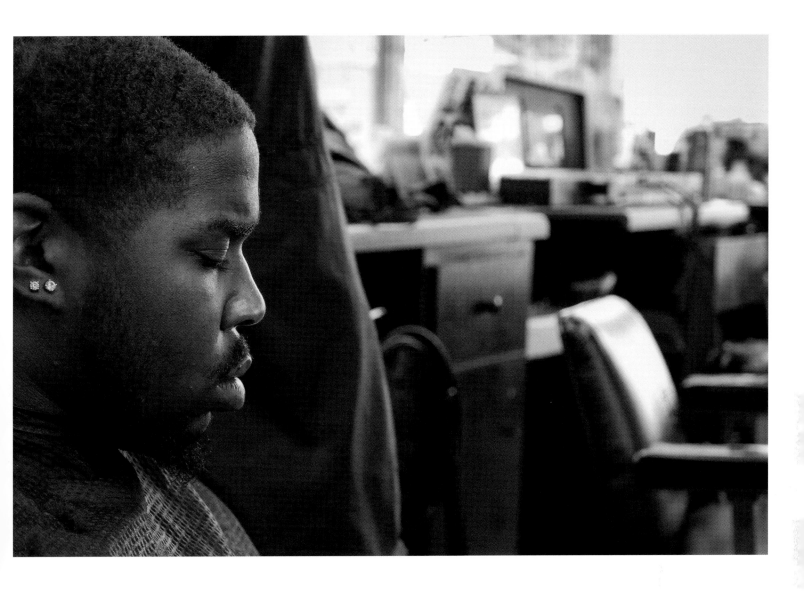

Before.
Philly's Finest in Atlanta, GA. August 2018

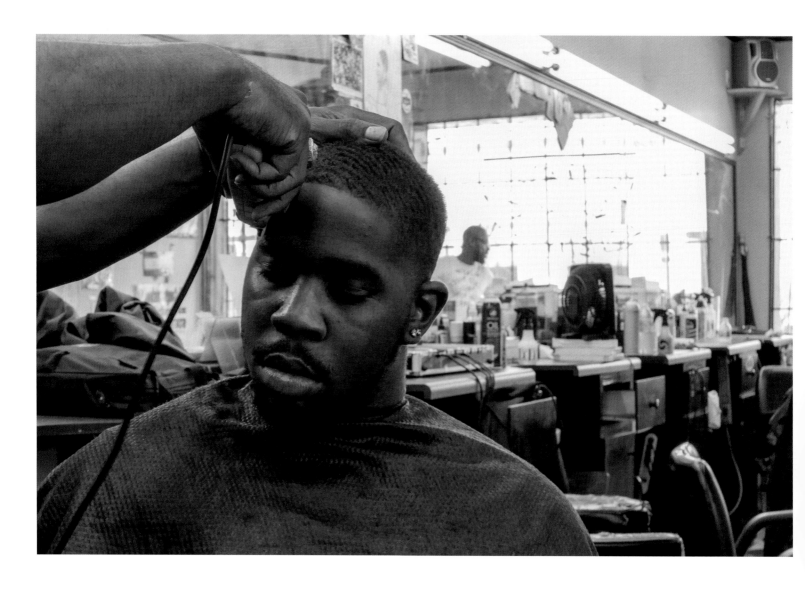

After.
Philly's Finest in Atlanta, GA. August 2018

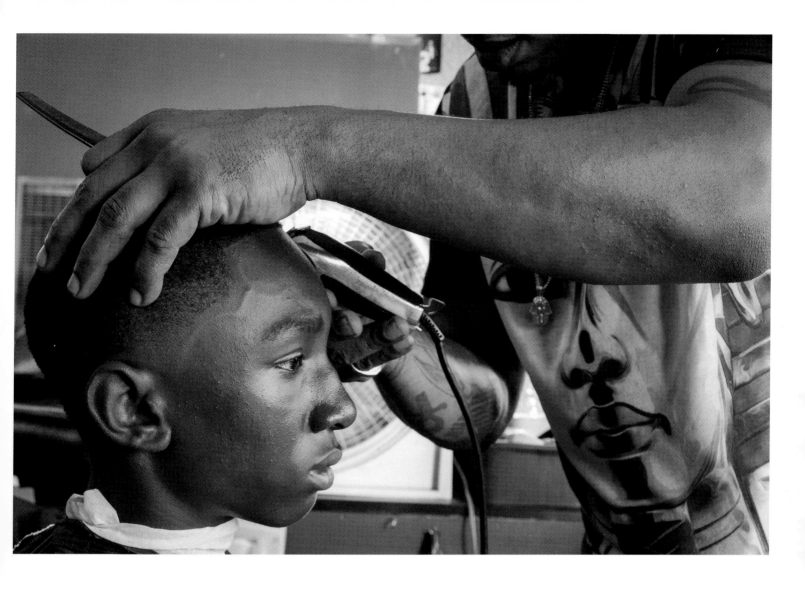

The profile of a kid's face as he gets a haircut.
Jackie's Cuts and Styles in Oakland, CA. October 2018

A CUSTOMER'S HOPE

FELIPE DELERME

follow one barber on Instagram and as of this writing, he hasn't posted anything for about two years. The account itself is nothing special, a pretty remedial attempt at engaging social media from someone in a skill-driven business practice trying to promote their skill set. When viewed in tile form, the account presents like one of the haircut charts that adorn Black barber shop walls across America. The whole of its roughly five hundred posts—at least as deep as I was willing to scroll before I got bored—are of various heads post-appointment, Black and Latino children and men showing off crispy shape-ups, perfectly rounded Afros, sharp fades, regal caesars, smooth tapers, sparkling baldies, and mostly in the instance of the children, designs shaved into their temples.

The pictures themselves aren't of any exceptional quality and look to have mostly been taken with a phone whose camera is a few technological cycles removed from the latest. Sprinkled in among the glamour shots are a few selfies of the account's operator, a barber named Lee who used to cut my hair at "the legendary" Hut in Jamaica, Queens. The Hut is infamous to hip-hop fans of a certain age from its appearance in the Hype Williams film *Belly*, the shop acting as a backdrop for a scene where Nas (as Sincere) is almost murdered while he catches up with rapper AZ as Born.

I can't remember how long Lee actually cut my hair. Our time together is marked by intervals of his disappearance. I remember one such instance, going maybe six months without seeing him, which made for a triumphant reunion on the street a couple blocks from the shop. He was standing outside of a bodega in the spring wearing an olive M-65 jacket, light blue jeans, and heavy-duty hiking boots. "Man, one of these lil niggas shot me," he said, nonplussed. It felt uncouth to press him for details. "I'm a'ight though, I'm back in the shop again," he said, before he handed me a business card, limping away gingerly.

I'd begun going to the Hut about halfway into my time as a student at St. John's University. Before that, I—along with most of the kids I ran with—frequented Headquarterz, a shop located directly across the street from campus, run by a stocky Haitian man we took to calling Sigel because of a resemblance to the then-popular Philadelphia rapper. Sigel was a phenomenal barber but just as consistently a jerk, even, and in some cases especially, to customers. He would complain loudly and openly when he wasn't satisfied with a tip, halt your haircut to take extended phone calls, lie about how many people were in front of you to be cut, and for whatever reason, just couldn't be made to extend a welcoming report. I stuck it out with Sigel until I couldn't anymore, eventually wandering into the Hut after an excursion to Jamaica's infamous 165th Street block to buy mixtapes or clothes or, in all likelihood, both.

Haircuts at this time, in my circles at least, were almost entirely a walk-in experience. Modern technology has made setting up an appointment as easy as selecting a preapproved time slot from an app, but the closest you'd come back then was to hope your barber picked up the phone when you called and could tell you when he'd arrive at the shop and/or how many people he had waiting on him. Fridays were especially rough with regard to a wait time because of the influx of people trying to get fresh for the weekend, but the reality of the situation is that there never wasn't a wait of some sort.

Any number of distractions or inconveniences might lead to spending an entire morning, afternoon, or evening—and in rarer cases, a full two out of the three—at a barber shop waiting for a cut. In the right shop, this wasn't the worst thing in the world. The ease in which a barber shop's waiting area becomes an

open-air forum for topics as diverse and complex as politics, philosophy, sex, race, style, and most commonly, sports and music is, in many instances, part of the reason a great many of any shop's clientele are who they are.

From Ray, one of two Puerto Rican brothers who owned a shop in New Haven called Hair Pazazz, I learned how to combat an unrelenting dandruff issue. From his brother Danny I learned about bodybuilding nutrition. From Bart, another New Haven barber with a distinctly effeminate manner who ended up siring five children and at one point served time on a gun charge, I learned to appreciate Kool G Rap, an underheralded rapper who flourished a full generation before my own, whose music I wouldn't have bothered with if not for Bart once stopping my haircut to recite the lyrics to "Poison" in sync with the stereo.

From the aforementioned Sigel, I learned—and not without some skepticism—that Jay Z had had sex with the mother of his rival Nas's first child. This was, to be clear, well before this was public information, Jay going on to proclaim as much on "Takeover." From Lee, I learned that a local homeless man who would come in the shop on occasion to ask after odd jobs or just catch up with some of the stylists had actually played in the NBA in the 1980s. And from Black, the man who became my go-to barber at the Hut in the midst of all Lee's disappearances, I didn't gain knowledge so much as an actual friend.

Black was dark-skinned and handsome, unmistakably funny, and damn near a sorcerer with a pair of clippers. His ability to finesse my increasingly receding hairline allowed me to put off getting a baldy for about two full years before I succumbed to God's one true will for my dome. Going to Black was a premium experience that demanded patience (there was always a wait), but was rewarded with cups of Hennessy, news or gossip about other stylists and clients, and inevitably some good-natured jokes at your expense. He would talk to you about problems with the mothers of his children and with other barbers he worked with and would do his best to give advice if you felt compelled to share problems of your own. He'd lived quite a bit by his early thirties, and had once witnessed—among plenty of other horrors—a patron murdered in the chair next to him while getting a cut. As far as I know, a suspect was never identified.

Black himself had served time for an unrelated shooting but was way too talented to be cutting hair in jail. He should have been cutting rappers' hair. And he was for a time before he'd end up leaving the Hut in what I understood to be some kind of business dispute. Last I heard he had relocated deep into Long Island. I have no idea if he has an Instagram account and I'm not really inclined to seek it out. I'd found Lee's through a close friend who got it from Lee himself when our former barber approached him in the dayroom of Riker's Island, where my friend is a corrections officer. Lee was awaiting sentencing on drug-related charges. I doubt I'll ever see Lee in person again, but my hope is that one day in the not so distant future, Instagram will alert me to a new post from him, Lee letting his followers know that he's finally back where he's supposed to be, in a shop somewhere cutting hair.

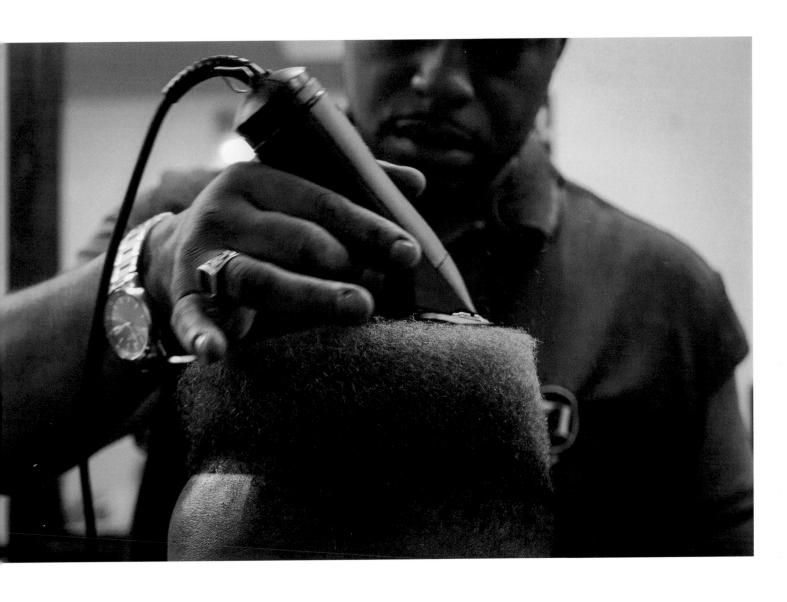

Buckhead barber shop.
71 Barbershop in Atlanta, GA. August 2018

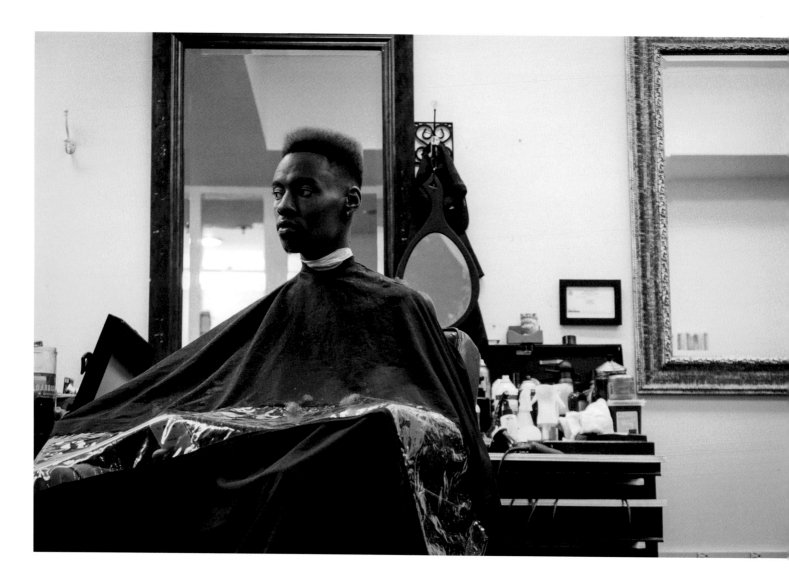

71 Barbershop in Atlanta, GA. August 2018

CRISPY SHAPE-UPS, PERFECTLY ROUNDED AFROS, SHARP FADES, REGAL CAESARS, SMOOTH TAPERS, SPARKLING BALDIES

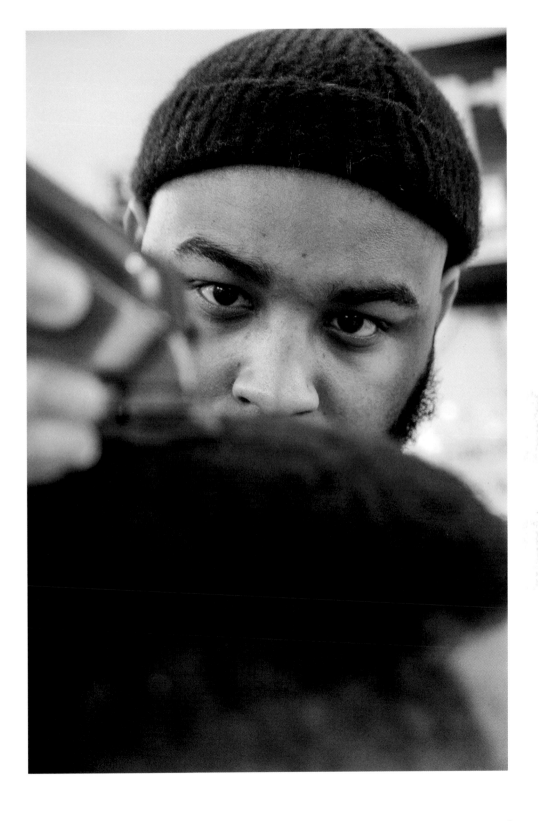

Close inspection.
Faith Barber Shop in Atlanta, GA. March 2019

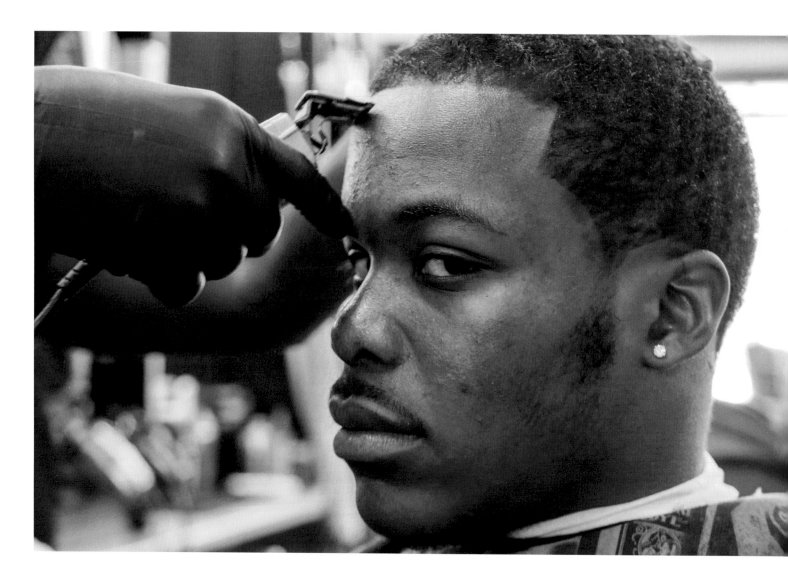

Atlanta-area college student looking on.
Vintage Barber Shop in Atlanta, GA. March 2019

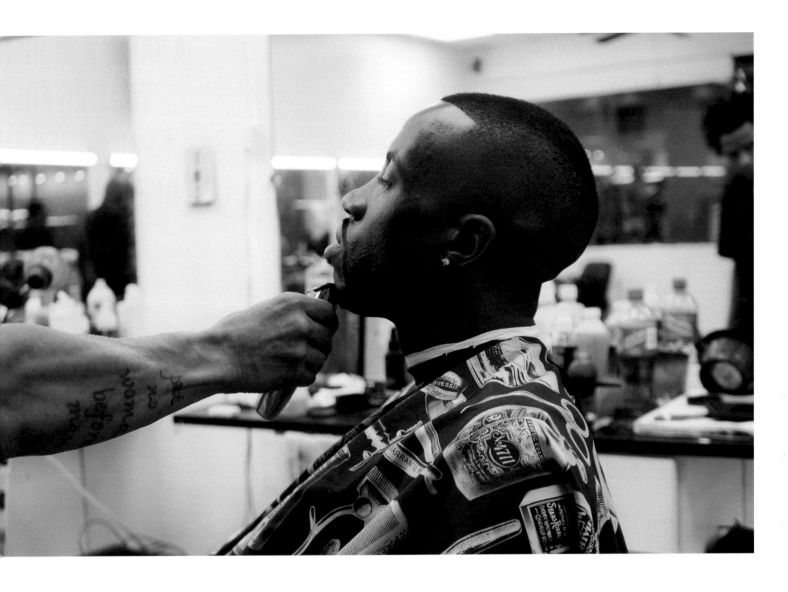

West End Mall Barber Shop in Atlanta, GA. August 2018

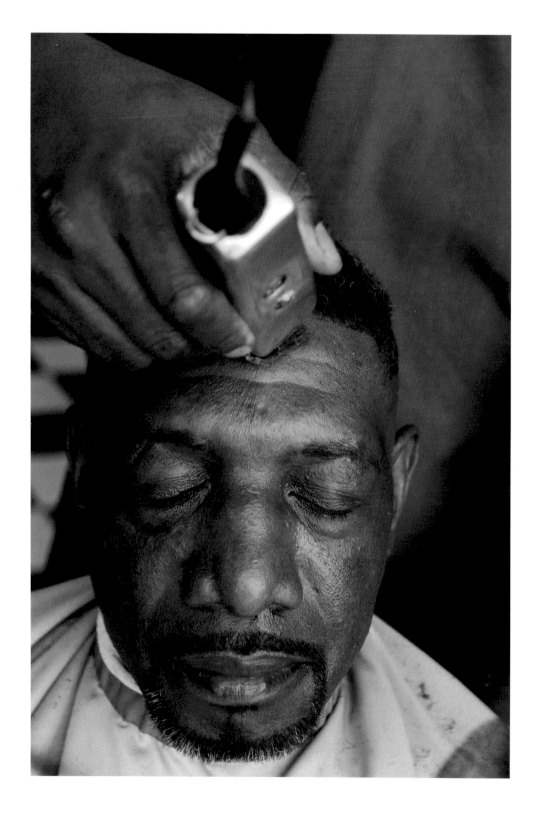

A BARBER SHOP'S WAITING AREA BECOMES AN OPEN-AIR FORUM

Man with his eyes closed
*Pure Essence Barber Shop in
Atlanta, GA. March 2019*

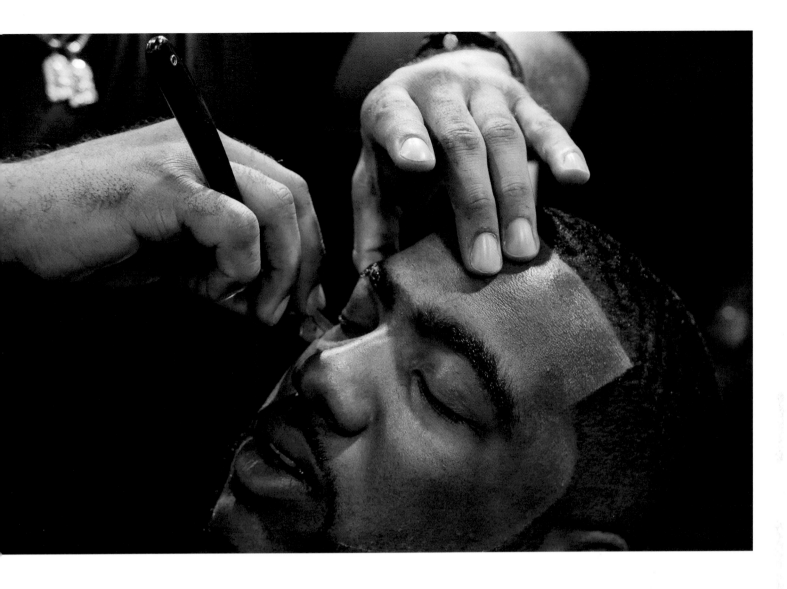

Hands.
RVM Cutz in Los Angeles, CA. September 2018

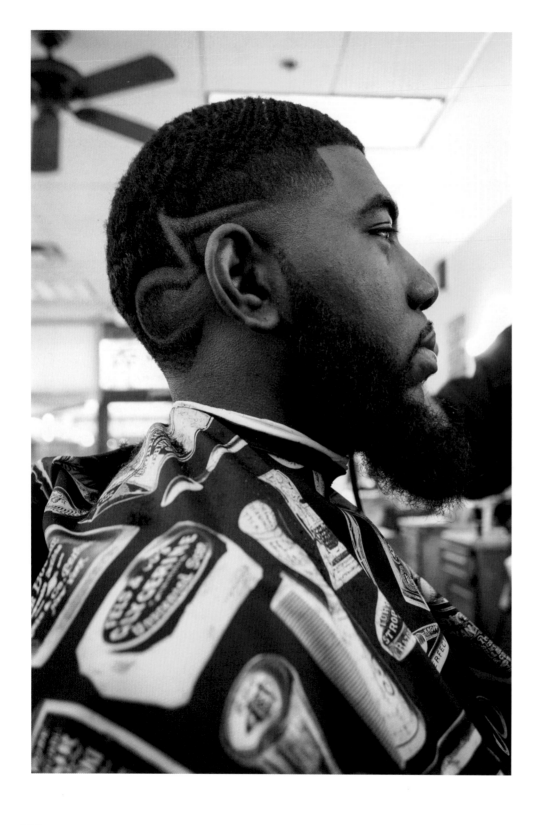

Freestyle design
Faith Barber Shop in Atlanta, GA. March 201

194

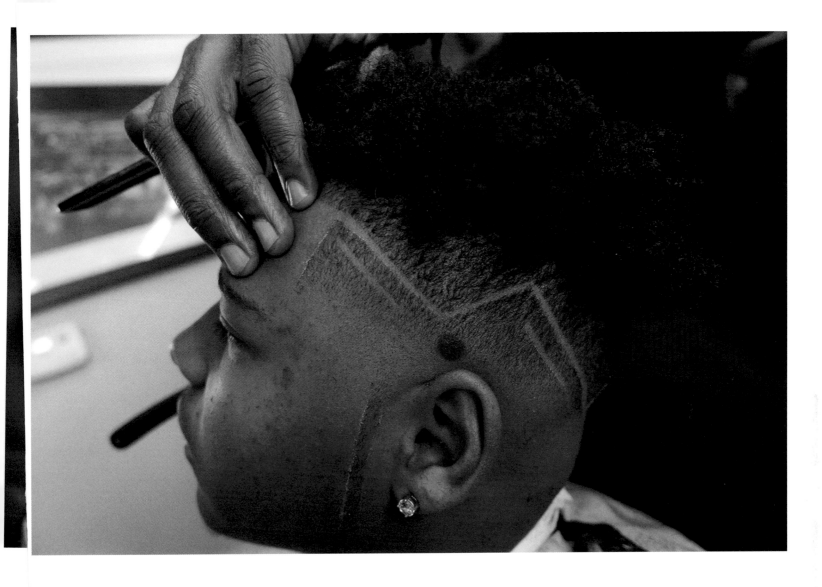

The c
relax **Something a little fancy for a trip to Colombia.**
Vintag *Vintage Barber Shop in Atlanta, GA. March 2019*

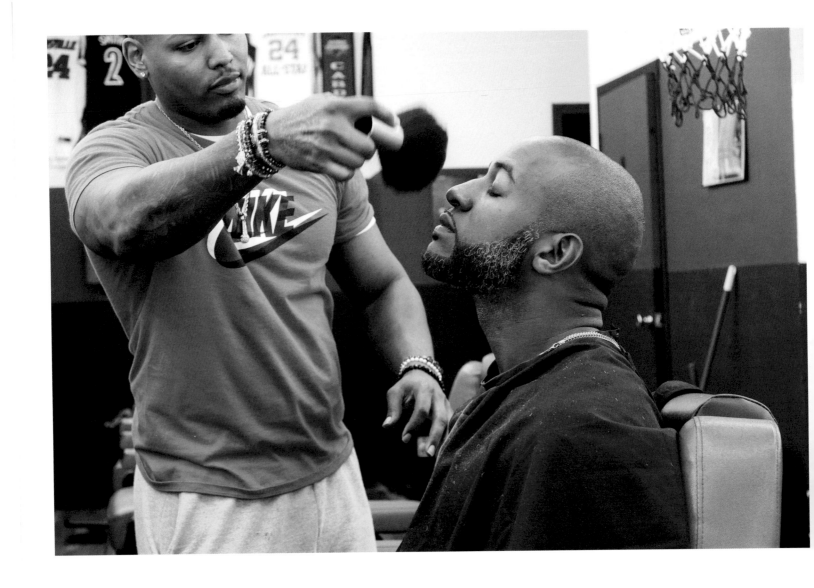

Tito, a Harlem-based barber, brushes fallen hair from a customer's face.
Big Russ Barber Shop in Harlem, NY. May 2019

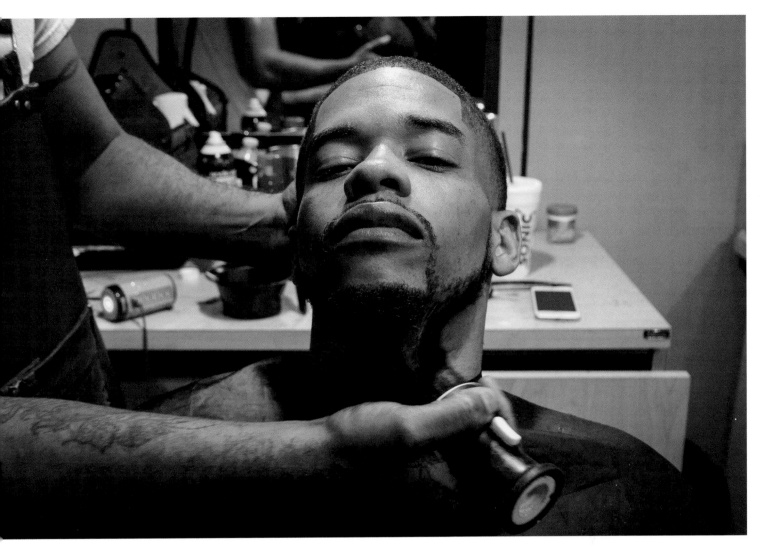

A PREMIUM EXPERIENCE THAT DEMANDED PATIENCE (THERE WAS ALWAYS A WAIT), BUT WAS REWARDED WITH CUPS OF HENNESSY, NEWS OR GOSSIP ABOUT OTHER STYLISTS AND CLIENTS, AND INEVITABLY SOME GOOD-NATURED JOKES AT YOUR EXPENSE

hadows on man's face. *The Grain Grooming Studio in Atlanta, GA. August 2018*

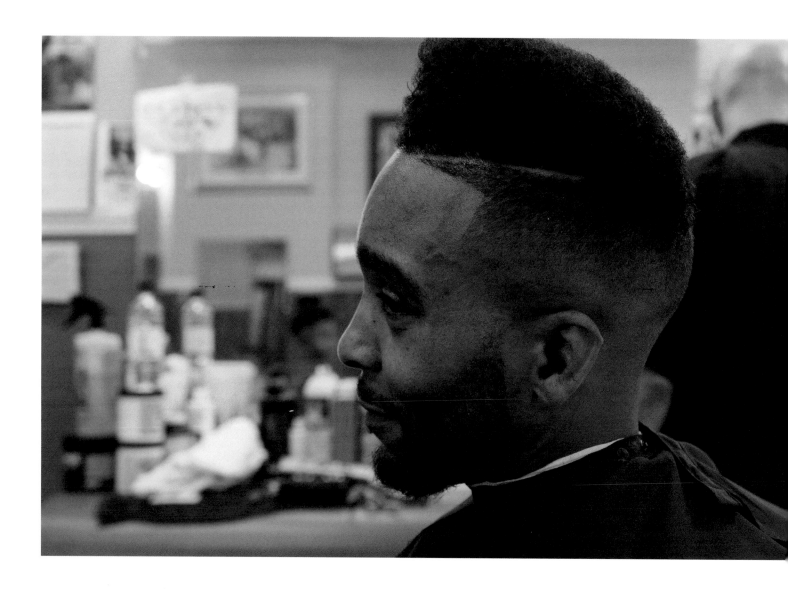

Billy Shaw shows off his cu
A Sharper Image Barber Shop in Washington, DC. June 20

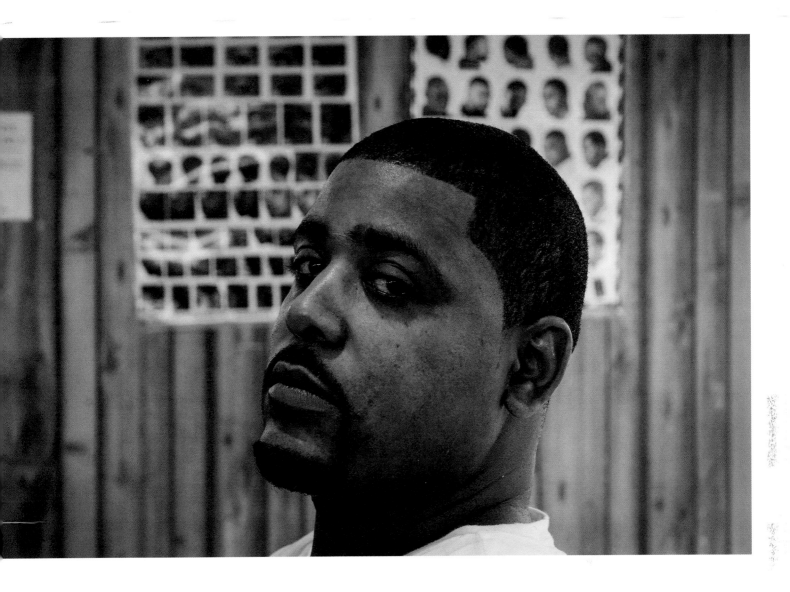

A Chicago man stands in front of a classic style guide.
Frank's Place in Chicago, IL. August 2018

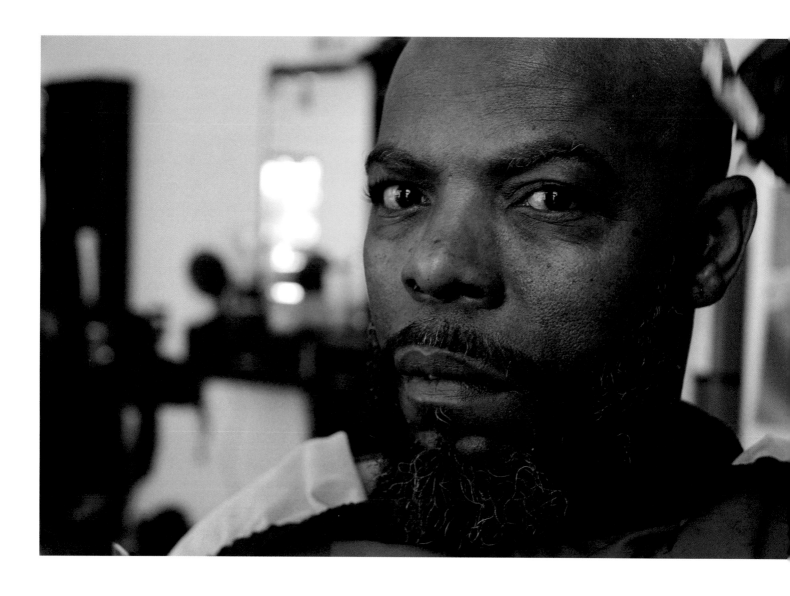

Man with beard
Pure Essence Barber Shop in Atlanta, GA. March 201

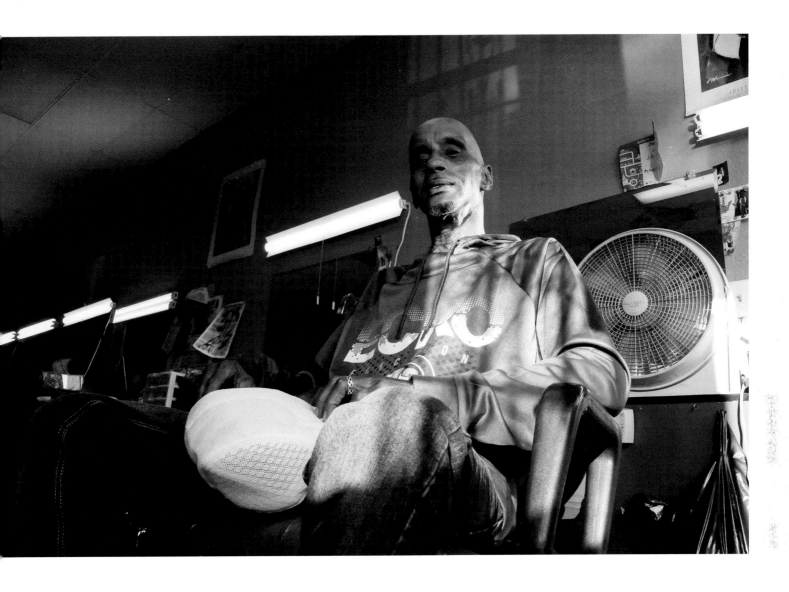

Older man after, in the chair.
Jackie's Cuts and Styles in Oakland, CA. October 2018

YOU AFTER

QUINCY T. MILLS

What does it mean to be next? If we respond too quickly, the answer might turn to the individual with excitement, angst, or ambivalent expectations of the future. Yet, be next encourages us to consider who and what we are following. Therefore, another way of considering time, and one's place in it, is to ask: What does it mean to come after?

As a Black man, the grandson of a late barber, and a historian of Black barber shops, it is humbling to reflect on the countless people who stood behind the barber's chair, sat and squirmed in the chair while being groomed, and waited in that row of seats for their turn, and in community. Any history of Black barber shops is by necessity a collective one that includes the barber, the patron or customer, and the waiting public in concert.

Black barbers come after a litany of Black men and women who defined the American commercial ethos of customer service. Despite, in some cases, being dehumanized, disrespected, and disavowed, they brought immaculate shaves to all who sat in their chairs, even to enslavers. Barbering, in the nineteenth and twentieth centuries, provided a path toward freedom and economic autonomy.

All labor, all people, want control over their lives, which runs counter to the aims of a capitalist economy that requires labor to be in constant production. Barbering is an exit ramp from wage labor. Black men's objectives of controlling the fruits of their labor met Black consumers' needs and desires of looking and feeling good.

Black men have the freedom to seek out any barber of their choice, yet many frequent Black barbers because they trust these barbers know how to cut and trim curly hair at minimum, and all hair types writ large. Beyond the expectations of skill, Black customers expect their barbers will appreciate the latest hairstyles in Black cultural production. This level of trust and intimacy is no small matter. The transaction between barber and customer is at once economic and personal. A barber could remake a man after a week of hard, dirty labor in a West Virginia coal mine; a hat constantly covering one's head as a Pullman porter on the train; or the intensity, toil, and sweat of practice for the upcoming Negro Baseball League contest. A shave and haircut could instill confidence in a man preparing to ask his partner to marry him, preparing to stand before a congregation on Sunday to deliver the word of God, or even before an assemblage of protestors ready

to disrupt a racist society, or simply in preparation to stand and be in public with pride in one's appearance and joy. But, before the world sees these transformations, the shop serves as that inner world of construction.

While men have waited to be the next person to undergo such transformations, they talk, laugh, sneer, debate, shudder, listen, and sit in silence. The combination of barbers, patrons in the chair, and a group of people waiting, combined with the production of Black culture, have historically defined the very significance of these shops. Many Black men were in the barber shops when news spread of the *Brown v. Board of Education* decision, Shirley Chisholm's announcement of running for president of the United States, and Nelson Mandela's release from prison. They likely discussed the differences between freedom and liberation, manhood and personhood, and the state of the African diaspora.

In all, historically, there were few places in the public sphere where Black men could escape the surveillance of a white public, pursue economic autonomy, and shape individual lives and worldviews. Considering who we come *after* makes being *next* all the more scary and glorious.

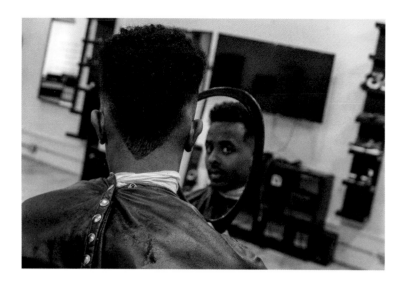

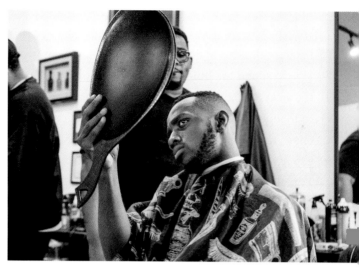

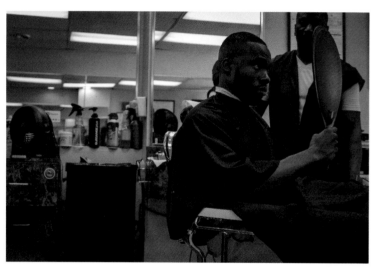

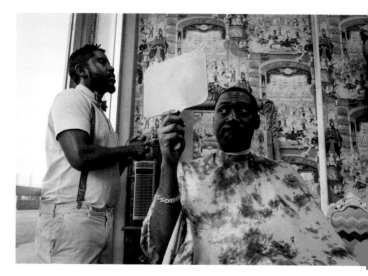

Final Inspection

Benny Adem Grooming Parlor in Oakland, CA. October 20

Benny Adem Grooming Parlor in Oakland, CA. November 20

Best Cuts DC in Washington, DC. 20

The Funhouse in Los Angeles, CA. September 20

ANY HISTORY OF BLACK BARBER SHOPS IS BY NECESSITY A COLLECTIVE ONE

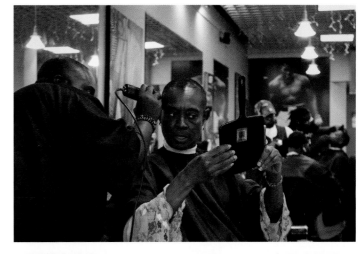

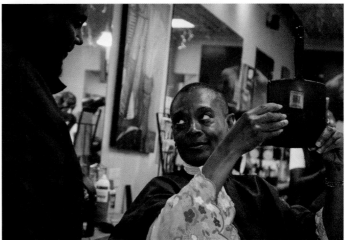

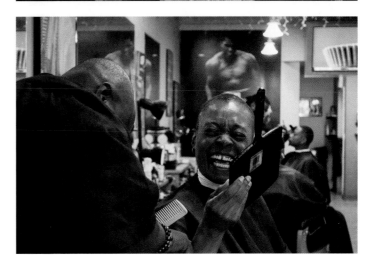

Hyde Park Hair Salon in Chicago, IL. August 2018

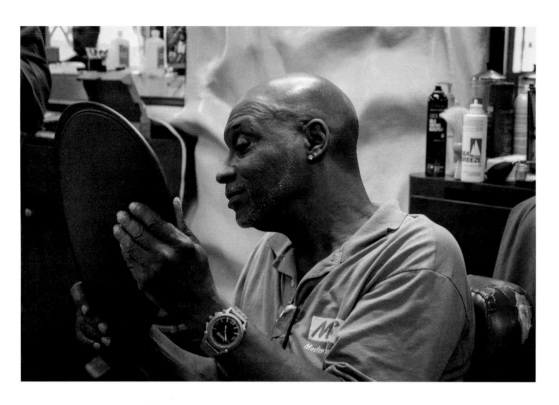

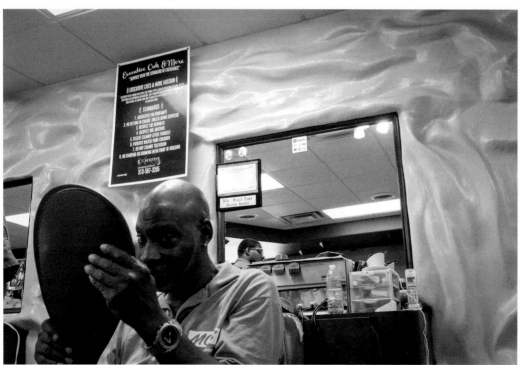

Executive Cuts and More in Detroit, MI. July 2018

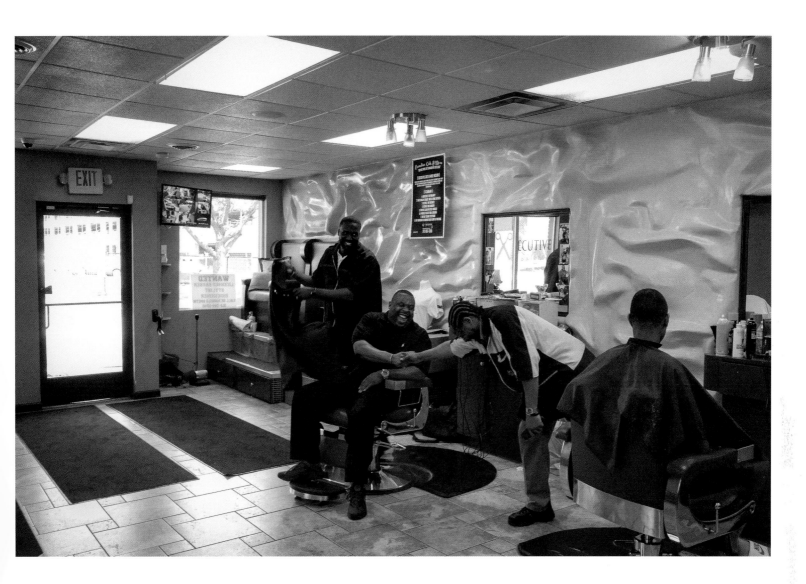

Shop laughter.
Executive Cuts and More in Detroit, MI. July 2018

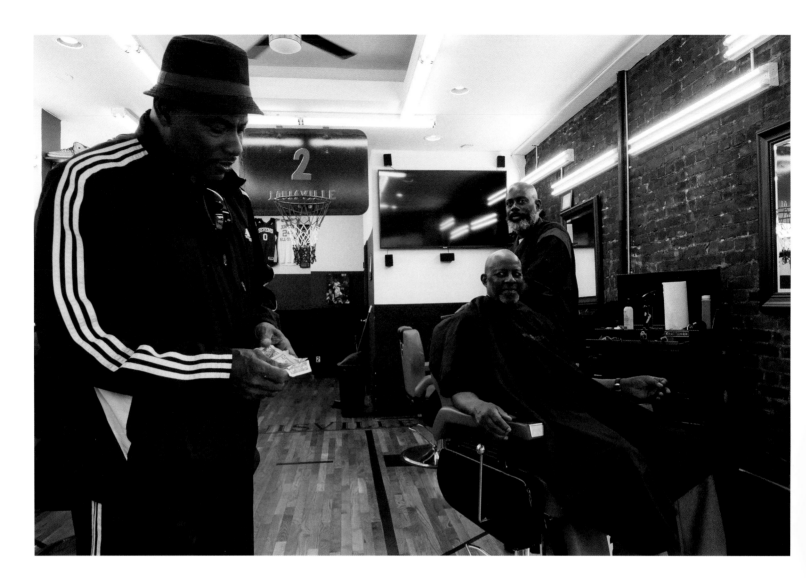

THE TRANSACTION BETWEEN BARBER AND CUSTOMER IS AT ONCE ECONOMIC AND PERSONAL

A gentleman preparing to pay for his haircut at Big Russ Barber Shop in Harlem.
Big Russ Barber Shop in Harlem, NY. May 2019

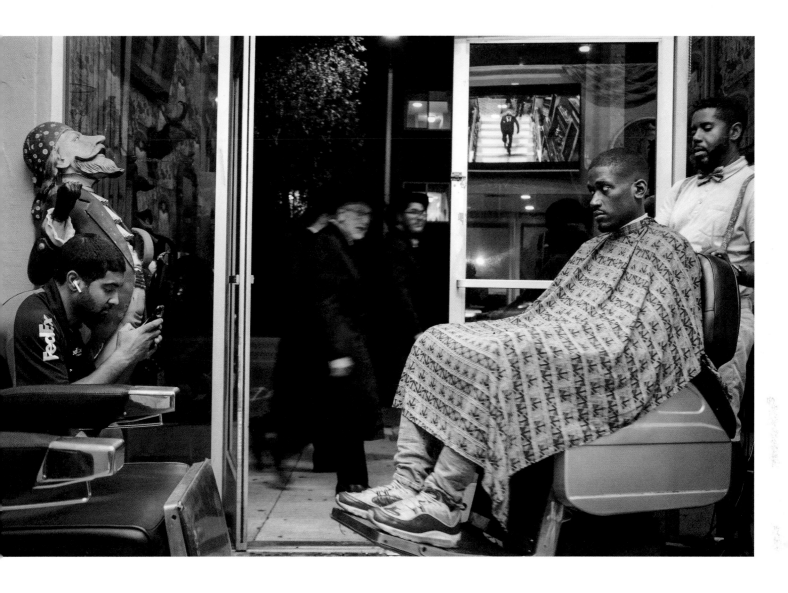

Jewish men walk by, peeking into the Funhouse Barber Shop as men are serviced.
The Funhouse Barber Shop in Los Angeles, CA. September 2018

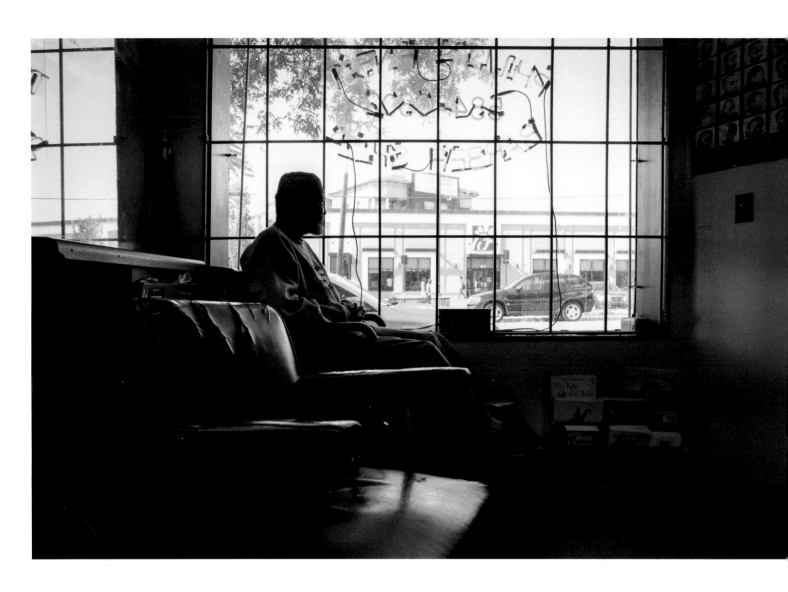

An elderly man sits in the window of Atlanta's Philly's Finest barber shop.

Philly's Finest in Atlanta, GA. August 2018

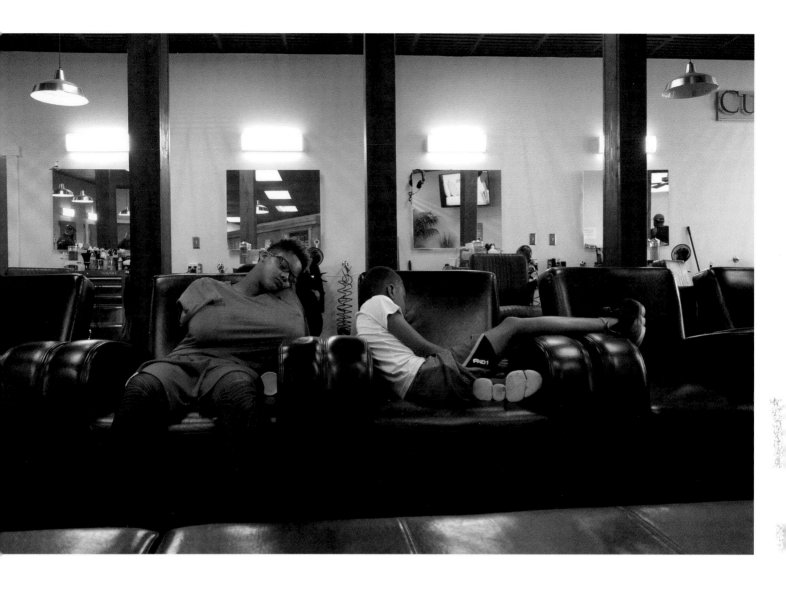

Two young boys sleep at the barber shop after haircuts.
Cutting King's Barber Shop in Fayetteville, GA. May 2019

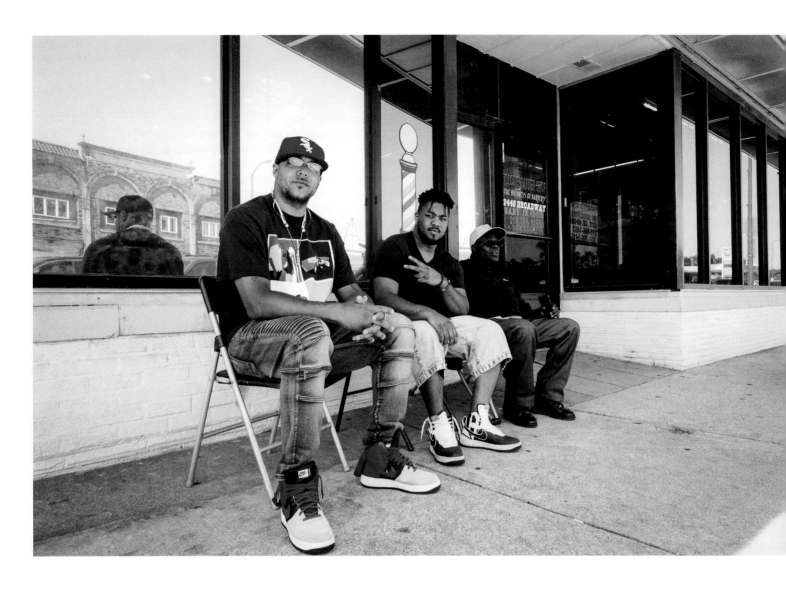

The barbers of Billco's Barber shop after a busy day

Billco's Barber shop in Gary, IN. August 2018

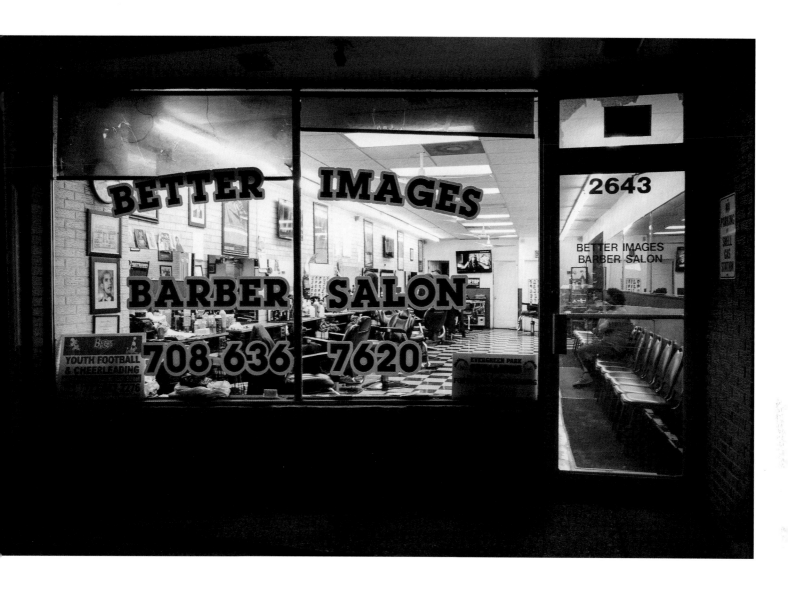

view inside of Better Images Barber Salon as it closes.
Better Images Barber Salon in Evergreen Park, IL. August 2018

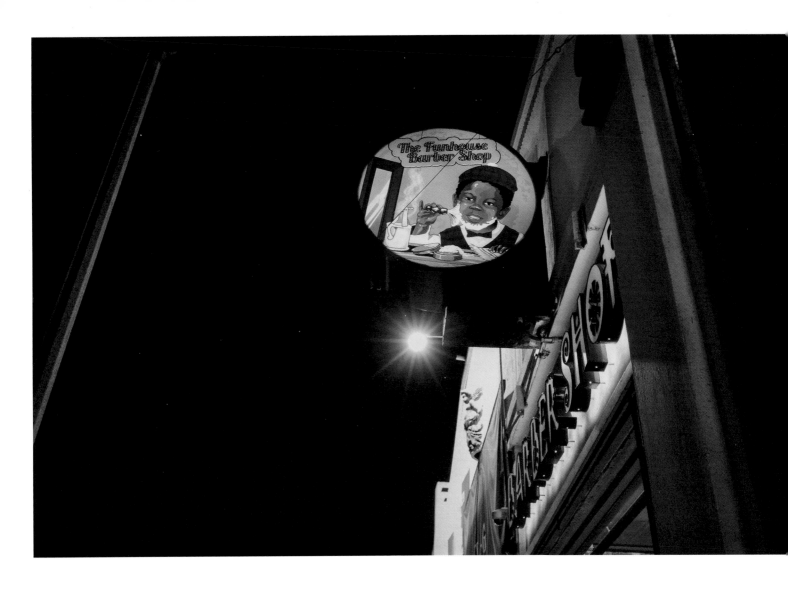

CONSIDERING WHO WE COME *AFTER* MAKES BEING *NEXT* ALL THE MORE SCARY AND GLORIOUS

The Funhouse Barber Shop at night
The Funhouse in Los Angeles, CA. September 2018

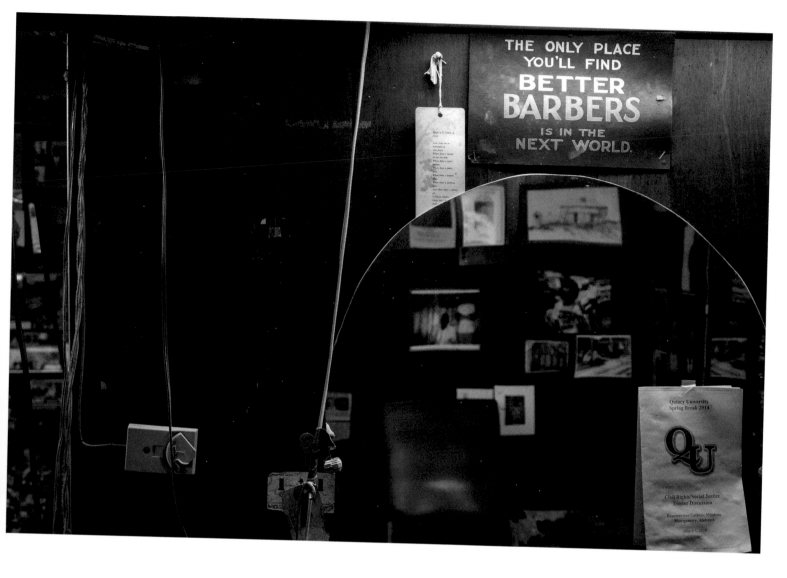

Shop sign on top of a mirror reflecting an empty chair that reads
"The only place you'll find better barbers is in the next world."
Malden Brothers Barber Shop in Montgomery, AL. August 2018